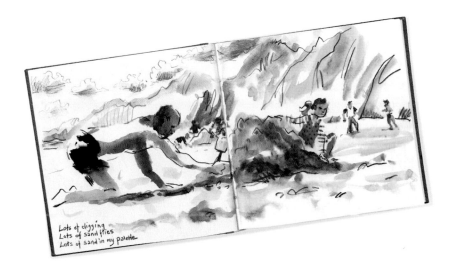

Lots of digging
Lots of sand flies
Lots of sand in my palette

Sketching People

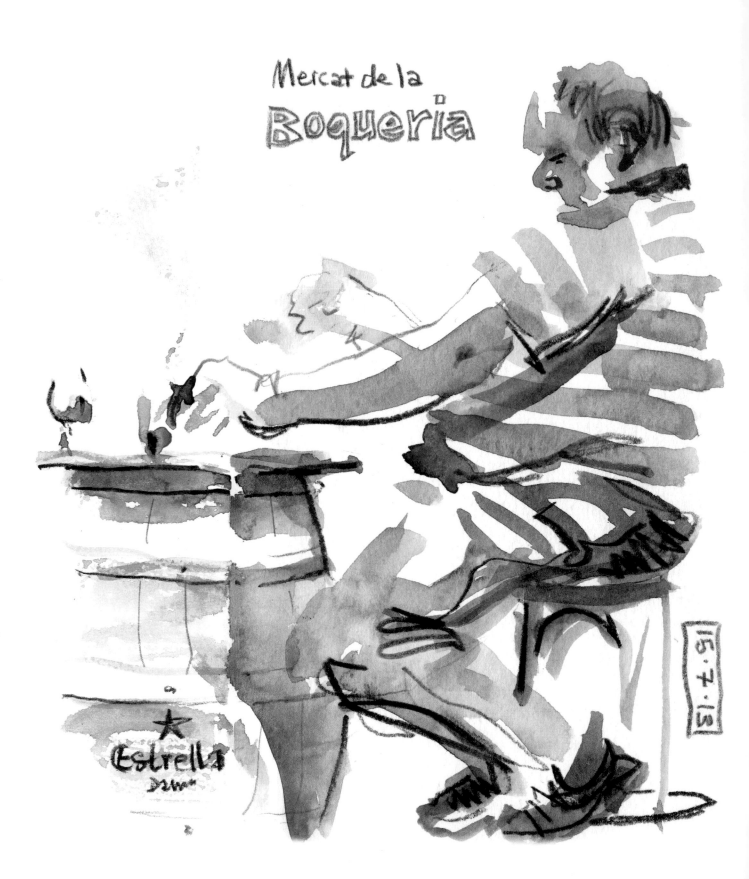

Mercat de la
Boqueria

Estrella

15·7·13

Lynne Chapman

Sketching People

An Urban Sketcher's Manual
to Drawing Figures and Faces

BARRON'S

Contents

Sketching People
A QUARTO BOOK

Copyright © 2016 Quarto Inc.

First edition for North America published in 2016 by Barron's Educational Series, Inc.

All inquiries should be addressed to:
Barron's Educational Series, Inc.
250 Wireless Boulevard
Hauppauge, New York 11788
www.barronseduc.com

ISBN: 978-1-4380-0726-7

Library of Congress Control No.:
2015951015

QUAR.SKPE

Conceived, designed, and produced by
Quarto Publishing plc
The Old Brewery
6 Blundell Street
London
N7 9BH

Senior editor: Lily de Gatacre
Designer: Sue Wells
Design assistant: Martina Calvio
Picture researcher: Sarah Bell
Photographer: Phil Wilkins
Proofreader: Claudia Martin
Indexer: Helen Snaith
Art director: Caroline Guest

Creative director: Moira Clinch
Publisher: Paul Carslake

Color separation in Singapore by Pica Digital Pte Limited
Printed in China by Hung Hing Off-Set Printing Co., Ltd

9 8 7 6 5 4 3 2

20 Getting Started

82 Different Styles and Approaches

2

58 Sketching Out in the Big, Wide World

4

108 People Move!

Welcome to My World!

Drawing is my passion and has always taken a central role in my life. I have worked as a freelance illustrator for 30 years but, throughout that time, I have continued to draw purely for pleasure, in my sketchbooks. There is something special and uniquely personal about a sketchbook drawing: The moments in time and the people you capture, once enclosed in the pages of a book, remain yours forever.

Until around 10 years ago, I only sketched in pencil, occasionally colored pencil. I rarely drew people and only took my sketchbook out when I was on vacation. In between times, it languished on a shelf in my studio.

Then everything changed. Shortly after I started illustrating children's books, I began getting invitations to give workshops in schools and suddenly found myself traveling on trains all over the United Kingdom. One day, instead of taking a novel to pass the time, I took a sketchbook and started to draw my fellow passengers.

By chance, I had discovered one of the easiest places to sketch people and had finally realized that capturing my everyday world was just as interesting as sketching on vacation, probably more so.

I posted some of those train drawings online, where they were spotted by Gabi Campanario, who invited me to be part of an exciting new group called Urban Sketchers. I had no idea that it would change my life and take me all over the world. It changed my sketching too: The inspiration I got from other urban sketchers' work freed up my approach.

▼ **Capturing Light on the Train**
This is one of my earlier train sketches. I was particularly taken with the way the light caught his face and sleeve, exaggerating his bone structure and the patterns of the folds in his jacket. Notice how, despite his dark skin and the dark fabric, there is still a lot of white left, preventing the sketch from getting overworked.

3B pencil

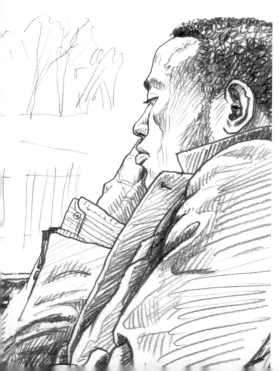

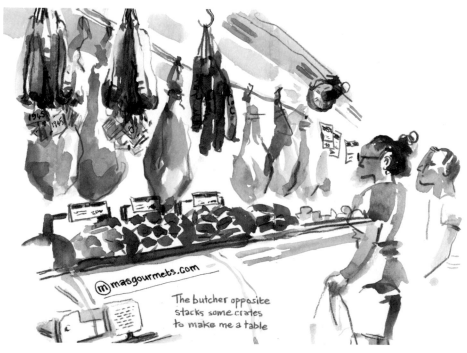

▲ **Adding Context**
Once I began drawing people in various settings, I became far more interested in adding context. By sketching clues to the environment through which the people are passing, a more complete picture of the moment is painted, and the sketch becomes a narrative.

Watercolor, watercolor pencils

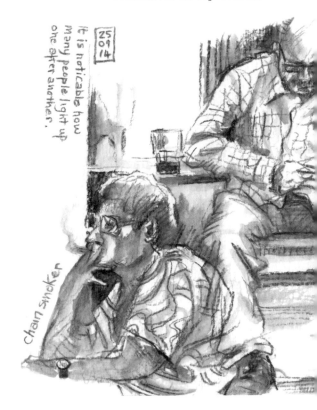

My train portraits burst into color. I started drawing musicians, people in cafés, on buses, in the street … I experimented with all kinds of different media and taught myself how to use watercolor. My sketching continues to evolve, because there is always new excitement to be had.

Throughout this book, I will be sharing an array of tips and techniques to help you sketch people with more confidence, but I also hope I can pass on to you some of that inspiration I discovered. I want to empower you to tackle people in many different situations and increase your confidence for drawing in public. Along the way, I will be offering suggestions that aim to enrich your sketching experience generally, to help make sketching as much fun as possible.

▶ Celebrating the Ordinary

It is fun to just people-watch with a sketchbook. The most insignificant and ordinary moments can be the richest: The chain smoker's slightly hunched posture, dragging at another cigarette; the man in his big boots, relaxing with a drink at the end of the day, idly checking his phone.

Watercolor pencils, waterbrush

▼ A Problem Becomes an Asset

I can never resist drawing a musician, especially in an informal setting like this music café, where I could get up really close. My pen ran out of ink halfway through and I had to scramble in my kit bag to quickly find an alternative to finish him off before he finished his song. Now I rather like the playfulness of the sudden change from black ink to the rainbow pencil.

Sailor fountain pen, black ink, rainbow pencil

▼ People Turn a Building into a Story

I used to draw a lot of architecture, but at one time, it never occurred to me to capture the life passing by in front of the beautiful buildings. These days, I realize that people are a massive part of the story. I was so absorbed, I didn't notice until the next day that I'd drawn only half a van, which had arrived halfway through.

Sailor fountain pen, black ink, watercolor

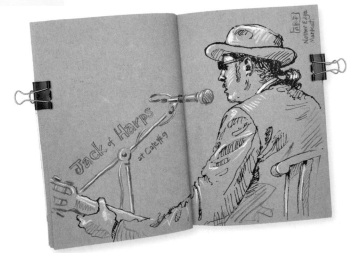

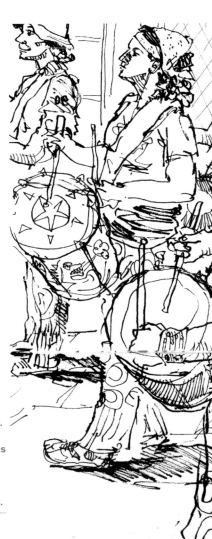

▶ Getting Adventurous

I have grown more and more confident over recent years and will give most things a go. The only way I could capture these marching drummers was to walk sideways, between them and the crowds on the sidewalk, trying to keep pace and scribbling as I went along.

Sailor fountain pen, black ink

What Is Urban Sketching?

Urban Sketchers is an international community of artists who draw on location, capturing the life that flows around them, wherever they happen to be. From humble beginnings in 2007, it has grown into a massively popular movement, connecting sketchers from all over the globe, who share their work, support, and inspire one another and sketchers everywhere.

There are fundamental differences between the reportage drawings that an urban sketcher creates onsite and work done in a studio. Sketching people out in the world as they go about their life is difficult, but exciting: The drawings you create might not be as polished, but there will be an immediacy and honesty to them. You also have the opportunity to try to capture a tiny bit of the world they inhabit. That's a big part of the fun: Soaking up the moment and then choosing details that help to paint a picture and tell a story.

At the center of the Urban Sketching movement are more than 100 correspondents (a few of whom are showcased here), who are invited to share the work they do on the Urban Sketchers blog, and to do their best to inspire sketching in the area where they live. If you have not seen the blog at urbansketchers.org, take a look.

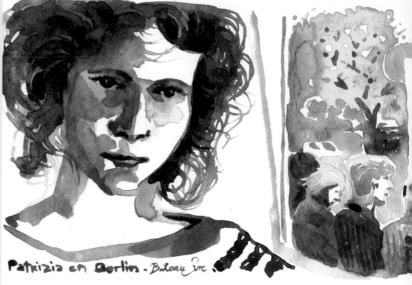

▲ **Omar Jaramillo, Catania, Italy**
Patrizia in Berlin

Watercolor

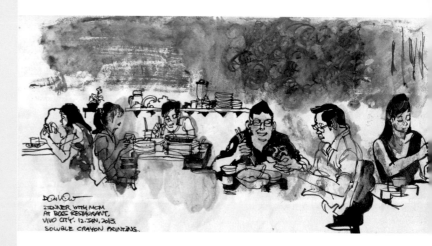

▲ **Don Low, Singapore**
Dinner

Ink, brush pen, water-soluble crayons

◀ **Miguel Herranz, Bologna, Italy**
A Beer with Roberta en Sant Feliù

Fountain pen, watercolor, white POSCA marker pen

The Urban Sketchers blog, which you can find at urbansketchers.org, is a wonderful place for getting inspiration and new ideas. The constant flow of exciting new work by the correspondents showcases an extraordinary array of techniques, and presents a series of uniquely personal stories about the variety of places where we live, work, and travel.

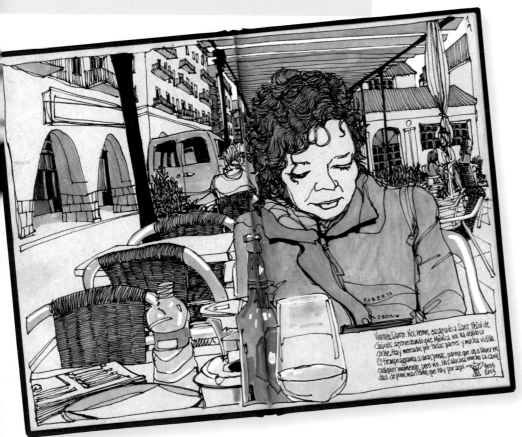

▶ **Marc Taro Holmes,
Montreal, Canada
Mural Festival**

Pencil, watercolor

▼ **Inma Serrano, Seville,
Spain
Marruecos**

*Black Bic ballpoint pen,
watercolor*

▲ **Marina Grechanik,
Tel Aviv, Israel
Friday at South Tel Aviv**

*Watercolor, watercolor
pencils*

▼ **Lapin, France
"All You Can See!"
180° Sketching Workshop
in Singapore**

Ink pen, watercolor

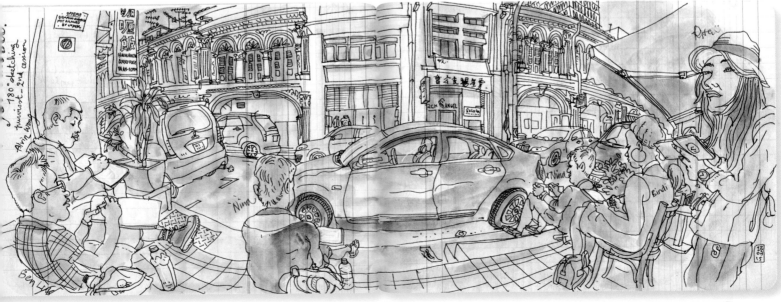

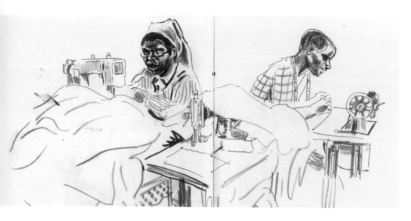

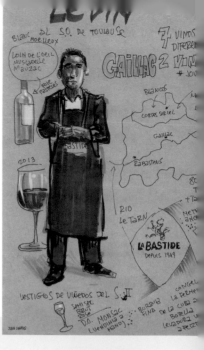

▶ Juan Linares Vargas, Spain
Le Vin
A sketch can sometimes be a compilation of elements. I love the idea of the wine map.

Fountain pen, black ink, Pentel markers, Tombow markers

◀ Jeroen Janssen, Belgium
Sister Katharina and her Chief Tailor
Sketches can be a form of social commentary, such as this test sketch for a graphic novel about the people of Rwanda.

Ballpoint pen, pencil, white POSCA marker

Sharing Around the World

One of the great joys of being part of Urban Sketchers is that we all get to see what the others are doing. Because the movement is based on sharing, sketchers from all around the world and at all levels of experience, from beginners to professional artists, use social media sites, like Flickr, Instagram, and Facebook, to post their urban sketches, share tips, and talk to one another about their work.

Urban Sketchers has a local face too. Many correspondents have set up groups in their hometowns: people who meet up to go out sketching together. My group, Urban Sketchers Yorkshire, started in 2010 and now has more than 350 members (luckily they don't all turn up at once!). We meet for a full day of sketching every month, somewhere in our region. It turns the usually solitary experience of drawing into a fun, social occasion. It's also a great opportunity for beginners to get over the fear of drawing on location, because being with others makes it far less scary.

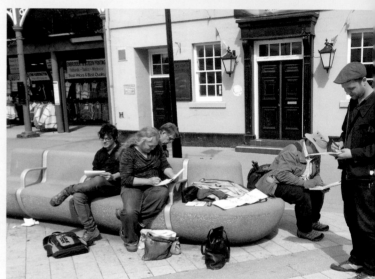

▲ **Urban Sketchers Yorkshire**
Sketching as a group empowers people. Each time we go out, passers-by come and ask if they can join, so new members turn up at every sketch-meet.

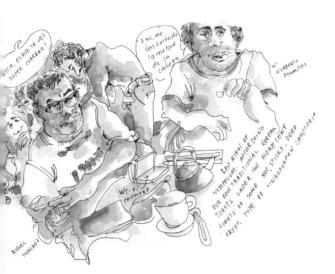

◀ Rita Sabler, USA
Last Night in Singapore
The captured conversation and little notes add real intimacy, as if we are looking over Rita's shoulder.

Ink pen, watercolor

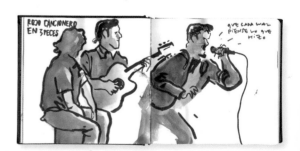

▲ **Enrique Flores, Spain**
Rojo Cancionero
The strong, fluid lines and simply applied color make this sketch really animated.

China ink, watercolor

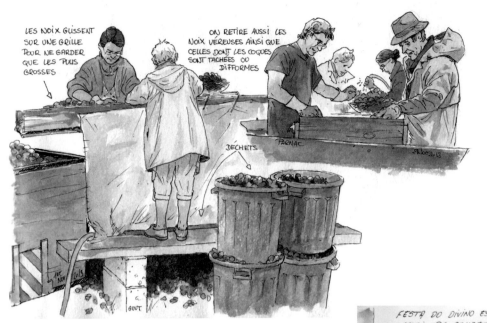

LES NOIX GLISSENT
SUR UNE GRILLE
POUR NE GARDER
QUE LES PLUS
GROSSES

ON RETIRE AUSSI LES
NOIX VEREUSES AINSI QUE
CELLES DONT LES COQUES
SONT TACHÉES OU
DIFFORMES

DÉCHETS

◀ **Catherine Gout, France**
Sorting Nuts
Some sketches tell a story: This is
one of a sequence, following the
process of a harvest.

Permanent marker, watercolor

▼ **Ana Rafful, Brazil**
**Entry of the Palm Hearts in Mogi
das Cruzes**
The vibrancy of this sketch really
conveys the color and liveliness of
the place.

*Fountain pen with flex nib, gray ink,
watercolor*

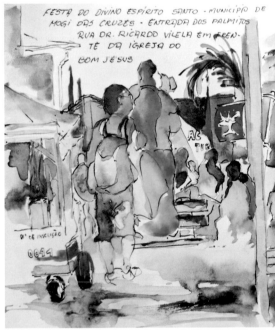

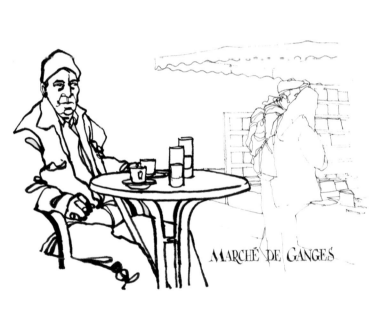

MARCHÉ DE GANGES

▲ **Xavier Boutin, France**
Ganges Market
Two different weights of line are
an excellent way to create contrast
and direct the viewer's focus.

Brush, pen, ink

▶ **Andres Silva Vignoli, Spain**
Kurfürstendamm/Olivaer Platz
I love how urban sketches like this
give you a real feel for everyday
spaces in other people's towns.

0.05 fineliner, 0.1 fineliner

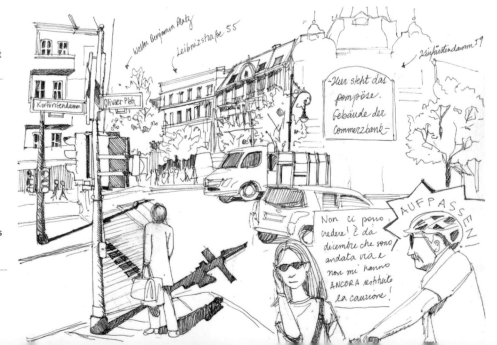

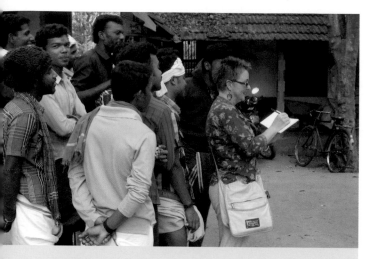

▲ A Positive Mindset
Sketching in Kerala, India, I often gathered a small crowd. This kind of attention might seem daunting, but people are just interested, which is a positive thing, so the secret is to embrace it. When you are traveling, drawing is a great way of bonding with local people.

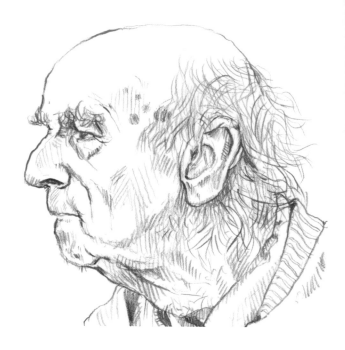

Connecting with Strangers

Letting other people see your work, especially while it's still in progress, can feel a little uncomfortable, particularly if you are sketching people. Once you get used to the idea, though, sharing can truly enrich the drawing experience and help you to grow more confident.

The chances are, if someone is peering over your shoulder, they are not judging the quality of your work; they are simply fascinated by the process of sketching. Try not to feel intimidated—most people do not draw, but wish they could. In my experience, people either know nobody who draws and so are spellbound by the act, or they are remembering when once they used to enjoy drawing at school and so are envious that you are doing something they lack the confidence to do themselves. If you find yourself frowning and wishing an onlooker would leave you alone, try instead simply looking up and smiling. They will smile back, and the tension will be eased.

Some of my fondest memories are about the brief connections I have made with strangers because of sketching. Here, I share just a handful of examples.

◀ ▲ An International Language
I was drawing an old, wooden house in Sumiac (a hamlet in what is now the Czech Republic), when the owner came out. We shared no language, but exchanged names, and he wrote that he was born in 1900. After I had sketched him, his neighbor, an equally elderly man, came marching down the hill and communicated through mime that I should not be wasting my time there, and should go and draw his house instead, which I duly did.

3B pencil

While you are still building your confidence, there are plenty of ways to share your work remotely. Use the #urbansketchers hashtag on Twitter, or Urban Sketchers has a Flickr and a Facebook group you can contribute to. If you have a smartphone, you can share your work on Instagram, or why not start a blog? It's so much fun sharing your work and any tips with like-minded people across the world.

Flickr (above) and Twitter (below)

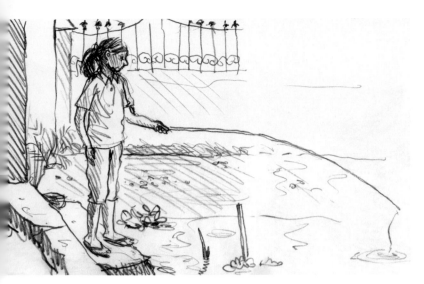

▲ Memories to Cherish

This little girl in the backwaters of Kerala, India, was fishing for dinner outside her tiny house. Her younger brother fetched all the family to see my sketch, and I was invited inside. Only the two children spoke any English, but we spent a magical hour. The proud parents showed me the boy's school drawings, and I sang along while the girl played "Jingle Bells" on a small, plastic keyboard and Granny giggled.

3B pencil

▶ Sharing a Moment with Strangers

A sketcher never knows what little adventure awaits them. I stumbled upon a music festival in Ghent, Belgium, where some African musicians were performing in a large square. A crowd encircled them, so I tucked myself in behind the band, where I could get close enough to draw. But I was spotted! After the applause for their next song, the singer invited me out in front of the crowd to take a bow.

Watercolor pencils, waterbrush, Sailor fountain pen, black ink

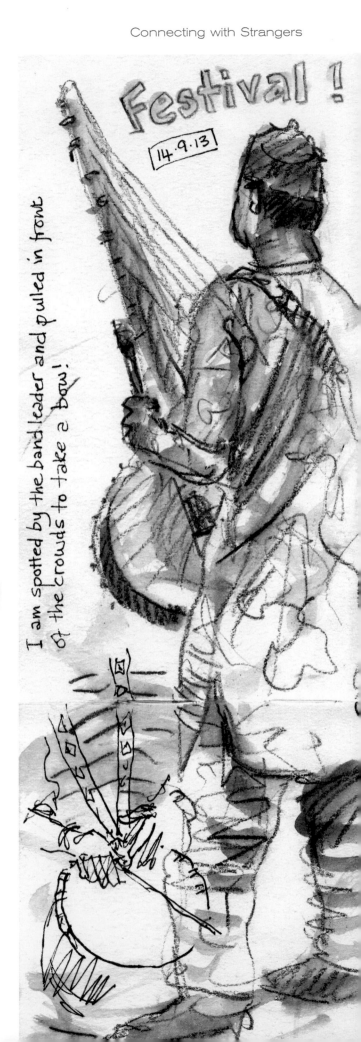

Festival !

14.9.13

I am spotted by the bandleader and pulled in front of the crowds to take a bow!

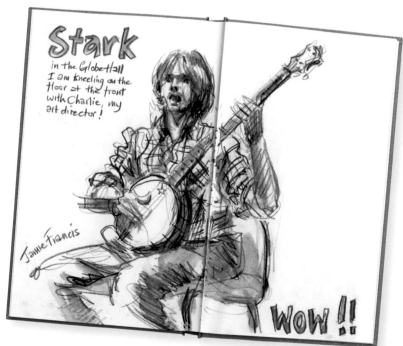

Stark

in the Globe Hall I am kneeling on the floor at the front with Charlie, my art director!

Jamie Francis

WoW !!

▲ The Joy of Random Connections

To get such a good view of the performers at this folk festival, I had to kneel on the floor directly in front of the stage, where assorted small children were milling about. Charlie, age 6, stood transfixed beside me. After a while, he began offering me drawing tips and was very quick to notice when I forgot the little star on the banjo!

Watercolor pencils, waterbrush

12.5

The radio plays, people occasionally burst into song, a cockroach scuttles past my feet...

...the dog sleeps on.

7.15am

Baggage reclaim

'Look at your picture,' says his wife. 'Oh dear,' he says. 'I look like Alfred Hitchcock.' Which he does a bit.

Recording Extra Detail

The most interesting way to sketch people is to catch them going about their lives and interacting with their environment. Luckily, a sketchbook is an extremely versatile medium, so there are many different techniques you can use to capture what is happening and bring your sketch to life.

Because it takes longer to do a sketch than to take a photograph, various things occur while you are drawing, either through what your subject is doing, or because of interactions you have with your surroundings. If you think in terms of a short film, a photograph would represent a single frame, whereas a sketch can

attempt to pluck the most interesting elements from the film as a whole, presenting an overall impression of the period of time you were observing.

It can be fun to make a note of anything that strikes you while you are sketching. Sometimes these observations might be entirely unrelated to the main drawing you are doing, but still part of the moment. It can all go into your sketchbook, either as subsidiary sketched elements or as text. Comment on the weather, catch snatches of conversation—it's all relevant detail and can add to the page's visual impact, as well as the sense of place.

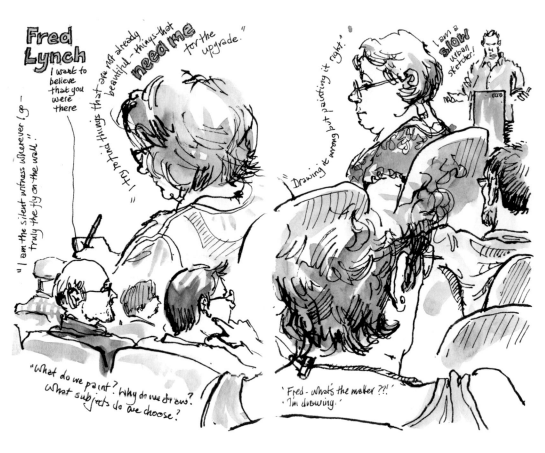

Highlights and Bulletpoints

Lectures are a great place to sketch—and not just because of all those people sitting pretty still. The speaker is giving you the benefit of their knowledge: Your sketchbook provides a great opportunity for pulling out salient or amusing highlights from the presentation. Note how playfully text can be incorporated into the drawing.

Sailor fountain pen, black ink, watercolor

▼ Background Incidents

This is a great example of how you can record unexpected events that are part of the period when you are sketching. I was pretty lucky here—the background incidents that happen while you are sketching are not usually quite as colorful!

Black fineliner, watercolor

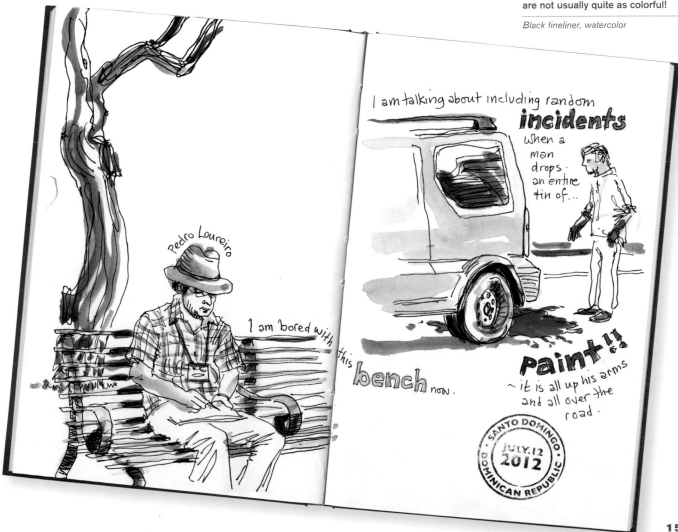

Getting the Most Out of the Page

There is a lot of fun to be had once you stop worrying about creating the perfect representation of what's in front of you and start thinking about the sketchbook page, or spread, as an entity that exists quite separately from your subject.

While sketching, your focus bonds you to your subject because of the unusual levels of concentration required, and you are, of course, doing your best to represent what you see. However, once the moment has passed and you have moved on, nobody looking at your sketch will be comparing it to the original subject—the drawing will stand alone.

With this in mind, you want to make your page as visually interesting as possible. Your sketchbook is your own space, where you can do whatever you like, so why not experiment a little? Try unusual compositions; montage combinations of images together; play with the way color balances across the page. If you add text, try out different ways of combining it with your sketches; experiment with different hand-drawn fonts; pull out key words in color. Basically, grant yourself the freedom to have fun, instead of being chained to a slavish need for realism.

This process of "designing" the spread eventually becomes second nature. The more you sketch, the more you learn to take account of the edges of the page as you first put pencil to paper, thinking about where the focus of your drawing will sit in relation to the overall space. The gutter down the center of each spread is also a dominant feature, which you should take into consideration. Make sure faces stay clear of it!

▲ **Using Text to Aid Composition**
You can just make out where I began drawing a different face. When the first man left, I started again below, but the final drawing then sat too low on the page. By adding the text, and tying it into the drawing through color and shading, the composition was rescued.

Black fineliner, watercolor

▲ **Using Text to Link Images**
When drawing people, you often end up with a page full of bits and pieces. You can use text to link them together, winding snatches of conversation or your thoughts between the sketches. You can help it all hang together if you use the same colors for your text as are in the drawings.

Watercolor pencils, waterbrush

▶ Unusual Formats

A way to incorporate multiple images is to divide the page like a comic book, as Miguel Herranz has done here. Note how the frames are not uniform and how many people break out over the edges.

Ballpoint pen

The edge of this face becomes the fourth side of the frame

▼ Flowing Across the Page

It's fun to let your work flow across both pages, but it's important to keep an eye on where the gutter falls. If my sketch had been half an inch farther left or right, the gutter would have created clumsy distortions that would have ruined the balance of the spread.

6B graphite stick, watercolor

▶ Multiple Images

Why not experiment with ways of placing more than one image on the page? With practice, this can be a great way to make an attractive spread out of the unfinished drawings you're left with, when people move away. Notice how you can make a feature of the gutter, by deliberately letting it split the text.

Watercolor pencils, waterbrush

Coming home: 5pm

Humped 30 books to school; sold 4! At least I'm there again tomorrow, so didn't have to bring them home with me tonight.

He is a bit of a wriggler!

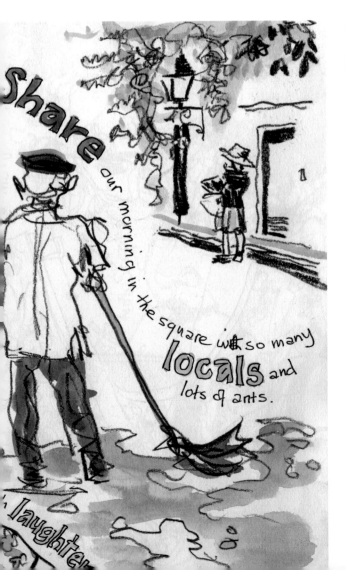

Share our morning in the square with so many locals and lots of ants.

...laughter...

▲ Exploiting Negative Space

Keep your eyes open for interesting negative space. Because he was standing close to the wall, this man cast a really interesting shadow. I zoomed in and placed him to one side of the page, so the space was divided into three distinct shapes. I tinted the shadow later to accentuate this unusual feature.

3B pencil (strengthened digitally), digital color

Back from Birmingham New St. ~ 12th Oct '09

▼ Making Blocks of Text Interesting

The tight framing of the boy's face creates a pleasing area of negative space. The block of text is not just telling the story; it is a visual element in itself because of the way it accentuates the shape of the space and echoes the boy's profile.

3B pencil

When I first find my seat, there are five unopened cans of Stella on the table of the seat next door. I think it's a shame it's not evening, since it seems they've been left behind, but eventually this man comes back to his seat. He drinks one, then falls asleep to what sounds like heavy metal on his Ipod.

Your Sketchbook as a Visual Diary

Your sketchbook can be private or public. Either way, it is a form of diary, or journal, recording where you have been and what you have encountered. It quietly catches those insignificant, everyday moments that would otherwise slip through your memory.

When you look back at your sketches, you will find yourself transported back in time. A drawing tends to be more evocative than a photograph, because the time you spend in that one place and the intimate observations you make glue the moment into your mind.

Because of this feature, I think of my sketchbooks as a form of continuous—if disjointed—narrative. It is, therefore, important to me that I fill a book from front to back, and I get really irritated if I accidentally miss pages. Some people prefer to use the pages randomly though, dipping in and out, even turning the book upside down. I suspect the way we use our books reflects different types of personality.

Many people date their drawings, which further enhances the journal element. I sometimes even record the time of day to pinpoint the moment exactly. It's an entirely personal thing, which is the beauty of a personal sketchbook—there are no rules!

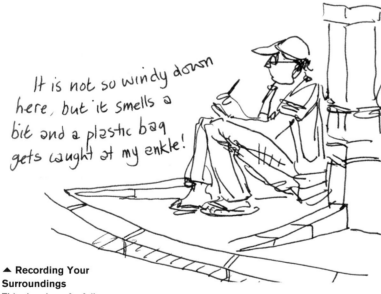

> *It is not so windy down here, but it smells a bit and a plastic bag gets caught at my ankle!*

▲ Recording Your Surroundings
This drawing of a fellow sketcher could be anywhere, anytime, but because I have recorded that little bit of additional background information, I am taken straight back to the moment and the grubby Lisbon street.

Black fineliner

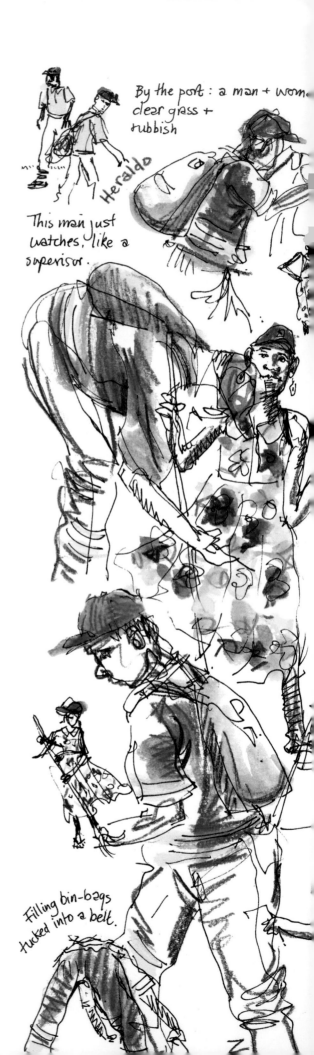

> *By the port: a man + woman. clear grass + rubbish*
>
> *Heraldo*
>
> *This man just watches, like a supervisor.*
>
> *Filling bin-bags tucked into a belt.*

▶ A Story as Stages
As you are observing a period of time, it is often possible to record an event in a series of steps. The stages can be formally arranged in sequence, or if the order is not particularly important, you can jumble them up on the page, so the spread becomes a record of the event as a whole.

Black fineliner, watercolor pencils, waterbrush

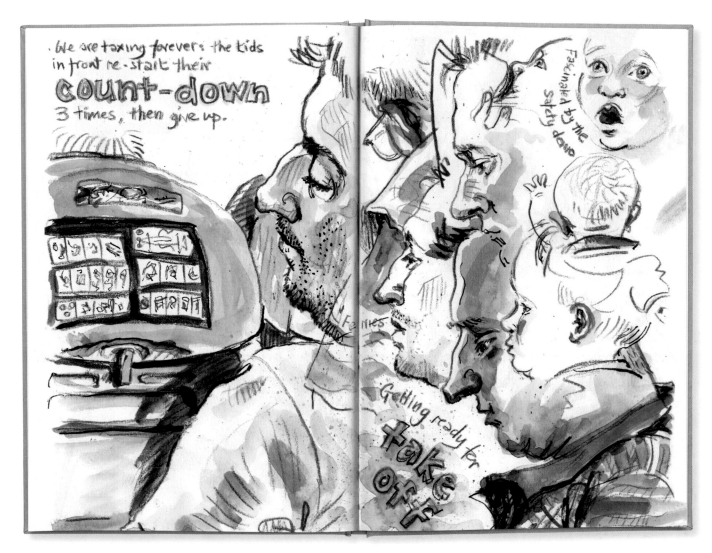

We are taxing forevers the kids in front re-start their **count-down** 3 times, then give up.

Fascinated by the safety demo

Getting ready for **take off**

Feet?

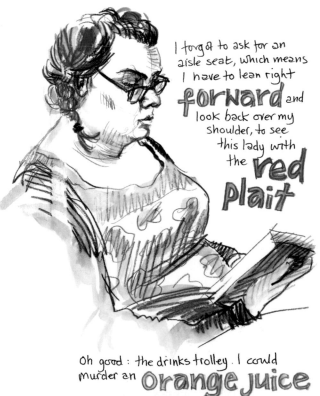

I forgot to ask for an aisle seat, which means I have to lean right **forward** and look back over my shoulder, to see this lady with the **red plait**

Oh good: the drinks trolley. I could murder an **orange juice**

▲ A Story Told Through Detail

Despite the montage of different faces on the right, this sketch is diarizing one event—a delay before takeoff of a flight. As with a written diary, it is recording the smaller details that bring an otherwise insignificant moment into vivid life.

Rainbow pencil, watercolor, fountain pen, black ink

◀ Recording Your Thoughts

As with any journal, a sketchbook is a place where you can record your thoughts. It is especially interesting if those thoughts revolve around what you are drawing, such as in this sketch of the lady with red braids, which was interrupted by the appearance of the drink cart. Accenting certain words in color breaks up the block of text and visually ties the words into the drawing.

Watercolor pencils, waterbrush

19

1

Getting Started

Part of the joy of sketching is the freedom to do whatever you want, but it can be hard to know where to begin when there are so many possibilities. Which medium to use? What sketchbook would be best? How much should you plan things out? What technique will describe hair, or clothing ... and how on earth do you draw hands? This section gives you tips to help with some common difficulties. It also gives you the information you need to begin wrestling all that freedom into submission, so that your sketching can become more focused and you have the tools to tackle the basic questions.

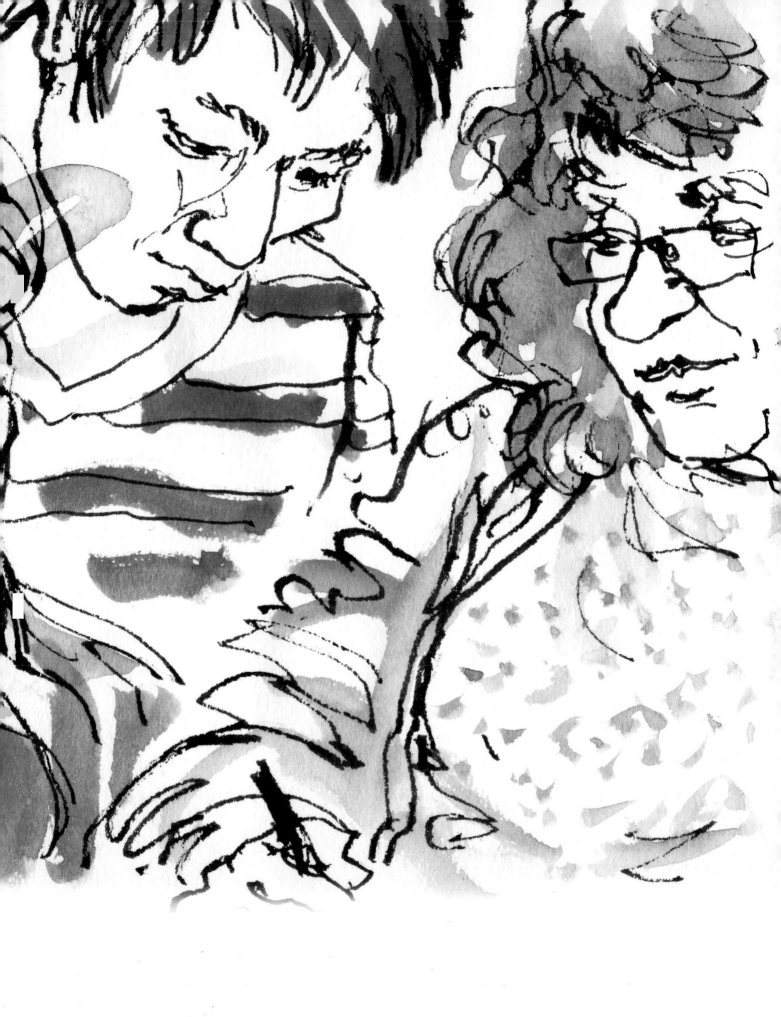

Sketchbooks

Sketchbooks come in many different sizes and shapes, with a range of papers, white and tinted. Some are spiral-bound, whether landscape, portrait, or square format; some are a continuous concertina of paper. Some people make their own, and some use books not originally intended for drawing at all. It can be hard to decide what you need. Ultimately, it's a very personal choice, and some experimentation is ideal, but there are definitely some kinds of books that are suited to certain jobs.

Paper Types

If you are using watercolor, you need a heavier paper, preferably watercolor paper, although heavy drawing paper in a decent weight will do fine if you are someone who is intimidated by good paper. For pastels, you need paper with a bit of "tooth," i.e., not too smooth, and a tint can be very effective, as white chalk allows you to draw highlights. Graphite works best on heavy drawing paper, but will adapt to any paper. Fineliner, fountain pen, or ballpoint pen are similarly adaptable, but tend to like very smooth papers more than other media.

Size and Format

While you are finding your feet, I would recommend trying out different formats. Again, it all depends on how you like to draw. For discreet people-sketching, especially up close, you don't want a book that will draw attention, so 4¼ × 5¾ inches (A6) or 5¾ × 8¼ inches (A5) work best. If you work in certain media, like pastel or charcoal, or enjoy sketching entire street scenes, 4¼ × 5¾ inches (A6) will usually be too small. For capturing urban or rural scenes, a landscape-format binding is worth trying, as it gives you a much longer page shape. This elongated format can be fun when turned on its head too, giving you the chance to draw a vertical slice through what you see.

Binding Style

Spiral binding has the huge advantage of opening flat and also folding back on itself, so you don't have to fight pages that want to close on you. This can be a great help if you want to work at 8¼ × 11¾ inches (A4) or larger, as the book can get cumbersome. A spiral-bind is not so good, though, if, like me, you enjoy working across the spread. Moleskins have been designed to open flatter than a conventional book to aid sketching across both pages. A natural extension of this is the Japanese accordion format, which you fold out as you go, so your sketch can be as long as you like.

Watercolor

Pastel

Smooth

Square

Portrait

Landscape

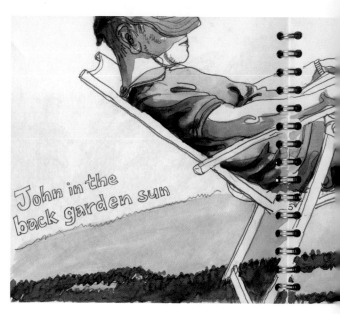

▲ **Spiral Binding**
I like a square book. The square page has a pleasing balance but also, opened up, you have the option of a longer format. A spiral binding creates a scar through the sketch when you work across the spread although, if you are careful about where it falls, it can be a feature of interest and add immediacy.

Pink Pig book, 8 in. (20 cm) square, spiral-bound, 100 lb (150 gsm) heavy drawing paper

3B pencil, watercolor

◀ **Tiny Books**
When I had an operation on my foot, a pocket-sized Pantone sketchbook was just the thing. A local anesthetic meant I could sketch throughout, which took my mind off things. The discreet size of the book didn't get in the way or distract the surgeon from his task (thank goodness!).

Pantone Universe book, 4 × 3 in. (10.5 × 7.5 cm), landscape-bound, thin paper

Fineliner

▼ **Japanese Accordion Format**
The concertina of folded paper is a very flexible format, as you can work on individual facets, run a long sketch across several facets, create a series of related sketches which flow together, as here, or do a really long panorama. The main drawback is that concertinas have a tendency to "explode" out onto the floor while you are working, so clips are a good idea.

Special edition Moleskin, 5 × 8 × 118 in. (12.5 × 20.5 × 300 cm), accordion, 129 lb (190 gsm) watercolor paper

Watercolor, watercolor pencils

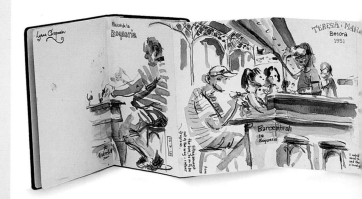

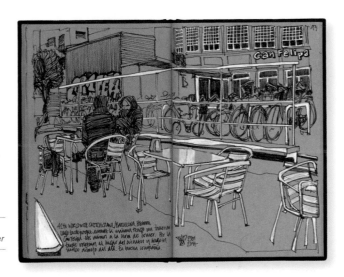

▶ Tinted Paper
The gray paper of this sketchbook allowed Miguel Herranz to draw in both black and white, pulling out the highlights for an interesting effect. A portrait-bound book gives you the additional option of a squarer format when working across the spread.

Strathmore toned book, 8 × 5½ in. (20 × 14 cm), portrait-bound, 80 lb (180 gsm) 100% recycled paper

0.8 fineliner, white POSCA marker pen

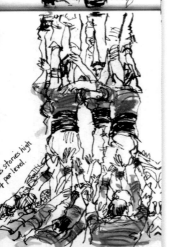

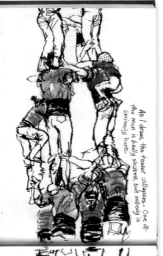

▲ Landscape Format
The landscape binding allows Virginia Hein to pan across the beach front, giving a panoramic view and a sense of place. This format is great for rural or urban settings, when you want to pull back a little and give context to your subject.

Moleskin sketchbook, 5 × 16 in. (12.5 × 40.5 cm) spread, landscape-bound, watercolor paper

Ink blue drawing pencil, watercolor

◀ Inverting a Landscape Book
Some subjects require more height than you get in a conventional portrait-style binding. By turning a landscape book on end, I was able to draw the figures a little larger, although still couldn't fit everything in—an accordion book would have been better!

Homemade book, 7 × 5 in. (18 × 13 cm), landscape-bound, 129 lb (190 gsm) watercolor paper

Sailor fountain pen, waterproof ink, watercolor pencils, waterbrush

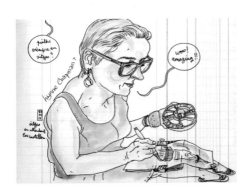

▲ Unconventional Paper
Lapin is one of a few sketchers who routinely uses paper with a pre-printed element. Lapin's ledgers make his work instantly recognizable, but the different colored lines also contribute something interesting to the sketch.

Old accounting book found at a Barcelona flea market, 8¼ × 6 in. (21 × 15 cm), 54 lb (80 gsm) paper

Ink pen, watercolor

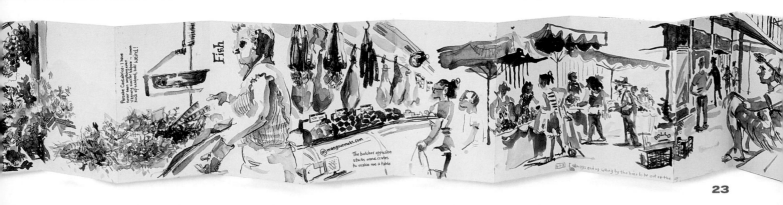

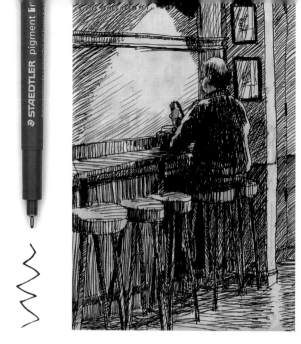

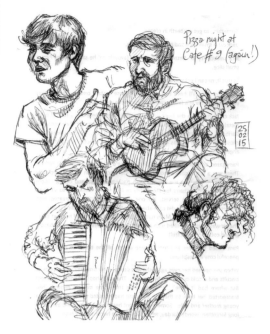

▲ Shading with a Fineliner

Fineliners give a pretty constant line width, lending themselves well to hatching and cross-hatching. Using these techniques, Peter Wenman achieves an incredible range of tonal values, from slight shadows right through to solid black.

Fineliner

▼ Whatever Comes to Hand

If you forget your kit, a ballpoint pen is generally lying around. When I found myself without my sketchbook in a café with an impromptu music session, I grabbed a ballpoint from the counter and drew on a piece of scrap paper. The line is less versatile than a pencil, but I was able to vary the weight more than I expected.

Black Bic ballpoint pen

Dry Drawing Materials

The great thing about drawing is that you can travel light: You can get by with one tool and draw pretty much anywhere, any time—perfect for quick people-sketching. Most beginners sketch with a pencil because it is the most familiar medium and so feels safe, but it is important to experiment with different media. You need to discover for yourself which tools best suit your approach and be able to select the right medium for a given situation.

There are many ways to create a drawn line. Different drawing tools feel different to use, and the marks you get can vary a great deal. A ballpoint pen or fineliner will give a controlled and regular-width line, ideal for detailed work and great for hatched shading. Black ink is used by many sketchers because it is so bold and so controllable, but it is, of course, less forgiving than a medium like graphite, which allows for a lightly sketched underdrawing.

A waterproof ink will let you add paint on top for color. Some fineliners also come in a range of colors, and fountain pens give you the chance to choose the color of your ink. Most fountain pens will give a regular line,

▶ Rainbow Line

When I first saw this tool, I dismissed it as a child's pencil, but now it is a permanent part of my kit. I like the buoyancy it lends to the drawing. You have some limited control over which color you get, but mostly I enjoy the randomness of it.

Koh-i-Noor rainbow pencil

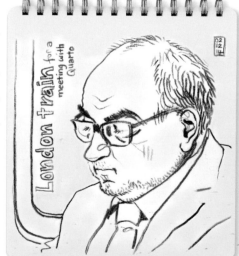

▼ Graphite

The chunky and solid quality of the graphite stick allows Julie Bolus to boldly create a range of textures and line weights. The ivory brush pen applied on top, smudges the graphite stick, creating a new, soft medium tone.

Graphite stick, ivory brush pen

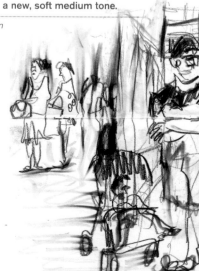

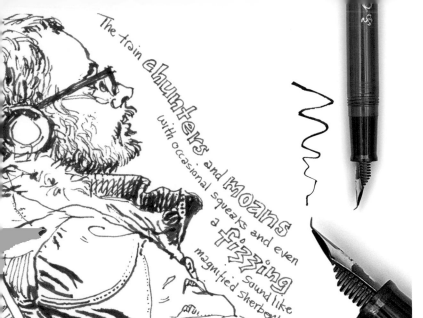

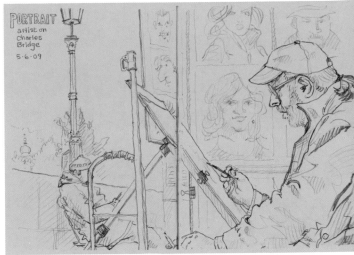

▲ **Expressive Inking**

The "bent" Sailor nib was originally designed for Japanese calligraphy and allows you to create dramatically different line widths. The variation is created by the angle at which you hold the pen. This technique takes a little getting used to, but I like the way it makes me draw from the elbow, which helps to achieve an even more expressive line.

Sailor fountain pen, Noodler's black "bulletproof" ink

▲ **Good Old-Fashioned Pencil**

A pencil is an incredibly versatile medium, allowing maximum control with minimum fuss. Even with a simple, linear sketch, the range of different line weights you can create provides an easy way to give depth of field and helps focus our attention.

3B pencil

although some, including my Sailor, provide the varied line-width of a dip pen, but in a portable format. Be careful about using waterproof inks in a fountain pen: I like Noodler's ink because it never blocks, although the waterproof element works better on some papers than others, as it's a chemical reaction.

Colored pencils allow for different weights of mark-making and give you the widest range of colors at your fingertips, but it's a good idea to pare things down and take out a compact set of just your favorites. Koh-i-Noor makes a surprisingly effective "magic" rainbow pencil with a multicolored lead, so the line color alters as you draw.

Other drawing tools, such as graphite sticks, oil pastels, or Conté, create wonderfully irregular marks, giving greater variation and texture for really expressive sketching. They can be especially effective if you are trying to capture a quick impression or draw people in motion.

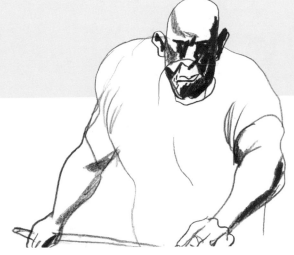

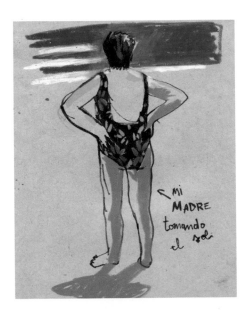

◀ **Oil Pastels**

Inma Serrano first sketched the outline of this figure in black ink, then used oil pastels on top to add color and shadows. Being opaque, the pastels covered some of the original line work, allowing Inma to adjust her initial drawing and add small ink corrections on top.

Brush pen, water-soluble oil pastels on gray paper

▲ **Colored Line Work**

The boldness of the colored line work in this sketch by Victoria Antolini is really striking. Note the different ways she has used the red pencil to create a variety of tones and styles of mark.

Colored pencils

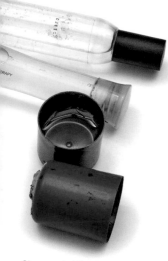

Watercolor palette

Waterbrush

No. 8 travel paintbrush

Shampoo bottles and hairspray lids for water

Watercolor pencils

Wet Sketching Materials

If you are not used to impromptu painting, you might imagine there would be way too much clutter and fuss involved for working "on the go," especially given the restrictions around sketching people. However, it doesn't have to be complicated and can be very compact. With a small watercolor set, a waterbrush, and a wrist sweatband (instead of a rag), you can paint pretty much anywhere. I have painted while walking along and even while paddling in the sea.

Palettes

I started out with a rather fancy Winsor & Newton traveling set, with foldout mixing areas and an integral brush and water chamber. These days, I prefer my basic, hinged Frank Herring palette because it manages to incorporate lots of space for colors and mixing while remaining simple and compact.

Water

If I'm sketching on the train or in somewhere like a museum, I use a waterbrush to avoid the issues of loose water. The water chamber lasts me about half a day. When I want loose water, though, I sometimes fill a couple of mini hotel shampoo bottles with water. They tuck into the corner of my kit, and I'm set for at least a couple of sketches. Thanks to a great tip Liz Steel gave me, I also carry the plastic lids from a couple of mini hairsprays stuck together with poster putty. When I'm ready to paint, I stick them on my open palette and fill them from my little shampoo bottle: one lid for clean water, one for dirty water.

Brushes

Brushes come in so many shapes, sizes, and materials—the choice can be overwhelming. They are also tricky to carry without damage. I like to travel light, so I use a No. 8 travel brush; its fat head and fine point will cover most of what I need.

Paints

I have done fine up to now with a very standard range of Winsor & Newton colors in the half pans that fit my palette. Artist-quality paint is worth the extra money, as the pans have more pigment and less binding, so you don't have to "scrub" to release rich color.

Ink

Inks are lovely and vibrant, but bottled ink is just not practical for out-and-about sketching. I once tried to sketch with a dip pen and a bottle of ink. Half the bottle ended up down my leg and in my shoe. A better way is to fill a waterbrush with ink and use it as a brush pen at full-strength for "drawing," or diluted to half-strength for tinting line work.

Watercolor Pencils

I never much liked using watercolor pencils in the past: They were a little washed out. Then I discovered the far more vibrant Inktense range—the perfect tool for very quick but colorful sketches of people. There is so much pigment in them that, even when you add water, the original marks stay in place. They are also really useful for adding extra detail into watercolor sketches and are the only drawing medium I've found that works well on wet paper.

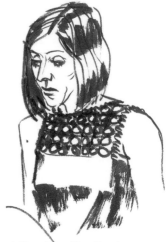

▲ **Drawing with a Brush**
By drawing with a brush rather than a pencil, Mikael Eklu-Natey is able to create a fluidity and softness in this sketch: perfect for depicting the texture of hair and clothing. Look at the range of possible marks!

Brush and ink

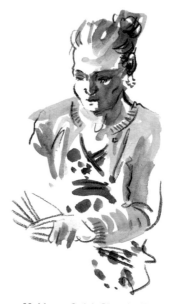

▲ **Making a Quick Sketch 3D**
The linear sketch was done first, in less than a minute, capturing just the essence of the structure. The watercolor does a different job, adding form by pulling out highlights and shadows. I do this on the spot because I want to observe how the light falls. The yellow cardigan makes the sketch jump off the page. Note how the yellow is shadowed with green rather than brown to keep things fresh and light.

Koh-i-Noor rainbow pencil, watercolor

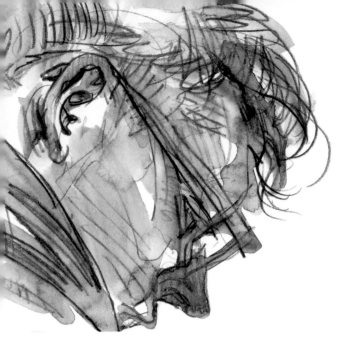

◀ Adding Water to Inktense Pencils

My waterbrush was leaking when I created this sketch, so more water than usual was added. It took a long time to dry, but I love the marks created. The drawn watercolor pencil lines remain in place, and their mark-making interplays with the softer waterbrush textures.

Watercolor pencils, waterbrush

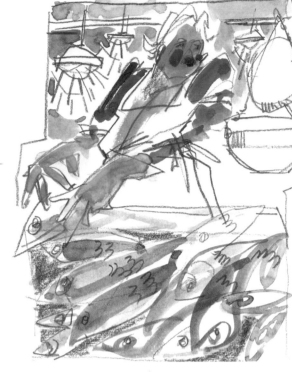

▶ Adding Water to Ink

To create this effect, Manuel Hernández González first drew his subject using a pen and ink and then, using a waterbrush, applied brushstrokes to extend the ink to create the areas of shadow and light. Adding water to the ink drawing blurred and softened the contour lines of the figure.

Fountain pen, violet ink, waterbrush

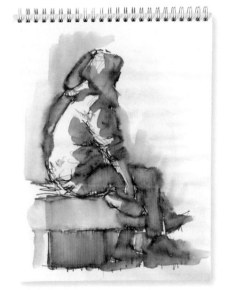

▲ Splashes of Color

By adding just a few splashes of watercolor, Melanie Reim has transformed a flat line drawing into a vibrant and frenetic piece, perfect for capturing a busy market scene.

Ink, watercolor

▼ Watercolor Without Lines

For this sketch, Omar Jaramillo sketched the people quickly as they were passing, and then sprayed water over the sketch to loosen the color from the water-soluble crayons and lighten the pigment. Watercolor was then added to define the shapes.

Watercolor, Neocolor Caran d'Ache water-soluble wax crayons

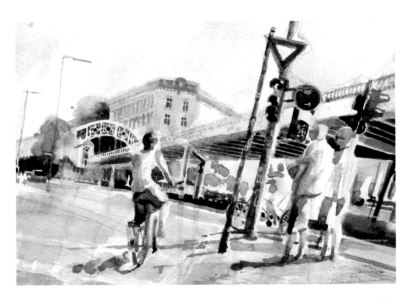

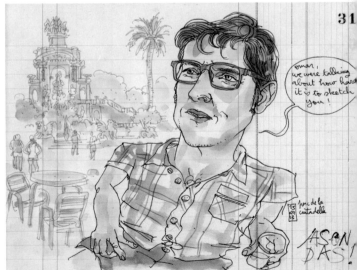

▲ Soft Tints

Lapin often tints his line drawings with watercolor, adding just a hint of color. The softer colored line and muted paint in the background provides a sense of place, without distracting from the figure in the foreground.

Ink pen, Colorex Brilliant watercolor

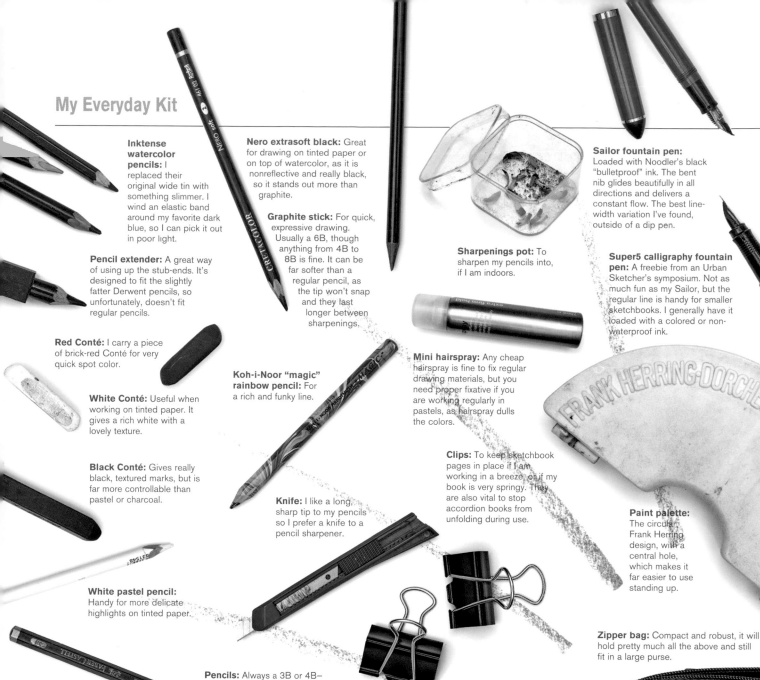

Inktense watercolor pencils: I replaced their original wide tin with something slimmer. I wind an elastic band around my favorite dark blue, so I can pick it out in poor light.

Pencil extender: A great way of using up the stub-ends. It's designed to fit the slightly fatter Derwent pencils, so unfortunately, doesn't fit regular pencils.

Red Conté: I carry a piece of brick-red Conté for very quick spot color.

White Conté: Useful when working on tinted paper. It gives a rich white with a lovely texture.

Black Conté: Gives really black, textured marks, but is far more controllable than pastel or charcoal.

White pastel pencil: Handy for more delicate highlights on tinted paper.

Nero extrasoft black: Great for drawing on tinted paper or on top of watercolor, as it is nonreflective and really black, so it stands out more than graphite.

Graphite stick: For quick, expressive drawing. Usually a 6B, though anything from 4B to 8B is fine. It can be far softer than a regular pencil, as the tip won't snap and they last longer between sharpenings.

Koh-i-Noor "magic" rainbow pencil: For a rich and funky line.

Knife: I like a long, sharp tip to my pencils so I prefer a knife to a pencil sharpener.

Pencils: Always a 3B or 4B—soft enough to give a decent black and a variable line, but not so soft that they snap under pressure or wear down too quickly.

Sharpenings pot: To sharpen my pencils into, if I am indoors.

Mini hairspray: Any cheap hairspray is fine to fix regular drawing materials, but you need proper fixative if you are working regularly in pastels, as hairspray dulls the colors.

Clips: To keep sketchbook pages in place if I am working in a breeze, or if my book is very springy. They are also vital to stop accordion books from unfolding during use.

Sailor fountain pen: Loaded with Noodler's black "bulletproof" ink. The bent nib glides beautifully in all directions and delivers a constant flow. The best line-width variation I've found, outside of a dip pen.

Super5 calligraphy fountain pen: A freebie from an Urban Sketcher's symposium. Not as much fun as my Sailor, but the regular line is handy for smaller sketchbooks. I generally have it loaded with a colored or non-waterproof ink.

Paint palette: The circular Frank Herring design, with a central hole, which makes it far easier to use standing up.

Zipper bag: Compact and robust, it will hold pretty much all the above and still fit in a large purse.

Personal Kit

It takes a while to work out your personal kit, and it's easy to start off by carrying too much, as you don't know what you might need. A suitcase of art materials might give you plenty of choice, but you'll be likely to spend ages deciding what to use (and trying to find it). A heavy or bulky bag also makes it impossible to carry your sketching gear on a day-to-day basis, just in case you have a moment or spot something interesting. In the end, you have to make decisions, although nothing is set in stone, and my kit is constantly evolving.

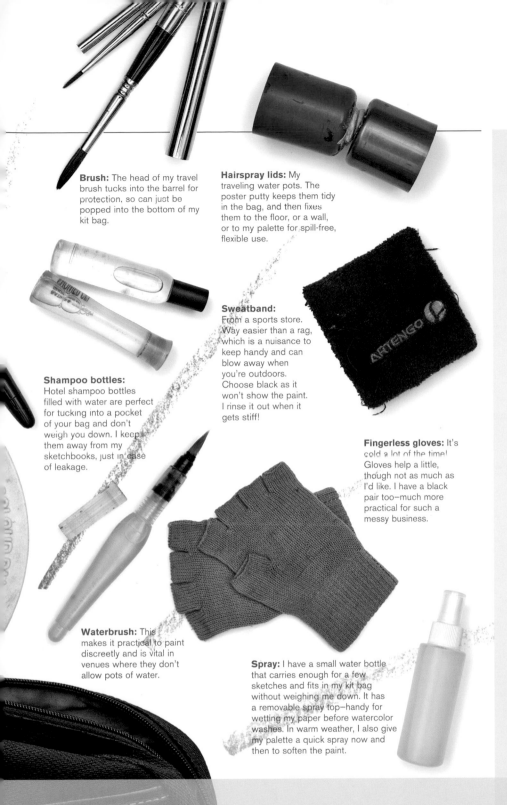

Brush: The head of my travel brush tucks into the barrel for protection, so can just be popped into the bottom of my kit bag.

Hairspray lids: My traveling water pots. The poster putty keeps them tidy in the bag, and then fixes them to the floor, or a wall, or to my palette for spill-free, flexible use.

Sweatband: From a sports store. Way easier than a rag, which is a nuisance to keep handy and can blow away when you're outdoors. Choose black as it won't show the paint. I rinse it out when it gets stiff!

Shampoo bottles: Hotel shampoo bottles filled with water are perfect for tucking into a pocket of your bag and don't weigh you down. I keep them away from my sketchbooks, just in case of leakage.

Fingerless gloves: It's cold a lot of the time! Gloves help a little, though not as much as I'd like. I have a black pair too—much more practical for such a messy business.

Waterbrush: This makes it practical to paint discreetly and is vital in venues where they don't allow pots of water.

Spray: I have a small water bottle that carries enough for a few sketches and fits in my kit bag without weighing me down. It has a removable spray top—handy for wetting my paper before watercolor washes. In warm weather, I also give my palette a quick spray now and then to soften the paint.

Big Stuff

Sitting pad: From a camping store. This is what I used before my stool, and is still better for rural settings, where the ground is uneven, and slightly more discreet for sitting on the street.

Stool: I hated carrying a stool around, but then Nina Johansson showed me this tiny one, which is only 8 inches (20.5 cm) high. It fits in a large purse and weighs nothing.

Two sketchbooks: I like to have two, in case I decide to work in watercolor—I can work on two sketches at the same time, rather than having to wait for things to dry.

The mainstay of my personal kit used to be a case of around eight presharpened 3B pencils. You don't want to waste time sharpening your pencil if you are halfway through drawing someone, as you never know how long you have left. Over the last few years, I have been using pencil less and have introduced lots of new elements to my kit, particularly ways to sketch in color.

A 3B pencil is still in there, along with at least one 6B graphite stick and a mini hairspray, as a fixative for those occasions when I draw across the spread to prevent the graphite from transferring.

My favorite drawing tool is now my Sailor fountain pen, as I so love that expressive line. It works really well in conjunction with pretty much any other medium in my kit, too, because it is bold enough to hold its own, no matter what else you add.

Another really important addition is my set of Inktense watercolor pencils. Interestingly, I added extra colors to the original set of 12, but took them out again: less is definitely more. The colors in the set are very well chosen and work well together.

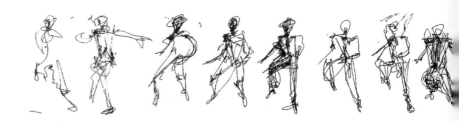

Karole Amooty is finding and recording the basic body lines that underpin this series of movements. The resulting quick studies are a more sophisticated version of the stick man. To capture movement, lines have been drawn very quickly without removing the pen from the paper. The body is fleshed out as the line returns, reinforcing or correcting itself.

Pen and ink

"I Can't Even Draw Stick Men!" Looking for Structure

"You are so good. I can't draw at all—I can't even draw stick men!" This is something I hear a lot. It's always adults who say it—never children. Children haven't yet learned to prejudge their drawing skills, and so allow themselves to just give it a try. The truth is that everyone can draw if they are interested enough to want to learn. If you can look, you can draw: The key is learning how to really see what you are looking at. As it happens, stick men can help with that.

Most of us are surrounded by people much of the time, so we think we know what they look like. This can get in the way when you start to sketch. To capture the reality of a person's shape, their posture, and the way they move, we have to learn to stop second-guessing what's in front of us and concentrate on what's actually there.

I find it sometimes helps to try to forget the thing I am drawing and just look for abstract shapes. When the thing you are drawing is a person, it is especially useful to look for angles and the curving of lines. If you have pulled back and are viewing the person from a reasonable distance, this process of seeing body-lines effectively finds the stick man living beneath the position.

You don't necessarily need to draw the stick man, but being aware of it is important. Some people do find it useful to start with a soft underdrawing of this inner structure to help get the angles right. Take special care with the shoulder line and hip line, as it's easy to assume they are horizontal, but they tilt as we reach, bend, and twist. Other common mistakes are making the head too big or too upright.

Once you've established the angle and any curvature of the backbone line, it can be useful to sketch the torso as a basic shape: it might appear as a square, an oblong, or a triangle, depending on the pose and your viewpoint. Flesh out the limbs a little (remembering that legs are wider at the top, narrowing to the ankles), and your stick man begins to become a believable person. If you have been looking properly, your person won't appear as stiff and flat as a traditional stick man. If it doesn't look right, go back and re-examine your structure—if this is faulty, the pose won't be believable.

Continued on page 32

Establishing Backbone and Torso Shape

Posture varies from person to person, and individuals also hold themselves differently in varying situations. Be on the lookout for curvature in the backbone, so you judge the torso shape correctly:

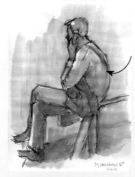

Rounded Back
(from sketch by Manuel Hernández González)

Concave Back
(from sketch by Erdune Iriarte)

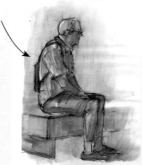

Straight Back
(from sketch by Manuel Hernández González)

Angled Backbone
(from sketch by Marc Taro Holmes)

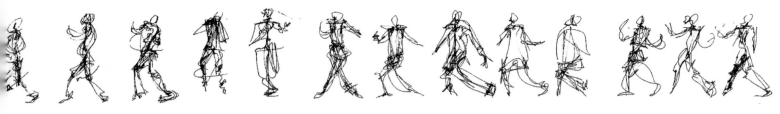

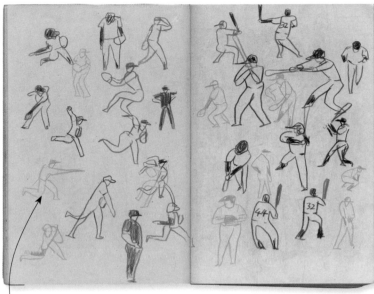

The Stick Man Structure Beneath the Body

The hand on the hip in this sketch by Manuel Hernández González would normally push that shoulder higher, but the left hand resting on the luggage evens it out. The legs appear crossed because one is thrust forward. Note the slight spine curvature.

◀ Capturing Many Variations

Though the principle of the stick man underpins our drawings, most of the time the pose we are capturing is neither as upright nor as symmetrical as the classic stick man we all bring to mind. Look at how Takeuma has captured all these variations involved in just one activity.

Colored pencils

Legs should not be "stuck onto" the torso, but part of one structure: See the continuous line from knee to shoulder

Marking knees and elbows makes it easier to see limbs in two sections

Apparent limb length will vary due to foreshortening. Note the dipped head on the figure on the left: His ear is level with his shoulder.

The angles of the shoulder and hip lines can be very different if a person is twisting. In this sketch by Marc Taro Holmes, notice the head is fairly level, but the neck is thrust forward at quite an angle.

▲ Shapes, Not Sticks

Practicing looking is very important for improving your ability to convey convincing poses. Suhita Shirodkar fills many sheets like this; it is good practice and builds up the visual memory. You can get at the heart of a position by doing away with all details and concentrating on structure, again and again, in subtle variations of the same pose. Suhita is using simple shapes as building blocks, working on the same principle as the linear stick man.

Black Sharpie

Practicing Looking

If you regularly practice quick sketches of a variety of postures, you will gain a good understanding of how the body fits together and how it moves, so that eventually the structural underpinning will become an instinctive part of your people-sketching, whether you are drawing quick little sketches or larger studies.

If you want to speed up the process, go to regular life-drawing sessions. Observing the bone structure through the skin and seeing muscle shapes unimpeded by clothes is incredibly useful and very good practice for both your looking skills and your speed-sketching. Life-drawing is completely unforgiving: Without coats, dresses, and pants to hide behind, your smallest mistakes scream at you from the page. This can be terribly disheartening at the outset, but don't give up—everybody has to start out that way, and there is no better way to achieve rapid improvement than a weekly life-drawing class.

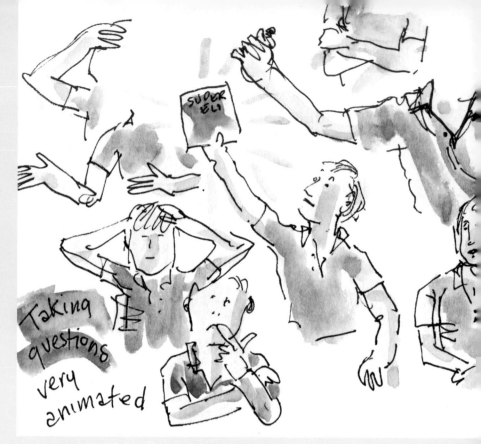

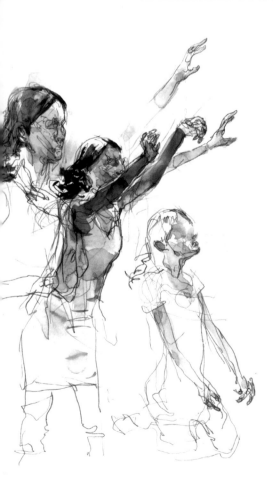

▲ Body Language Tells a Story

We all use our arms unconsciously to express what we are thinking and feeling. If you capture that body language, your sketch can convey some of what is happening inside your subject's head. The author David McKee was very expressive during this interview. By using the stick man approach to observe basic shapes and angles at speed, I was able to capture part of his thought process.

Waterproof fineliner, watercolor

Watercolor has been added after the line work. Because it pulls the eye, it is effective for correcting occasional faulty observations

◀ ▲ Seeing the Structure Beneath

In this sketch by Marc Taro Holmes, you can feel the stretch of the woman's body and the weight of her extended arms. This is because the invisible structure beneath has been so well observed. Notice how the standing sketch bends straight-backed from her hips, not from her waist, and how her lower body remains upright: details that could easily be misjudged if you were assuming rather than looking.

Pencil, watercolor

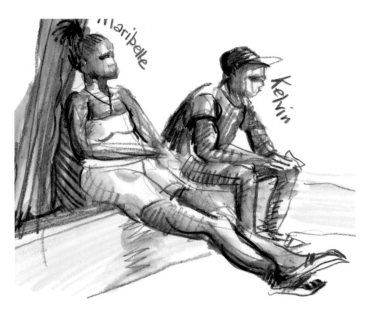

◀ Straight Is not Necessarily Straight!
Be wary of "straight lines" when it comes to people: The girl's "straight" legs are not straight at all. To avoid stick-man stiffness, it's important to observe the muscles and bones that shape the body: See how the flesh and muscle of the thigh and calf bulge, then dip into the back of her knee, which is slightly prominent above.

Watercolor pencils, waterbrush

Notice how the weight of her body is conveyed by the wall pressing her thigh out of shape

The weight at her crossed ankles is achieved with cast shadow

Things to Remember

- Watch for tilts of the torso, head, shoulders, or hips.
- Check the shoulder-line height against the ears.
- You can use negative space to help judge angles.
- Be aware of the center of gravity.
- Don't assume anything. Look!

Observation Is Key

These poses were mostly too brief to allow me to think consciously about structure as I was sketching, but years of practice and life-drawing have now made this element largely second nature. Despite this, I still need to observe keenly, as every slight tilt or change of angle is vital.

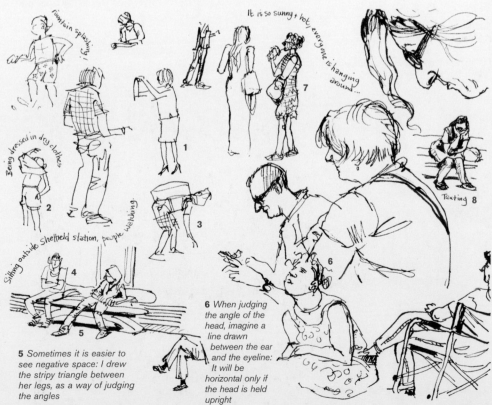

1 High heels alter your posture: When not consciously standing up straight, women have a tendency to lean forward

2 The slight backward tilt of the boy's torso is important to convey his battle with the clothing

3 It is unusual to bend with such a straight back. This detail conveys the weight (or the stiffness) of the backpack

4 The height of the shoulder line is a very expressive feature. This youth's crossed-arm posture is tense rather than relaxed because his shoulders are slightly hunched

5 Sometimes it is easier to see negative space: I drew the stripy triangle between her legs, as a way of judging the angles

6 When judging the angle of the head, imagine a line drawn between the ear and the eyeline: It will be horizontal only if the head is held upright

7 Because I haven't quite judged the leg angles accurately, her center of gravity is off, and she doesn't quite stand convincingly

8 Women in skirts usually sit with their knees together, but note how, when leaning forward, the feet may move apart for stability. Unfortunately, I have judged the feet angles badly, so she doesn't balance well

Sailor fountain pen, black ink

33

Understanding Tone

When we draw, our first inclination is to describe objects by their outline, but there are no outlines around people in real life. What we actually see is color and tone. Color will help you to create mood and make your sketches jump off the page, but it is the careful observation of tone that will really help to describe the form and texture of your subject and make your work three-dimensional.

If you are overly tentative and find yourself reluctant to use darker tones, your work will appear flat and uninteresting. Try to get a good range of tones—from the pure white of the paper, to the darkest marks that the tool you are using will make. When you are trying to work out where the different tonal values need to go, it helps enormously if you squint at your subject. This simplifies the information and makes it easier to judge the darkest and lightest areas.

There are many ways of shading in the different tonal values. This partly depends on the medium you are using, but also on your personal approach. Sketching people out and about inevitably means finding quick ways to code the shadows rather than attempting photographic realism, but this mark-making can contribute greatly to the interest of the sketch. Experiment with various techniques to find what suits you, and don't be afraid to combine different media to allow yourself a greater range of possibilities within a single sketch.

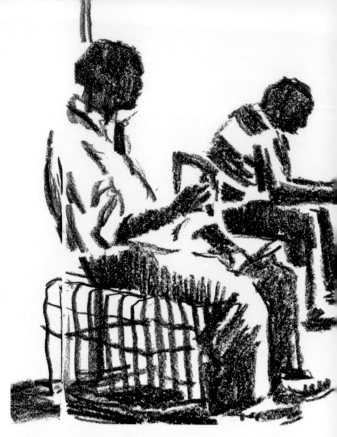

▲ Black and White
In strong sunlight, when you get deep shadows and sharp highlights, it can be interesting to draw with a tool that limits your ability to create half-tones. Notice how the figures come across with no difficulty despite the limited information.

Wax crayon

▶ Tones Without Outlines
In this quick drawing, only tones are described—there are no outlines at all. Despite this, and the roughness of the sketch, the shoes, pants, and socks are clearly defined. Notice how the direction of the shading marks helps to describe the structure of the subject. The addition of laces is all that is needed for definition.

3B pencil

Step 1 *Patches of directional mark-making echo the contours of the shoe and sock. The pant leg marks are at right angles to the rest, providing visual contrast and clarity. The upper shoe and sock front are left white for highlights.*

Step 2 *Where the shadow is deepest, additional patches are added over the original marks, sticking to the same direction of travel, rather than cross-hatching. New marks are added to suggest creasing above the toe.*

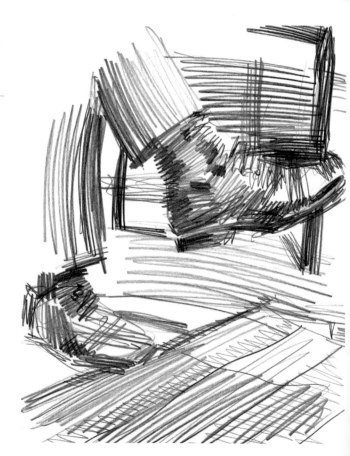

▼ **Combined Techniques**

One quick way to achieve subtle shadowing is to do your drawing with non-waterproof ink. If you first draw loose hatching for the shaded areas, you can then use a waterbrush to blend the marks and make the diluted ink run where you guide it. These wet marks add a softness, which complements the harder lines.

Sailor fountain pen, non-waterproof ink, waterbrush

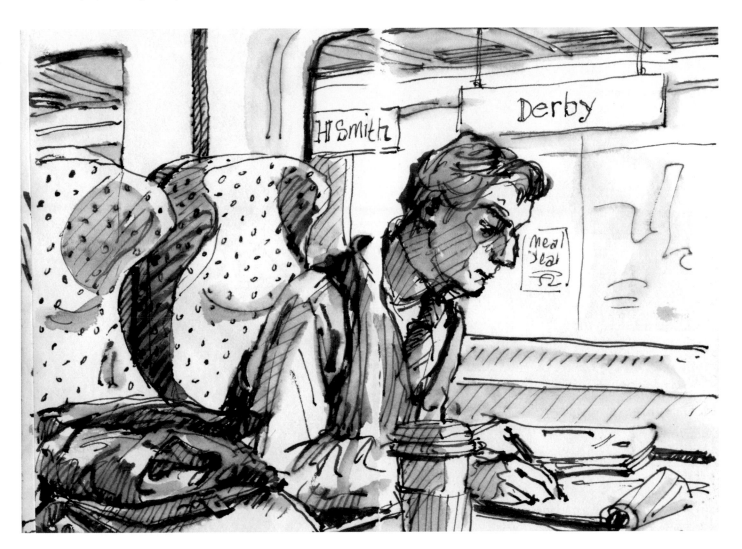

Step 1 *A linear sketch builds up the composition by establishing the main shapes, taking care that the man's head and coffee cup avoid the book's gutter.*

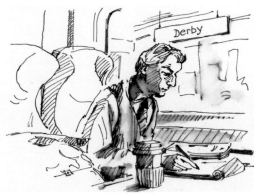

Step 2 *Hatching establishes the areas of shadow and is then blended with a waterbrush to guide the shadows where they are needed. Don't overdo the linear shading, or the sketch will get too dark once water is applied.*

Things to Remember

■ Squinting helps you to differentiate the tonal values.

■ Aim to get a range of values, including darker tones.

■ Mark-making can add enormously to your sketch's impact.

■ You can use shading to "mold" your subject, so be aware of the structure you are describing.

■ Accurate tone matters more than accurate color.

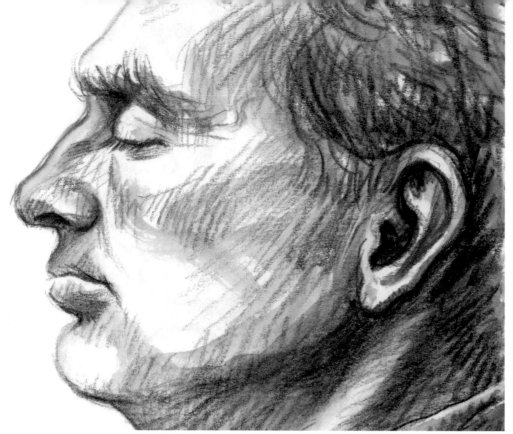

◀ **Color Shading**

The shadows here are built up from hatching gently overlaid in a range of colors. A waterbrush was used to blend colors together in places, but delicately, so all the separate colors are still visible, allowing the eye to do the work. Note the importance of the white paper highlights on the ear and face.

Watercolor pencil, waterbrush

Skin tones are created by overlaying hatching in two colors at a time. Green prevents things looking artificially pink

Ears and noses are often pinker than the rest of the face. Magenta and tan combine with dark blue to shade

▶ **Layered Shading**

The characters in this sketch by Behzad Bagheri have been sketched without the use of either line or detail. By layering different strengths and tones of calligraphy ink, Behzad has created figures that are extremely lifelike. Because he is not tethered by an outline, the man in front appears to be almost in motion.

Calligraphy ink

Softer washes are overlaid with dark ink. Translucent shadows blend the two together

Jacket colors are washed in and then overlaid with layers of translucent shadow

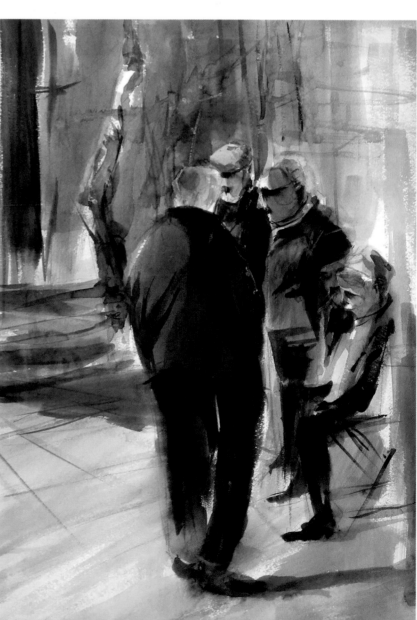

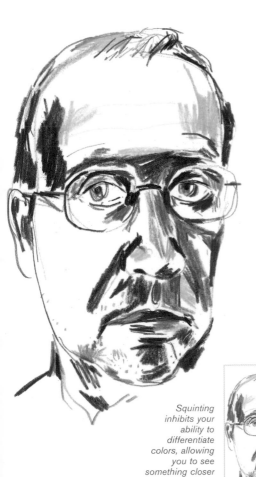

◀ Hatching in Ink
A spidery line drawing can be jumped into three dimensions with small amounts of hatching. Don't overdo it, though—a sketch quickly becomes overworked if you are not careful. Vary the direction of the hatched lines. Generally, you need to echo the form.

Sailor fountain pen, black ink

Try to make your hatching meet any outlines "end-on": This will help to accentuate edges, rather than disguise them

Cross-hatching gives you a slightly darker tone, as does drawing your hatched lines closer together

▼ Tone Is More Important than Color
The wonderfully wild colors in Nick Kobyluch's sketch suggest reflected color, but are far from realistic. If you squint though, you will reduce your light, and it will be easier to judge tone. You can play around with color all you like. If the tonal values are right, the image will still read. It doesn't work the other way around.

Colored pencils

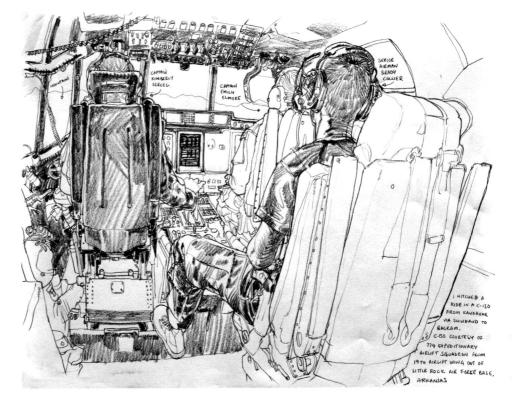

I HITCHED A RIDE IN A C-130 FROM KANDAHAR VIA SHINDAND TO BAGRAM. C-130 COURTESY OF 774 EXPEDITIONARY AIRLIFT SQUADRON FROM 19TH AIRLIFT WING OUT OF LITTLE ROCK AIR FORCE BASE, ARKANSAS.

Squinting inhibits your ability to differentiate colors, allowing you to see something closer to a purely tonal image

▲ Intuitive Pencil Shading
Beginners often try to remove all signs of mark-making when shading in pencil. Not only is this impractical when working quickly, but it is important to understand how the marks you make are often a beautiful part of the sketch. Notice how, in this sketch by Richard Johnson, the pencil is used to tint just certain areas, with others described in line only. This allows the white paper to provide contrast.

3B pencil

Wide strokes follow the direction of the hair, radiating from the crown

To ensure that the different shaded areas don't get confused, the highlighted edges of the seat are exaggerated and left white

Drawing the Details:
Eyes

Though the basic structure of the eye is very similar for everyone, as we age, we grow increasingly different, so all eyes are unique and vary enormously. It is very important to get the eyes right. They are the focal point of a face and a major indicator of character and mood.

Observe closely and keep looking as you draw. It's vital you don't assume anything because it is the little details or nuances that tell us whether a person is tired or excited, happy or sad, how old they are, how hard a life they have led. Be careful: A person's eyes are not necessarily symmetrical, and their eyelid shapes can sometimes be quite different from one another. Look carefully at tone, too, rather than just linear shapes; the whole eye area is very sculptural. Carefully placed shadows can really help to describe the structure.

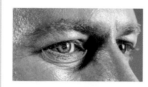

Remember the eyeball is a sphere. Even if much of its shape is hidden beneath the skin, there are usually areas of highlight and shadow created by the buried structure. This may be most evident beneath the lower lid.

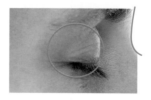

When the eyes are closed, it is easier to see the shape of the eyeball below the surface. Its size and prominence can vary—to help get this right, look at the shape enclosed between the eyeball and the bridge of the nose.

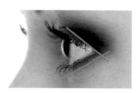

In profile, the top and bottom lash lines form a V shape. Look carefully at the width of the V and how much eye is actually visible. It is often less than you think.

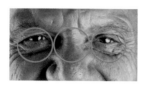

When drawing someone straight on, it is helpful to remember that the average distance between the eyes is the width of a third eye.

FIRST MARKS **TO TONAL SKETCH**

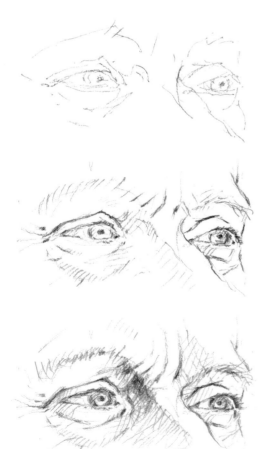

1 Begin with a very light underdrawing to establish the most important shapes and give yourself a framework. Don't draw detail, as elements might move. Be careful to leave enough space between the eyes.

2 Work over the top, adjusting any mistakes and strengthening lines as you become confident they are right. I use the creases above and around the eyes to help me judge distances.

3 Once the basic drawing is sound, concentrate on tone. I use hatching as a way to create different depths of shadow. Squint to establish the darkest area, in this case the shadow between eye and nose. The pupils are also dark, but it's important to leave white highlights. Note that the whites of the eyes are fairly shadowed.

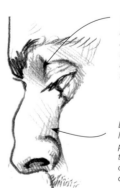

There is often a shadowy area where the eyebrow and eye meet the nose

Loose hatched lines allow the paper to shine through and don't overpower your draftsmanship

▲ **Tonal Shading**
Just a little shading will make your eye three dimensional. Eyes are a delicate area, so shade delicately. Look for the light source. If the light comes from directly above, the area beneath the brow will be shadowed, but the lid will be light. Lighting and shadow help accentuate the structure.

▶ Around the Eye

When we think of eyes, we first think of the pupil, but this is not always the most significant element. Look for lines or shapes around the eye, which tell a story. These make the person more real.

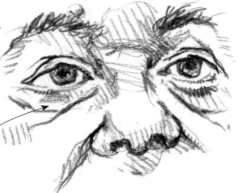

Older faces can have slight puffiness beneath the eye

The eyelid sometimes droops down over the eyeball when we are tired, and darker shadows appear. The eyeball will be less white, too

▶ Make a Page of It!

Sometimes, when I am sitting on a train, I practice drawing eyes and bits of faces from different angles.

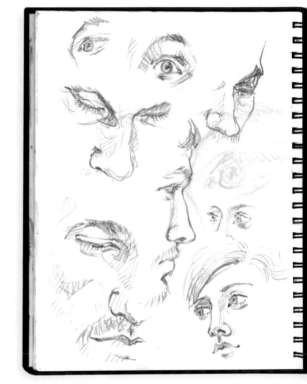

Sketching Glasses

◀ ▼ Eyeglasses

Use the glasses to help you judge the eyebrow shapes and position of the eyes, but be careful: The slightest movement of a person's head will change everything!

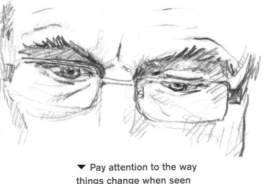

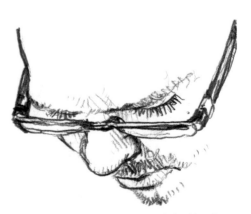

People's glasses often cut right through your view of their eyes. This is especially true from the side, as the glasses arm tends to be in line with the pupil

▼ Pay attention to the way things change when seen through the lens. Notice the slight distortion.

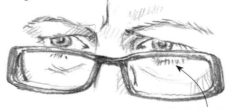

The bottom lashes appear lower because of the magnification

▲ When someone is looking down, and you are drawing from above, the glasses will be beneath the eye, and the eyeball may not be visible or is often seen only through the upper lashes.

Drawing the Details: Ears

Each person's ear is unique, and they vary a great deal, but all have the same basic structure. Because this structure is slightly complex, it's tempting to be vague or to make it up, rather than really look. If you're not careful, you can end up with peculiar mushroom-like shapes or mug handles. Take the time to observe different people's ears, so they become more familiar and less intimidating.

If you are using color, be aware that Caucasian ears can often be quite a different color than the face and neck. This again varies from person to person, but most ears need an extra touch of pink or red, especially around the outer rim and lobe. People's ears get even rosier if they are cold or embarrassed.

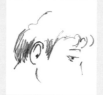 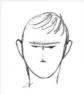 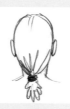

▲ Quick Ears
In most situations, there won't be time (or your subject won't be close enough) to draw the ears in great detail, so it is useful to know the different ways in which just a mark or two will suggest ears in any given position.

It helps to know how the various curves and indentations fit together, so you will recognize them when you come to sketch.

A *The firm outer fold (the helix), which determines the basic ear shape. This shallows to become the lobe at the bottom.*

B *The helix folds over more and more as it curls around the top of the ear, creating increasingly deep shadows underneath.*

C *There is an indentation just above the larger bowl of the ear, or "concha."*

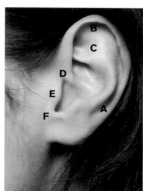

D *At this point, the helix blends into the face on one side and swings into the center of the concha on the other.*

E *The tragus: a little lump where the ear and face meet. Behind this is the "hole" that leads to the inner ear.*

F *There is always a deeply shadowed indentation between the lobe and the tragus.*

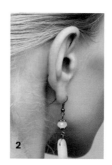 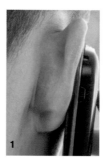 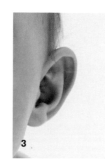

1 The cartilage support between the ear and head, usually in shadow, causes the helix to stand proud. **2** In a three-quarter view, the helix dominates, and the ear canal is clearly visible. **3** From the front, the concha is often shadowed, and any overhang of the curving helix will be clearly evident.

FIRST MARKS TO TONAL SKETCH

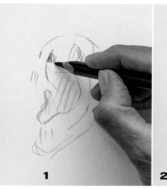 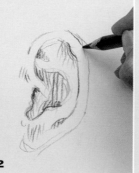 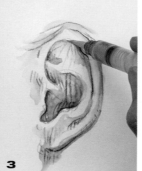

Using Watercolor Pencils: Seeing Shapes
1 Sketch the main shapes in a tan pencil, establishing areas of shadow. **2** Reinforce the darker areas and over-hatch shadows with a plum pencil. **3** Use a waterbrush to blend the two colors together and create a greater tonal range.

On Tinted Paper: Seeing Light and Shade
1 Starting from the center, establish highlights in chalk, then hatch shadows in ink. **2** Build up the structure in ink, then finally add further highlights in chalk.

Variation in Shape **Compare these three ears:**

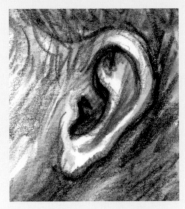

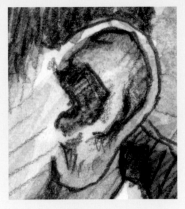

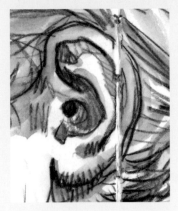

The ear is slender but with pronounced folds; the lobe is delicate and pointed.

The helix is narrow; the outer ear is flat; the tragus is tiny, but the lobe is wide and round.

The helix is full and round; the tragus is very small, revealing the ear canal; the lobe is small but plump.

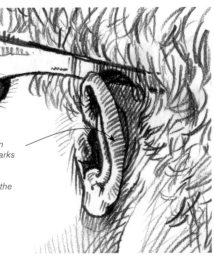

Some of the chin is visible. There is often a line of shadow leading down from the base of the ear, which will help you describe the shape of the neck

▲ From Behind
From the back, all you see is the line of the helix and lobe. The length and straightness will vary from person to person, but the ears will always stand away from the head.

Watercolor pencils, waterbrush

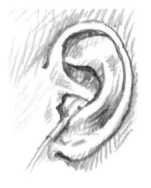

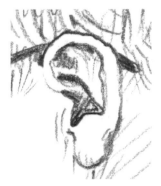

▲ Earphones
Note how standard earphones fit into the area behind the tragus, so the music feeds directly into the ear canal. The shaft for the wire sits conveniently in the indentation above the lobe.

3B pencil

▲ Wearing Glasses
The glasses sit on the cartilage between ear and head, which is at a lower level than the helix top. Watch for the arm tip, which may be poking out the back but will usually be angled down.

3B pencil

▶ Different Viewpoints
The area behind the ear will generally be in shadow, often cast shadow where the ear stands away from the face.

*4B pencil (left)
Watercolor pencils, waterbrush (right)*

When shadowing long, thin shapes, it is best to use marks that travel in the opposite direction, so your hatching doesn't get confused with the actual edges

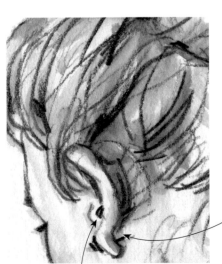

Note how the helix curves and then bends back at the bottom—this lower bend varies and can be exaggerated by earrings

From this angle, you can just see into the ear canal behind the tragus

Drawing the Details:
Noses and Mouths

The key to sketching both noses and mouths is to look at the different facets, using shading to "sculpt" the shapes instead of outlining them. Sketching a profile is very different than drawing a face from the front or three-quarter view. The profile can be described with a line, then refined with shading, but the front view needs to be subtle, or the features will look "stuck on."

When sketching facial features, it is useful to be reasonably close to your subject, so you can observe sufficient detailing. This presents obvious issues, especially for the beginner, which means people often practice by sketching themselves in the mirror. This is good for head-on views but, since these are probably the hardest, especially when it comes to the mouth and nose, I would suggest you start instead by drawing family and friends, trying a variety of viewpoints.

Look closely at how the light falls on the nose and mouth. The shadows cast, even if they are very slight, will highlight certain facets and indentations, showing you where you concentrate your mark-making in order to create three-dimensional features.

Light source

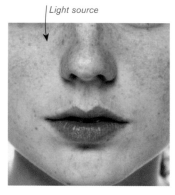

Light source

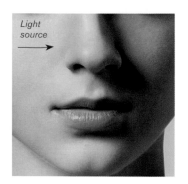

In general, ambient light comes from above, so you will get soft shadow on the underside of the nose and cast shadow directly beneath it. The end of the nose may be highlighted, and a paler line will generally run up from there to the nose bridge, falling away as softer shadow on either side and deepening behind the nostrils. Note the broken highlight on the lower lip and the deep shadow immediately below, both of which will vary greatly between individuals.

If your subject is sitting at a window, the light comes from the side. If it is bright outside, the shadows will be far stronger and more defined than usual. Only draw what you can see—if all the structure on the lit side is bleached out, don't be tempted to make it up. Less is more! The tiny areas of shaded definition, like the nostril and lip corner above, if carefully observed, will do all the work. Before you begin on the shadowed side, check for patches of highlight to help sculpt the face, such as the far cheek and the extended highlight on the lip and chin.

FIRST MARKS **TO TONAL SKETCH**

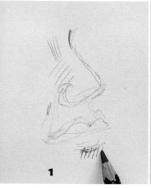

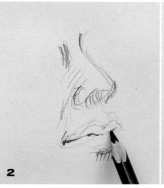

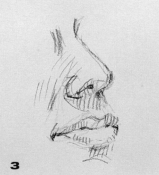

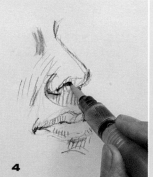

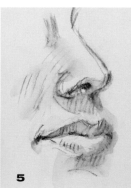

1 Begin with a soft underdrawing in a tan pencil to establish the basic shapes without setting anything in stone, then begin to define the shadows in an olive pencil. **2** Sketch nose shadows in olive green and establish the ragged central lip line in navy. **3** Shade the lips sparingly, hatching in pink and navy. Add nostrils and darker shadows under the nose, and add a pink blush to the cheeks. **4** Begin blending the colors with a waterbrush, starting with the darkest nostril area to establish that as a benchmark. **5** The water softens the hatching and removes white paper from the shadows, so the highlights have more power. Use the waterbrush delicately, so the original mark-making is largely left in place.

Face On

Sketching noses from the front requires very careful observation. Look for shadows around the mouth and nose that will give them structure, but don't overdo it.

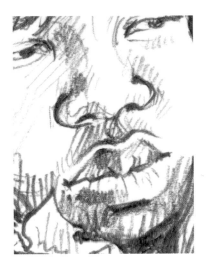

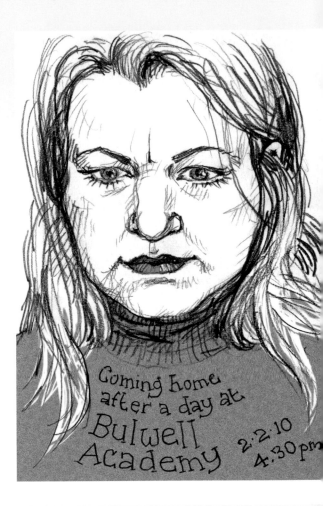

Coming home after a day at Bulwell Academy 2.2.10 4.30pm

▶ **A Nose from Above**
The nose is tricky to describe from this angle. Look for the cartilage shaping of the end, described here with a strong, horseshoe-shaped shadow. Behind that, the skin surrounding the nostrils is foreshortened, so it's vital to observe the shapes carefully. The nostrils themselves are subtly shadowed dints below.

3B pencil, digital tinting

The slight widening of the nose is described by subtle shading either side, but note the highlighting effect of not connecting this on the right

▲ **Shadows and Highlights**
With a deep-lipped mouth, there is sometimes a clearly highlighted line around the top lip. Note how the darker shading on the left section of the upper lip describes a slight angling back from the center. This woman's broad nose has strong shadowing where it meets the cheek behind the nostrils.

4B pencil

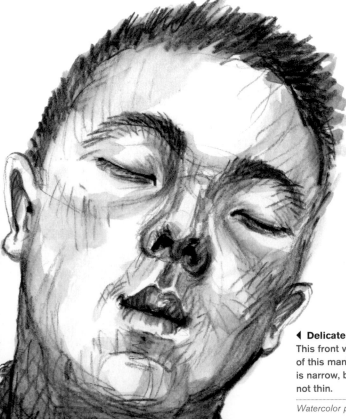

Describing a shallow bridge from a front view is hard, and careful attention is needed to the shadowing of subtly different facets

The white-paper highlights are important to describe the tight contours

◀ **Delicate Features**
This front view shows the delicacy of this man's features. The mouth is narrow, but the lips are full, not thin.

Watercolor pencils, waterbrush

Areas of Shadow

Noses: It varies with the light, but the nose often has a soft band of shadow down its length and a slightly stronger shadow below and around the nostrils, narrowing into deeper shadow still where it meets the cheek.

Mouths: In normal lighting, shade the top lip with a little accentuation at each mouth corner. There will be a central band of shadow running up toward the nose and a darker horizontal band above the chin, which widens and dissolves at the sides, according to the subject's face shape.

Three-Quarter View

This viewpoint offers the most variety. Just slight variations in the angle of the head completely change the shapes and the relationship between nose and mouth: Great fun when your subject is keeping still, but extra problematic, if not.

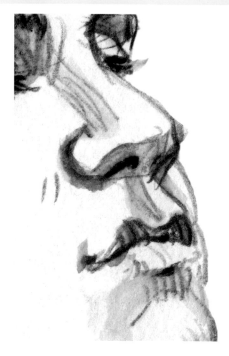

◀ Sculpting with Shadows and Highlights
The nose often has a soft band of shadow down its length, but be careful to leave the highlight along the top edge. Deepening shadow will curve behind the nostrils and flow into softer shading underneath. The shape of the shadowed top lip is accentuated by a vertical band of shadow up to the nose and further sculpted by a tiny dint of shading at the mouth's corner. The shadow above the chin dissolves at the sides, denoting the face shape.

Watercolor pencils, waterbrush

▲ Quick Lips
When sketching a mouth quickly or from a distance, draw and shade the upper lip only. Just suggest the bottom lip by drawing the shadow beneath it. Start with the center lip line—this describes the contours.

Sailor fountain pen, black ink

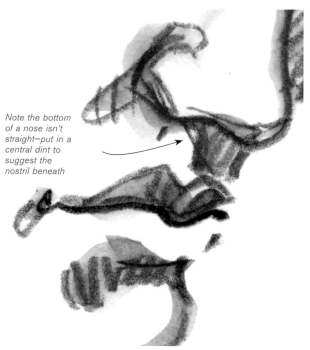

Note the bottom of a nose isn't straight—put in a central dint to suggest the nostril beneath

▼ Full Features
Note how the full lower lip is described by the subtle band of shading above its lower edge and the single dint at its center.

3B pencil

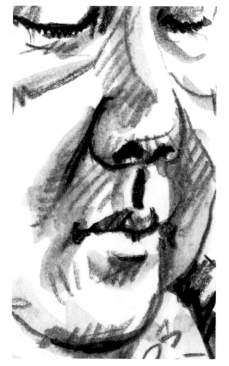

▲ Undulating Lip Line
The line between closed lips straightens as we age and our lips get thinner, but generally there is a slight upward curve from the corner, then a sharp dip at the center point. The size of the dip varies between individuals, but drawing it will sculpt the lip contours, making your sketch three dimensional.

Watercolor pencils, waterbrush

◀ Shallow Bridges and Nose Ends
Here, the bridge and the angle of the nose are both quite shallow. The end of the nose is rounded, and both nostrils are visible. Note the strongly defined cleft above the lips.

Watercolor pencils, waterbrush

Side View

This is probably my favorite viewpoint to draw. I love the uniquely personal line that runs from the bridge of the nose to the chin and all the delicious nips, tucks, and sweeps along the way.

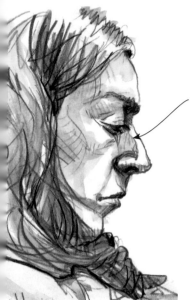

Sometimes I like to describe the edge of a shadow with a line before shading it to accentuate contours and exaggerate highlights

◀ Lit from Above
Whether you're indoors or outside, the light source is mostly above, so there will be shadow beneath the nose and mouth, but the lower lip will catch any light. Unless your background is shaded much darker than your subject, you will need a line to describe the nose edge. This line does not exist in reality, of course, but will accentuate the adjacent highlights.

Watercolor pencils, waterbrush

◀ Flattened Profile
Some people have small noses with extremely shallow bridges, which can be seen more clearly in profile. This varies from person to person, but in some cases, the line from forehead to nose end is not far from straight. Note the upward tilt at the end of the nose, so that the nostril faces slightly forward.

Watercolor pencils

The nose will cast a shadow on the upper lip if lit from above

◀ Facial Structure
Every individual is different and facial structure has subtle variations from person to person. This unusual viewpoint shows how the area below the cheek curves forward to meet the high top lip, and there is a sharp dip into the chin from beneath the lower lip.

3B pencil

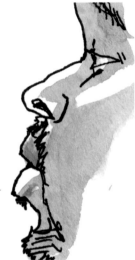

▲ Variation
A side view is probably the easiest to draw, but there are so many variations from person to person that you must observe carefully. Compare the under-nose region in these otherwise similar faces—one is short and forward-curving, the other long and completely vertical. If you want to capture the character of an individual, these details make a big difference.

3B pencil

◀ Shaping Deeper Lips
Note that the lips in profile are not necessarily the same as one another: the front of the upper lip here is quite upright, tilting slightly back; the bottom lip has a broad downward curve with a steeply angled indentation where the mouth meets the chin.

0.5 fineliner, watercolor

Creating Skin Tones

Olive, tan, and red
Green shadows prevent the skin from appearing too pink, warmed by the tan. A blush of red for the cheeks and ears makes the complexion less sallow. (See page 79.)

Blue, pink, olive, and tan
The tan, pink, and olive are blended for the skin, but stubble can appear blue/green. The olive takes the brightness from the blue and provides shadow. (See page 80.)

Navy and plum
A slightly florid, weathered complexion. The cool navy negates the warm plum, keeping the color balance and offering deeper shadows. (See page 102.)

Tan, navy, and blue
Dark skin can be blended by balancing tan and navy, providing cool and warm reflected light, and combining for a realistic tone. The blue creates a highlight. (See page 60.)

Drawing the Details:
Depicting Different Ages

Everyone knows that our appearance changes as we age, that our beautifully smooth skin develops wrinkles, and our hair gets thinner. When you sketch, though, you become aware of even more fundamental alterations. During our development from childhood to old age, some of our features seem as though they are entirely remolded: Try comparing the noses of a toddler, a young adult, and an elderly man!

It starts with the understanding that children are not just smaller than adults. Look closely and a child's facial features are very different indeed. They are not just less weather-beaten—things are actually a different shape. There are many reasons, including the fact that noses and ears are not yet sculpted by the cartilage that develops in adulthood, and a child's lips are pumped up with collagen, which will break down as they age. Then take a look at a child's head in profile and compare the overall shape to any adult's. The skull beneath is still developing, and a different arrangement of muscle and fat makes for a very different sculpting.

Of course, we all develop differently as the years roll by, but there are specific changes we have in common. Eyes lose their brightness and appear smaller, as the skin around them sinks or grows puffy; our lips become thin; our clean jawlines are gradually obscured as jowls develop; and our necks often disappear under double chins or hunched shoulders. All of our faces eventually develop a network of creases and sags, but in slightly different ways, depending on our weight and our most-used facial expressions.

Sketching Children

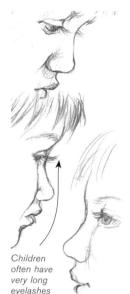

Children often have very long eyelashes

◀ Distinctive Shapes
When we are young, eyes are big, mouths are small, and our profile involves far smoother curves. The nose is a continuous sweeping line from the forehead and generally turns up slight at the end. The end of the "button" nose is small and rounded. In profile, you can see how the fullness of a child's pert lips causes them to part slightly.

3B pencil

The weight of the cheeks is often lower in the face, creating bulges to either side of the chin

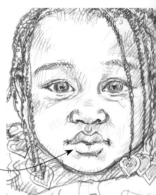

The shadowing of the dimples at the corners of her mouth and the sharply delineated medial cleft describe the fullness of her lips

▲ Baby Eyes, Noses, and Mouths
In babies and toddlers, the irises appear very large, so little white is visible in the eyes. A baby's eyebrows are very fine and should be underplayed. Notice how the overall shape of the mouth is more circular than linear, with the outer edges of the lips nearer vertical than horizontal. The bridge of a child's nose is much flatter than an adult's, lacking the highlighted ridge.

3B pencil

The baby fat of the cheek creates a prominent curve when seen in profile

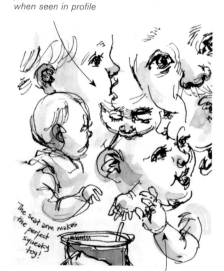

The seat arm makes the perfect squeaky toy!

A baby's arms are so chubby, you get a permanent crease at the wrist

◀ Round Heads
A baby's head is very round, doming out at the back, with a high, softly rounded brow. Once a baby is old enough to be animated, they are interested in everything, so a sheet like this is a useful idea, starting again each time they move.

0.5 fineliner, watercolor

Note the acute sweep of the brow into the nose and the soft curve of the chin, shadowed to create the full roundness of young skin

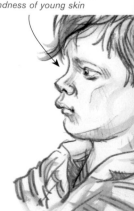

▶ Uneven Lips
It's interesting to note that a child's lower lip is generally smaller than the upper—the complete reverse of adult features. This young boy's face still has the rounded shapes of his early years, but you can see from the shading around the eye and cheek that he is developing the beginnings of a slightly older sculpting.

Watercolor pencils, waterbrush

Sketching Old Age

Aging Skin

Lines and shadows are unique to each individual, but generally fall in similar places. You don't have to draw every wrinkle, but recording the main features will gel across the age and character of the subject.

3B pencil (left, center-left, right), watercolor pencils, waterbrush (center-right)

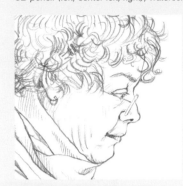 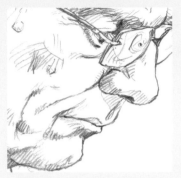 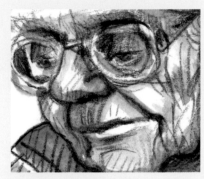

Parallel creases were created because her chin was tucked in and her skin is thin. Note how the pencil shading feathers away at the top, but is subtly harder at the bottom to show how the lines are nipped tighter where they curve

Keep skin creases soft by using a variation in line weight. The hatching at the ends blend them in and molds the skin folds

Soften stronger age lines with subtle shadows either side to give volume. Note the undulating jowl line surrounding the chin

As men age and their noses enlarge, their nostrils tend to elongate

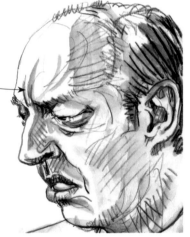

The waterbrush was dragged up over the pencil line, creating shadows to soften and mold the frown

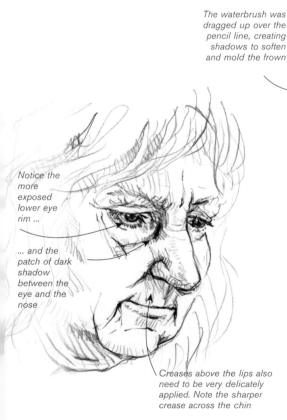

Notice the more exposed lower eye rim ...

... and the patch of dark shadow between the eye and the nose

Creases above the lips also need to be very delicately applied. Note the sharper crease across the chin

▲ **Older Eyes**
The skin surrounding older eyes is looser and there are very few straight or hard lines. The lid is often obscured by the skin above. The eyeball is often pink or yellowed and appears wet, and more of the lower eye rim is visible.

3B pencil

▲ **Frown Lines**
An aging face reflects its most constant expressions, so capturing key features in your sketch will help personality to shine through. Although this man is only middle-aged, the frown lines were already part of his expression of repose.

Watercolor pencils, waterbrush

▶ **Underplaying Wrinkles**
"Crow's feet" radiating from the corner of the eye can be very subtly indicated and yet still convey a powerful sense of aging. Look for other small lines, like the two tiny marks across the nose bridge.

3B pencil

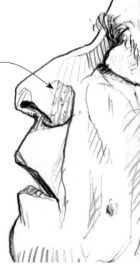

A few dots convey the slightly pitted skin around the nostrils

▶ **Thinning Lips**
The fleshy lips of our childhood gradually slip away as we grow older. Already thin lips may fade almost to nothing. This is most obvious with the upper lip.

3B pencil

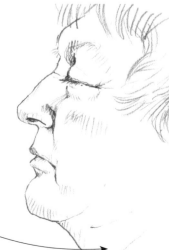

These few fragile pencil lines tell so much. The pressure has been varied, to create realistically delicate creasing

1 Look for the overall shape of straight hair, which flows out and down from a central point on the parting line. **2** "Choppy" hair is a mass of curves, but it is not totally random: Sections of hair will flow in the same direction. **3** Natural African-American hair has a curly texture that does not flow; it is far more sculptural. **4** The "flow lines" in the linked sections of a braid travel in alternate directions.

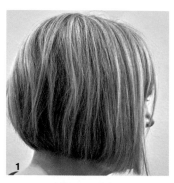

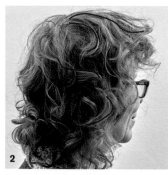

Drawing the Details: Hair

The difficulty people often face when sketching hair is that there is simply too much information. It is impossible to draw every hair, and yet, how else do you convey the texture and flow? How do you get across the delicate, formless quality and not end up with something that looks more like a helmet?

There are so many different hair types—and different ways of styling it—that every case has to be dealt with on an individual basis. However, there are ways to simplify what's happening and various techniques for depicting texture and body.

Things to Remember

- Sketch the overall shape of the hairstyle rather than individual strands of hair.
- Let your mark-making follow the direction of flow and describe the texture of the hair.
- Less is more: There will be areas of light and shade. Sometimes, it's enough to pick these out.
- Don't forget the head shape beneath the hair. However "big" the style, keeping the head in mind gives you form and symmetry.

FIRST MARKS **TO TONAL SKETCH**

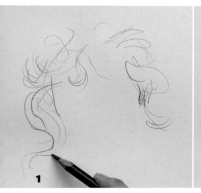

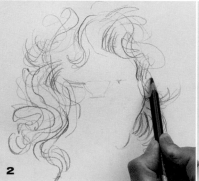

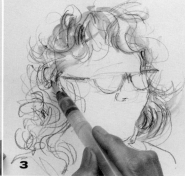

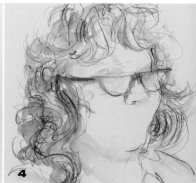

1 When drawing hair that goes in lots of directions, you need to build up a sketch, picking out the various shapes and flow lines. **2** Hair is made up of lots of subtly different shades. It's better to create the impression of brown: I have used tan and olive pencils alongside one another, with navy for areas where there is more shadow.

3 Blend the watercolor pencils with a waterbrush. This will begin to give the sketch body. **4** Make sure that the brush marks also follow the flow lines of the hair. It's good to leave some white paper highlights where the hair is lightest, even if, in truth, it is a paler brown rather than white.

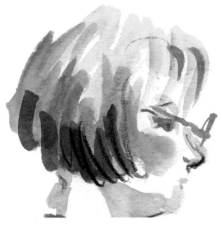

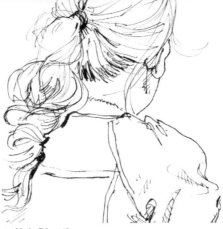

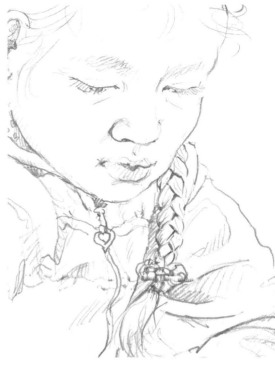

▲ Shading to Give Form

A bob needs to be viewed as an overall shape, but the watercolor marks still follow the direction of hair flow. The build-up of shadow along the bottom lifts and rounds the bob. Note the touches of green and purple to gently dampen the yellows and oranges.

Watercolor, rainbow pencil

▲ Hair Direction

This long hair was curly and wayward despite the ponytail. Too many lines would have quickly become a mess, so I drew only those that described a change of hair direction. The dark shadows against her back, at the nape of her neck, and at the hair tie act as a contrast, pinning the hair in place and preventing confusion.

Sailor fountain pen, black ink

When hair is very black, navy blue can be a more attractive color for the shadows than black or gray, and it is less likely to obscure your mark-making

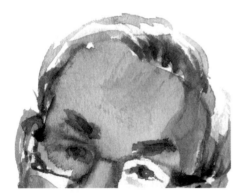

▲ Short Hair

The top edge of the hair is indicated by a series of soft, gray marks, but what really tells us the shape is the deep shadow in front and into the parting. The unpainted areas between the two keep the hair soft and prevent it from becoming a solid object.

Watercolor

▲ The Head Beneath

The tangled dreadlocks and the springy texture of the hair is suggested by the frenetically scribbled marks. Despite this anarchy, the shape of the head is followed through, remaining strong and clear.

Sailor fountain pen, black ink, watercolor pencil, waterbrush

Note the greater intensity of marks at the neck, where the underside of the hair is in shadow

▲ Braids

The important thing to get right when drawing a braid is the angling of the sections up (or down) toward the middle. Note how the two sides are offset, with dark shadows where they meet, creating a zigzag shadow up the center. The occasional pencil line for texture tells us it is hair.

3B pencil

▼ Mark-Making to Show Texture

These four people had very different hair types. Though I have used the same pencil, the marks I have created are very different, so the four textures are clearly communicated.

Rainbow pencil

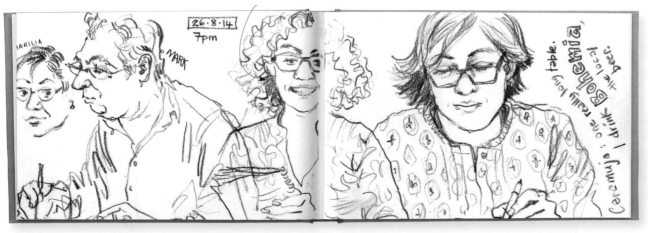

Drawing the Details:
Hands

If there's one thing most people worry about, it's drawing hands. Yet our hands are so expressive that, if you can get the knack of capturing them, you can instantly communicate much more about what your characters are feeling. The "banana-finger" problem comes from concentrating too much on all those fingers and not thinking enough about the hand as a whole and how everything connects.

The best way to learn how a hand works is to draw your own in different positions. Take particular note of the knuckle positions, as these are benchmarks to help gauge finger lengths and angles. Depending on the position, it can help to sketch in the knuckle lines first. In many positions, these echo the line of the fingertips. With more complicated positions, look out for the areas of deeper shadow, as they can help to make sense of things, by bringing depth to your sketch.

Things to Remember

- Half the hand's length is the palm, which is almost as wide as it is long.
- Fingers are very different lengths, and the middle finger is the longest.
- The fingers widen slightly at the knuckles.

1 When someone is writing, their hand presses against the table as a horizontal line, giving the hand weight. The knuckle line is a diagonal, at right angles to the diagonal direction of the fingers. **2** The overall shape is quite square, tapering to the wrist. The start of the lines between the fingers mirrors the slight slant of the bent fingertips. **3** Always draw the pen first, to help judge the other shapes. **4** In this position, the overall hand shape is pointed. Only the top of the first finger is visible, higher than the other fingers and directly opposite the thumb, supporting the weight of the bottle.

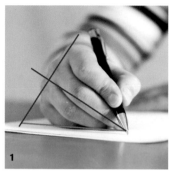

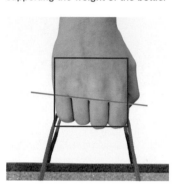

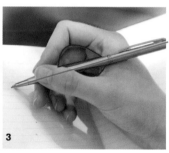

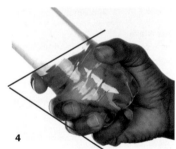

FIRST MARKS TO TONAL SKETCH

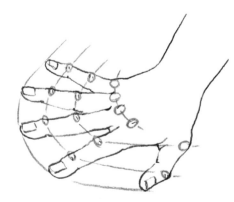

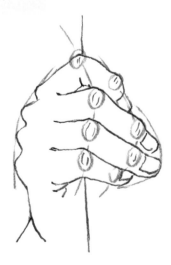

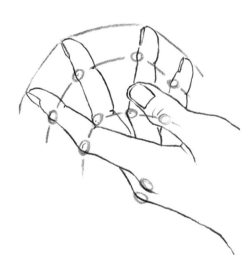

1 When the hand is laid flat, the knuckles line up in curves that radiate out. Note how the fingertips exactly match the curve pattern. The thumb knuckles are set slightly back, and there are two, not three, knuckles visible.

2 When holding a newspaper, the body of the hand follows the paper edge, but the fingers point slightly down. Knuckles and fingertips still line up, even where one finger is bent: This creates a slight step in the curve, but the lines still echo one another. Note how the knuckles on the far left now curve in the opposite direction.

3 Because fingers are fixed at the first row of knuckles, the knuckle lines will always line up when the fingers are straight, though the thumb has to be taken separately. This position is a good example of how you need to consider the overall shape, then use the knuckle positions to check and fine-tune the structure.

▼ **Familiar Positions**

People often bring their hand to their chin when listening or thinking. Look around you, watch people, and become familiar with how our hands look in these repeated positions, so that you are halfway there when you sketch them in action.

(From left to right) Sailor fountain pen, black ink; 0.5 fineliner; 3B pencil; watercolor pencils, waterbrush

Look at how similar the finger positions are in these two sketches

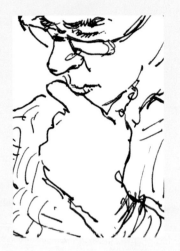

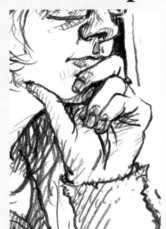

▶ **Less Is More**

Don't overdo the folds and tendons you observe, or you will age the hands beyond their years. Subtle indications of knuckles are usually enough. Don't overstate fingernails either, or they can draw the eye too much.

3B pencil

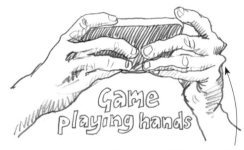

Game playing hands

This is only a subtle exaggeration. In certain positions, knuckles jut out sharply

◀ **Easy Subjects**

While you build your skills, it is easier to concentrate on hands that are not in constant motion. People playing digital games hold more or less the same pose for long periods. You can get quite close, as they need to concentrate, so they won't be interested in you.

3B pencil

The fingers are all in different positions and at different angles, but at the point where they join the hand, the knuckles are fixed in line

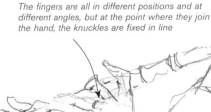

▼ **Practice**

Sometimes I sit on a train and just practice hands. If you fill a page with overlapping sketches, you worry less about unfinished drawings or ones that aren't quite right. Using more than one color helps to keep things from getting too confused.

3B pencil, Derwent terracotta drawing pencil

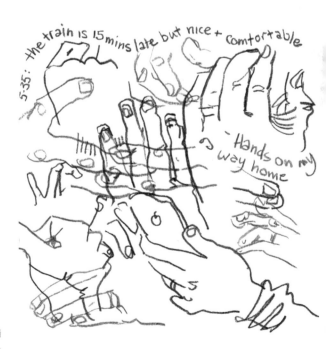

5:35: the train is 15 mins late but nice + comfortable

— Hands on my way home

◀ **Wrist Angles**

Often in conversation or when playing an instrument, hands are not held in line with our arms, but are bent up at the wrist, a very expressive position and important to capture.

3B pencil

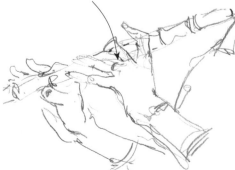

Drawing the Details: Feet

Unless you are sketching on the beach, you are more likely to be drawing shoes than bare feet. These are going to vary enormously—you might be faced with fluffy slippers, leather dress shoes, flip-flops, or high heels. This variety makes sketching feet fun. Start by practicing on your own feet, working your way through the different kinds of shoes you own.

Things to Remember

- The shoe is just a shell that surrounds the foot. Keep in mind the shape of the underlying foot when you are judging the shape of the shoe.
- Look for tones. Shadows and highlights will help to mold the shoes and make them three dimensional.
- The widest part of a shoe or foot is at the ball of the foot, approximately one-third from the tip of the toes.

Although each shoe always has the basic foot shape at its center, the structure of the shoe can radically change the way the foot, and even the leg, is positioned. High heels force a woman to walk on her toes, with the rest of the foot angled upright. This, in turn, tightens and accentuates the calf muscles as well as changing her standing posture.

The shape of a shoe is subtle. It's interesting to put one on a table and take a good look. Even "flat" shoes are very rarely flat-bottomed. Not only will the sole usually curve up under the instep, but if you look closely, a lot of shoes are designed so they bend up away from the floor at the toes. Consider the material, too: Leather shoes are often hard and shiny, which will require a different kind of mark-making than fabric. Also, look at how different shoes show their age: Leather creases where it folds, but in a different way than sneakers, and there are never any creases in a pair of rain boots, just the occasional scuff or stain.

You won't often have time for this level of detail, of course. If you are speed-sketching, concentrate on getting the overall shape as accurate as you can. If the person is standing, all their weight will be pressing down, so some part of the foot must be flat to the floor. If they are seated, it's important to get the angle of the foot correct in relation to the leg.

SKETCHER'S CORNER
SEEING IT

1 Look for the sole line, which is generally less flat than you'd expect. Here, it is a gentle curve, high at both heel and toe, only touching the ground at its center. **2** These sandals show how the foot is forced upright by high heels, so only the toes are flat, taking the majority of the weight. The sole of the foot is bent up; the front will be more or less vertical, depending on the heel height.

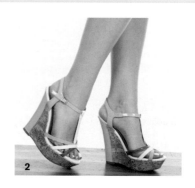

FIRST MARKS TO TONAL SKETCH

A minimal amount of shading really helps to "sculpt" the back of the leg, ankle, and instep

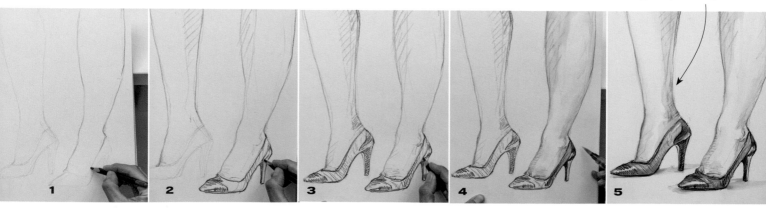

1 Sketch the overall shapes, paying close attention to the angles and curves. **2** Add soft hatching to round the legs. Sketch the shoe in a darker color, being careful to leave plenty of white for highlights and molding. **3** Accentuate the darker leg and ankle shadows in a midtone. **4** Use a waterbrush to blend the pencil color and soften the hatching. **5** Drag the waterbrush horizontally from the bottom of the shoes to smear the color into a soft shadow.

▼ ▶ Toe Length

The relative lengths of people's toes vary a great deal, changing the overall shape of their feet. My big toes are shorter than my middle ones (right), but many people's toes gradually reduce in size from a longer big toe (below).

3B pencil, watercolor (right); 3B pencil (below)

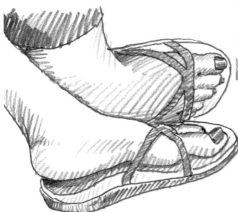

Sandal straps mold themselves around the feet, but with a crossed-ankle pose, they can fall in unexpected places, so careful observation is vital

▼ Foreshortening

High heels can be tricky when not viewed side-on. Here, the foot on the floor is foreshortened slightly, making the side of the shoe very slim and the heel barely visible.

Black fineliner, watercolor

The other shoe is reduced to a lozenge, with the heel appearing underneath. We see the sole as a triangle, because of the pointed toe

Note how the foot bulges at the front

▼ What's Important?

When doing a quick sketch, you must decide how to create the impression of the shoe, rather than drawing every detail.

Watercolor pencils, waterbrush

Important observed details, like the slightly bunched-up pant leg and exposed sock, make the person feel alive

Each lace line ends in a "spot," which makes them disappear into lace holes, rather than sit on top of the shoe

The top edge of the shoe is an uneven, wavy line, making it comfortably aged

The areas without color provide highlights, which suggest the shine of leather and make the foot three dimensional

Rough shading also helps to soften and age the shoe

Notice how a blue pencil shadows the brick red more richly than a dark brown or black would

Note how the sole line curves up into the instep to join the heel

▼ Basic Shapes

When you are a beginner, or you have minimal time, look for the simple shape that best describes the feet of your subject, as in this detail from a sketch by Manuel Hernández González.

Fountain pen, sepia and green ink, water

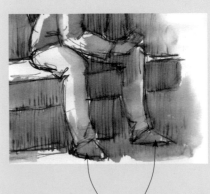

Note how the two shoe shapes are subtly different because of the different angles of the feet

Drawing the Details:
Clothing

The clothes people wear tell us about who they are and what they are doing. Some clothes make us look and feel formal; others are intrinsically casual. You don't necessarily need to draw every detail, but you need to convey a reasonable impression so your characters come across as real. Different kinds of fabric have different characteristics, and it can really help to highlight certain key features of particular items of clothing.

The way a person holds themselves affects the way the clothing falls, stretches, or crumples. Drawing these folds and creases will describe the person beneath and their pose. It's important you always remain aware of the body beneath the clothing. It can be helpful to lightly sketch in the torso and limb shapes first to ensure all is well, structurally speaking, before you begin "dressing" a character.

As always, it is the keen observation of light and shade that will be most helpful to you in describing the way cloth is sculpted. The folds are the most important element. You can say a lot about the weight of a fabric by the way it folds. A heavy coat will have rounded, rolling folds, whereas a shirt will crease tightly. Try not to overwork things—sometimes, you can say all you need to with a

Continued on page 56

1 Even a straight skirt will have very few straight lines, especially if it is tight, as it will follow the curves of the hips beneath. Note the tension lines running horizontally between the hips. **2** Fur has no distinguishable edge line. All the lines at the edge run at right angles to it. See how the direction of travel changes as the fur rounds toward the face. **3** The lines on a plaid shirt are fractured every time they hit a fold. Note how the vertical stripes narrow as the fabric undulates. **4** A padded jacket is very sensitive to light direction. Each square has broad, heavy shadow at the bottom, but almost no shadow at the top.

SKETCHER'S CORNER
SEEING IT

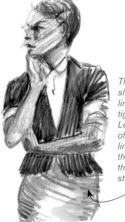

▼ Quilted Jackets
To get across the padding of a quilted jacket, it is vital to look at the shadows created where the fabric pulls around the stitching. There will always be tension in the fabric because it cannot lie flat.

3B pencil

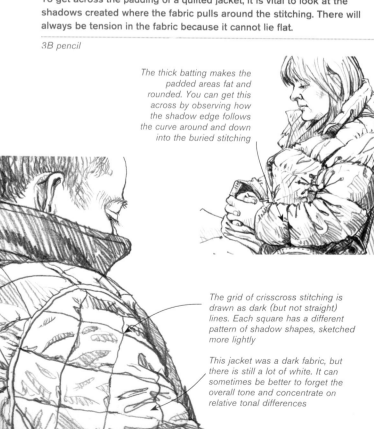

The thick batting makes the padded areas fat and rounded. You can get this across by observing how the shadow edge follows the curve around and down into the buried stitching

The grid of crisscross stitching is drawn as dark (but not straight) lines. Each square has a different pattern of shadow shapes, sketched more lightly

This jacket was a dark fabric, but there is still a lot of white. It can sometimes be better to forget the overall tone and concentrate on relative tonal differences

▼ ▶ Skirts
Full and fitted skirts behave very differently. Compare these two sketches.

Watercolor pencils, waterbrush

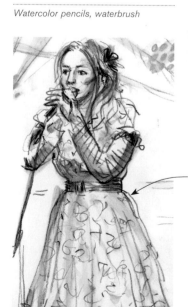

If a skirt is belted, there is sometimes a slight bulge just beneath before lines flatten out

It is not necessary to copy the exact folds. Draw a few lines radiating down, then look at the general shape of the bottom edge and draw a line that creates an impression of the undulations

There are often slight tension lines across a tightly fitted skirt. Let the directions of your shading lines echo the direction the fabric is stretched

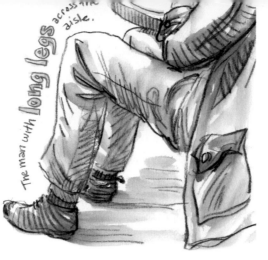

The man with long legs across the aisle.

▶ Riding Up
Bending our limbs creates tension, which causes the fabric of our clothes to ride up. When we sit down, pant legs are pulled up over the knees, so the bottoms sit much higher, exposing the socks and, often, a small section of leg.

Watercolor pencils, waterbrush

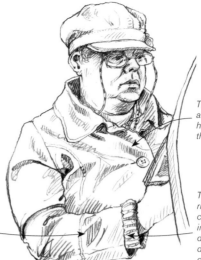

There is usually an area of highlight along the top of a fold

The shaded ribbing and crinkled outline immediately describe a different kind of fabric

▼ Shirts
There are certain things to keep an eye out for, when drawing a shirt.

Waterproof fineliner, watercolor

Establish a common direction for your hatching, one that runs across the folds rather than down their length

▲ Shading
Soft hatching can be very descriptive, but is best used sparingly. I often record the shape of a fold, then shade it. With pencil, you can hatch in different weights, to describe the depth of folds. Reserve the deepest shadow for the inside of collars, under the collar lapels, under the arm, and inside the sleeve bottom.

3B pencil

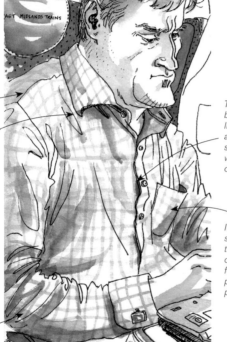

There is usually a seam that runs across the shoulder, from collar to sleeve. This helps to describe the shoulder shape and undulates to echo any folds below

The corners of a stiffened collar sometimes curl under

Notice how the fabric is bunched and wrinkled between the cuff and the elbow. Don't try to copy the exact folds. A wriggling line will give an impression

The line of buttons rarely lies flat—add a little more shadow where it raises or strains

If there is something in the pocket, it can drag forward, pulling the pocket open

◀ Fur
Victoria Antolini has described the texture of the fur at the collar very quickly with gestural flicks of the brush, working from inside to outside to create a suitably ragged edge. The solid black provides a powerful contrast.

Black ink, graphite pencil

Drawing the Folds
These two sketches show how you can describe the structure of clothing by concentrating on the folds created when fabric interacts with the body beneath. Note how the crease lines in the lighter shirt fabric are long and close together because the fabric has more give. The heavier jacket has short, fat kinks at the tension points and where the buttons and mayoral chain dint the fabric.

▶ In Matthew Midgley's sketch,
only the jacket's outer edge and creases are drawn. Its interior structure is inferred by the way it reacts to the body.

Pentel black brush pen, black Uni Pin fineliner

▶ The shirt's outer edges
are almost completely missing from Don Low's sketch, but the creases are all we need. Our eye fills the gaps.

Pentel brush pen

His arm is tucked forward, creating curved lines from his armpit that stop just short of his shoulder

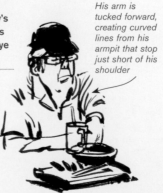

▲ Knitwear
You can describe knitwear by drawing the ribbing. You can get away with sketching just the heavier ribbing at collar and cuffs, but this sketch by Edurne Iriarte shows how effective it can be to draw the knit lines throughout. It is important to watch for the direction of travel and the way folds affect the lines.

0.5 fineliner, marker

few carefully chosen marks. Even if a jacket is dark, the darkest tones must be reserved for shadowing the folds. You can suggest dark fabric without coloring everything in.

Think about the textures of different fabrics, and alter your mark-making accordingly. Knitwear has ribbing (especially obvious on a heavy knit, such as a woolen hat) that can be conveyed with stripes; an angora sweater or a fur collar will not have a hard edge, but might be suggested by delicate, gestural marks; the shadows and highlights on silk will have hard edges; tweed can be suggested with a flecked texture. Using different marks will not just add texture to your sketch, but also help to differentiate items of clothing that are worn side by side.

Pattern

Patterned fabrics can be a real gift. A spot, a stripe, or a more random pattern will add different rhythms to the sketch, as well as the potential for splashes of color. You probably won't have time to slavishly copy the textile designs: You need to get across the impression of the pattern as quickly as possible.

◀ ▲ Variety and Color
These two very different dress fabrics are described very simply by Edurne Iriarte but add massive impact. The roughness of the paint spots on the smaller design suggests a simple, repeating motif. The larger flowers are drawn as irregular shapes of color with occasional black detailing, effectively portraying the random way in which a larger design is carved up by the pattern-cutter. Neither design has been carefully copied—both are loose impressions.

0.05 fineliner, watercolor

FIRST MARKS **TO TONAL SKETCH**

1 Apply the dominant color first, looking at approximate shapes and intervals rather than drawing the pattern. Be aware of the amount of white background you need to leave.

2 Add one or two secondary colors here and there, copying the style and frequency of the marks rather than the design. If the pattern has lots of colors, simplify things down to the most dominant ones.

3 A linear element applied on top can help to describe the nature of the pattern—in this case, floral. It generally works best if you keep your line loose and playful, either suggesting the overall flavor of the pattern or focusing in on the occasional motif.

Things to Remember

- Observe the places where the fabric creases.
- Heavy fabric has fewer, larger creases; lighter cloth has more, tighter folds.
- There are very few straight lines when clothing is on the body.
- Never forget the fundamental structure of the body beneath the clothes.
- Patterns can help to mold fabric.

▶ The Pattern Tells the Story

The gathered frills around the neck of this blouse have not been drawn at all. Instead, the linear pattern of the fabric has been allowed to explain what is happening. The slight curve of the stripes describes the curve of the folded fabric, and the lines don't join up, telling us that the fabric doesn't run directly across.

Watercolor pencils, waterbrush

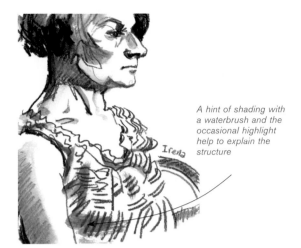

A hint of shading with a waterbrush and the occasional highlight help to explain the structure

▶ The Molding Effect of Stripes

Striped shirts are great fun to draw because the pattern follows all the ins and outs of the fabric like a rollercoaster ride. The stripes themselves don't need to be accurate, but you need to look carefully at how their path is curved and twisted by the folds.

Watercolor pencils, waterbrush

Notice how the stripes dip over into the shadow, echoing the line at the shirt's top edge

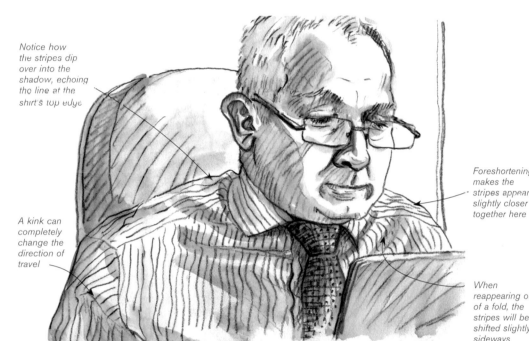

A kink can completely change the direction of travel

Foreshortening makes the stripes appear slightly closer together here

When reappearing out of a fold, the stripes will be shifted slightly sideways

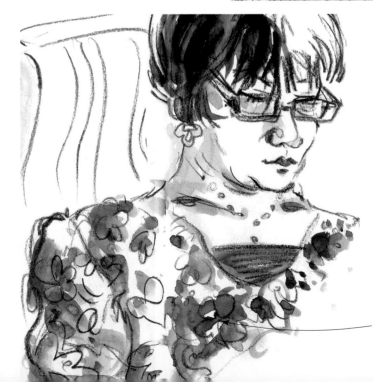

◀ A Busy Pattern

Women's fabrics can have very complex patterns, which might seem too intimidating to attempt. Simplify things down to the main two or three colors. Apply the dominant color, looking at approximate shapes and intervals rather than drawing the pattern—in this case the red. Add the secondary colors here and there, copying the style of mark rather than the design.

Watercolor, rainbow pencil

The blue scribbles suggest a floral pattern, but without drawing flowers; the yellow spots were randomly placed to finish things

2

Sketching Out in the Big, Wide World

Many sketchers avoid tackling people. It's true that people are tricky to capture in the limited time you often have, and any mistakes tend to be glaringly obvious. However, it is the embarrassment of being caught in the act of drawing a stranger that intimidates most people. As your confidence grows, this will get easier and, generally speaking, being discovered is not the big deal you think it is going to be. In this section, we'll look at ways to choose people who are less likely to notice you, and I'll share some tips on keeping a low profile—and what to do if your cover is blown.

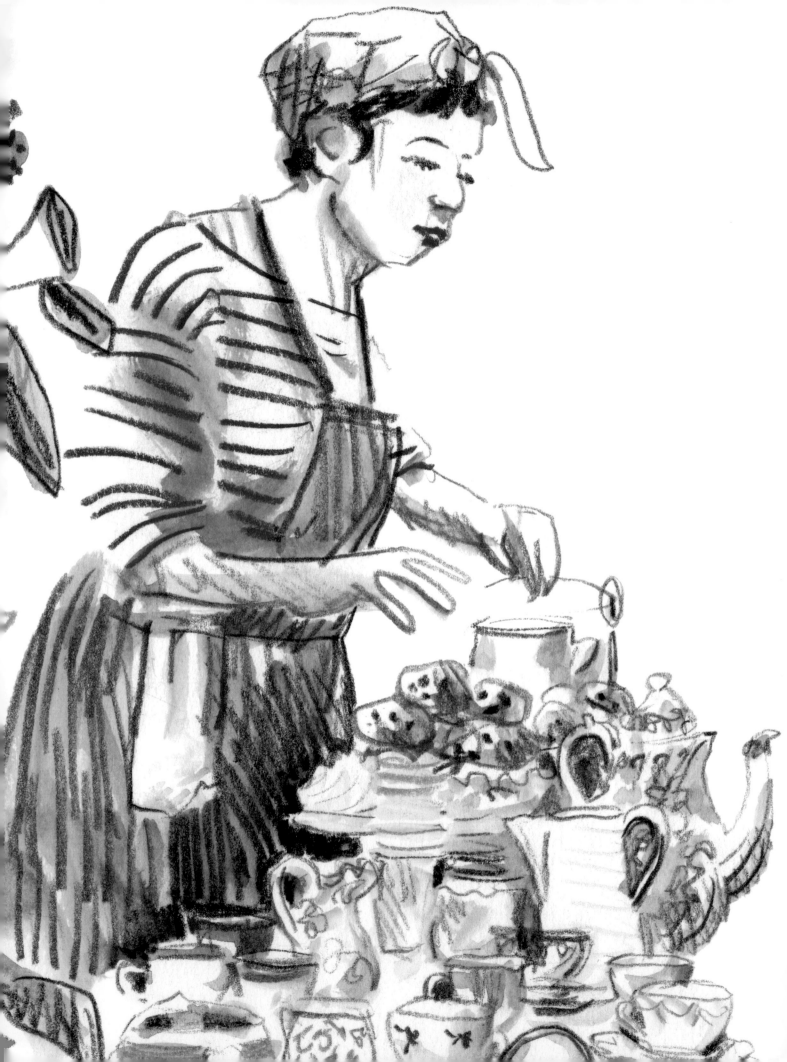

Drawing Strangers Is Scary

You might wonder whether you should ask permission before sketching someone—it is the question I am most often asked. I never ask permission because, as soon as you do, people become self-conscious and their instinctive, natural pose is lost. This not only defeats the object of urban sketching, but worse, it turns your drawing into a portrait, putting you under pressure to do something worthy of the moment and to achieve some kind of likeness.

The simplest thing is to do your best not to be noticed. So, how do you do that? Well, if you choose to draw people who are busy, they will probably never realize you are there. If you are sketching on a train, one trick is to get a seat with a table, so you can work with your sketchbook in your lap beneath the table's surface. This, of course, works well in cafés and bars, too. Even better, if you put a bag in front of you on the table, you can completely obscure what you are doing.

Watch somebody sketching, and you will see how their eyes flit back and forth between subject and paper. If your head is nodding up and down, this will immediately attract attention, so try to move just your eyes, keeping your head level. Hats with brims are very handy; they help to shield your eyes from other people.

You can usually tell if somebody is unhappy about being drawn, so look out for the signals. People rarely say anything, but might dip their head or turn their face. Women who are self-conscious tend to touch their hair a lot. Be sensitive: If someone is obviously getting irritated or uncomfortable, move on. That way, you avoid being challenged. If you are asked to stop, just apologize with a friendly smile. That's as bad as it should get—nothing to be frightened of.

You will, of course, be discovered sooner or later. Try not to be defensive. If you are friendly and share your sketch with the person, it can be a lovely experience. People are usually surprised, sometimes nonplussed (not everyone lives in a world where it's normal to sketch), often delighted. You may well be the first person who has ever drawn them, and they may want to take a photo on their phone to show their friends. If you forget how good, or not, you think your sketch is, and instead go with the moment, it can be fun.

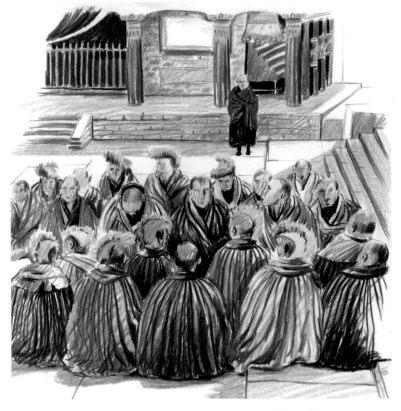

▲ A Sign of Respect
Many years ago, I was sketching in Inner Mongolia and was rather nervous about how these Buddhist monks would feel about being drawn. I needn't have worried. I was brought small gifts while I was drawing—a single walnut or a small flower. In situations where taking a photograph can be seen as intrusive, sketching often comes across as respectful.

Colored pencils

◀ Sketching in Disguise
A friend of mine, Jane Horton, used to sketch people on her phone. You can get up really close, but people just think you are texting.

Brushes app on iPhone

Caught in the Act

If you are sketching someone, and they suddenly look up and meet your eye, here are some things you can do:

- Tilt your head and stare at a point just over their shoulder. Hopefully, they will assume you are deep in thought and were simply looking through them.

- Look intently at the person next to them and pretend to continue sketching. Once they have lost interest, you can continue.

- Smile: Most people will smile back. Even if you feel a little embarrassed, any tension should slip away.

▲ People are Busy

If you draw people who are engrossed in something, as Caroline Johnson has done here, they are less inclined to be interested in you. Place yourself off to one side, or behind, so you're less likely to distract them. Note how the collaged color creates a dynamic composition and the receipt helps to journal the moment.

Collage, drawing pen, watercolor, gouache

▲ Drawing from Behind

A good way of drawing people without being noticed is to draw their back view. Without the challenge of faces (particularly faces that might look at you), it is possible to concentrate more fully on other aspects of your chosen characters, like their posture, their clothing, the shape of their head, hair texture, etc.

0.5 fineliner, watercolor

▶ Getting Above the Action

Another way to draw unobserved is to put yourself at a vantage point above your subject, like Jerry Waese did for this sketch. This is not always possible, but keep your eyes open for views from balconies, upstairs windows, etc. An urban sketcher is constantly staking out surroundings, making a mental note of future sketching spots!

Fountain pen, black ink, brush pen, china marker

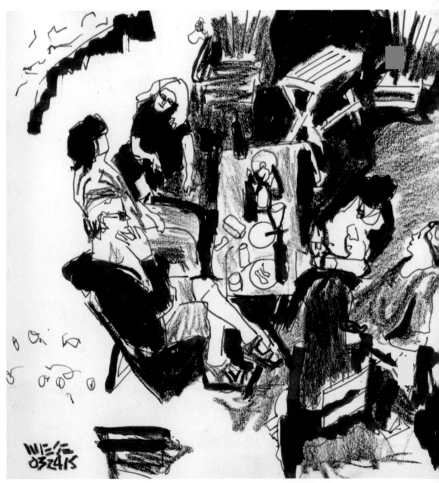

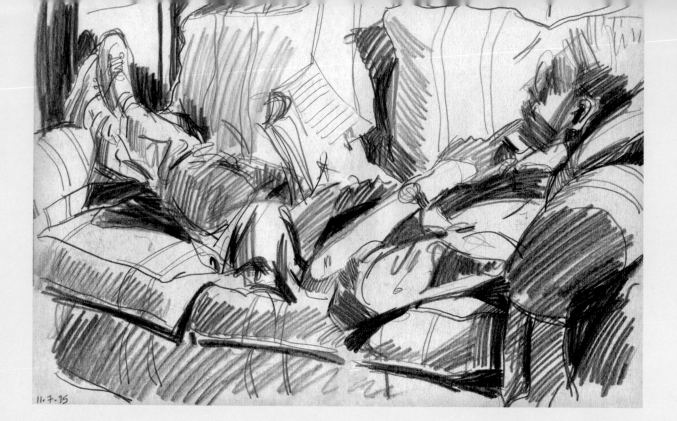

11.7.95

Who to Choose

There are a wide variety of venues where you can comfortably observe and sketch people doing a great many different activities. However, if you are a beginner, it is useful to know the locations that afford the most manageable possibilities, and which activities require a little more practice to capture. I am going to look at just a few of these in a bit more detail over the following pages.

Everyone develops favorite sketching venues. Sometimes, this is about places where you regularly find yourself with time to kill. Some people choose through a process of elimination, rejecting situations that make them feel uncomfortable, or focusing on venues that offer the sort of people they most enjoy sketching. Where you draw will also vary according to where you are based—there is a lot less beach sketching in the United Kingdom than in Florida! What follows in this section are various tips to bear in mind, but try as many different possibilities as you can to discover what works best for you.

▲ A Good Place to Begin
Friends and family are less scary to draw than strangers when you are finding your feet. Also, because you know them well, you can predict when they are in a favorite position and likely to stay put for a while. When reading a book or watching TV, people are generally absorbed, so will be less self-conscious about being drawn.

6B graphite stick on tinted paper

▶ The Train Station
When you find yourself waiting around for a late train, you can make the time fly if you attempt a drawing. Get some indication of the background structures in first, and add the people on top. This will not just give context, but also make things much easier, since platforms are places where people constantly come and go, and impressions are often all that is possible.

Sailor fountain pen, black ink

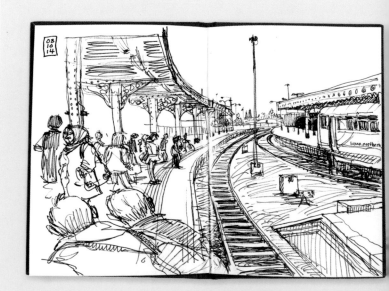

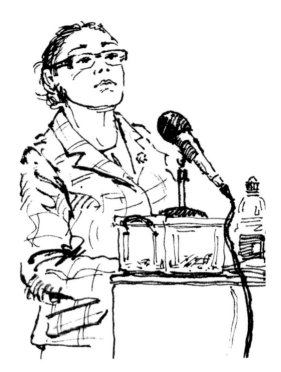

◀ Lectures

It is important to sit near the front to be able to draw a speaker in this amount of detail. Sit in the second row to hide your book, and it will look like you are vigilantly taking notes! To get more context and a longer view of the speaker, sit farther back and add the heads of the other audience members in front of you.

Sailor fountain pen, black ink

▼ In the Park

On a sunny day, there will be plenty of people in your local park doing a wide range of activities. Find yourself a spot on the grass and people-watch. It's possible to do more relaxed sketching in a park. Everyone is at ease, so they are unlikely to worry about you and, with all that open space, strangers are less likely to come close enough to observe what you are doing.

Watercolor

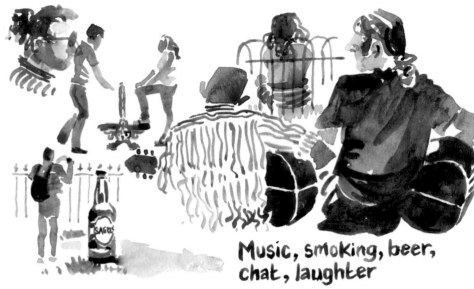

Music, smoking, beer, chat, laughter

▼ On the Move

Drawing walking people is tricky, especially if you are also moving. With a small enough sketchbook, though, it is not impossible. You can't keep your book still while you're walking, but this doesn't matter much, as long as you synchronize your drawing hand moving with your book. On this charity walk, the same people were in front of me most of the way, which made things much easier.

Sailor fountain pen, black ink, watercolor

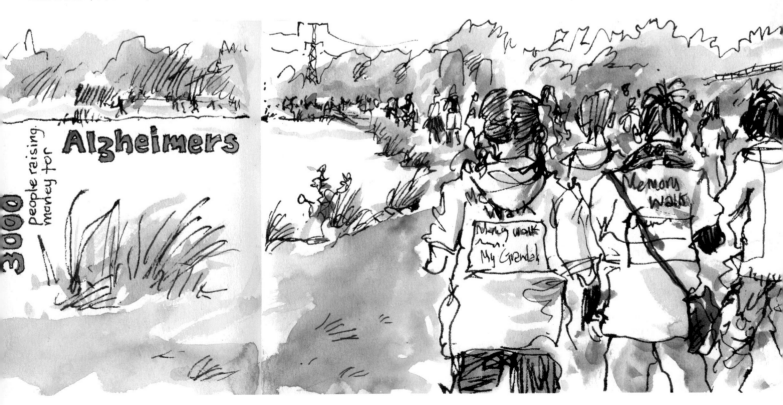

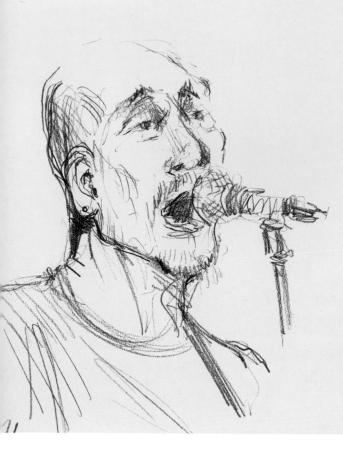

Musicians

One of my personal favorite subjects to draw is musicians, usually in bars or at local festivals. These small, informal occasions can be easier than a big concert because you can often get close enough to see detail.

At a small event, you are less anonymous than at a larger event and so more likely to be noticed, but are, to some extent, protected against too much attention, since both the performers and the audience are generally too engaged to be much interested in what you are doing.

Whether you are drawing the musicians or the people seated around you, sketching against a live soundtrack can be very inspiring—music and drawing seem to fit well together. I find that live music really helps me focus on being totally "in the moment." When you are sketching a performer, you and your subject are tied together by the rhythms, which can be a great help when you are learning to draw more instinctively, letting your mark-making come from the heart as much as the brain.

◀ ▲ Making Him Sing
I sketched this singer several times. It's easy for an open mouth to appear stiff and, in the initial two drawings (left and below), he lacked the spark of life. Sometimes you have to work through a few sketches to warm up to your subject and allow your arm to loosen up a little.

6B graphite stick (top and below), fiber-tip pen (left)

▶ Practicing in the Bar
When musicians meet to practice or to play for their own amusement rather than to an audience, there are opportunities for detailed drawing. The recorder and harp are both instruments where the player holds a single pose, so it was possible to capture the delicate lighting and the concentration on their faces.

Watercolor pencils, waterbrush

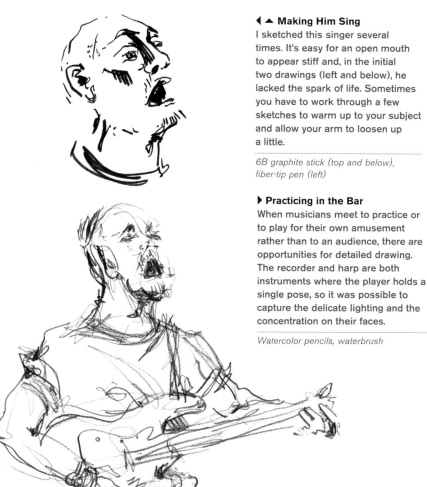

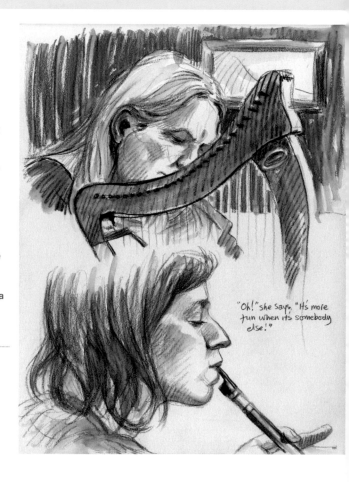

"Oh!" she says, "It's more fun when it's somebody else!"

▼ Conveying Energy

These two men struck up an impromptu duet in a music bar after most people had gone home. It was a sudden, joyous burst of energy in the largely empty room. My sketch had to remain loose because they were moving, but the lack of outline and the white space among the dramatic pencil marks communicates the musical frenzy.

Watercolor pencils, waterbrush

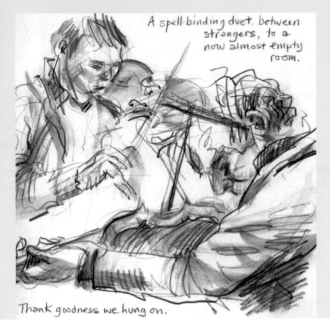

A spell-binding duet, between strangers, to a now almost empty room.

Thank goodness we hung on.

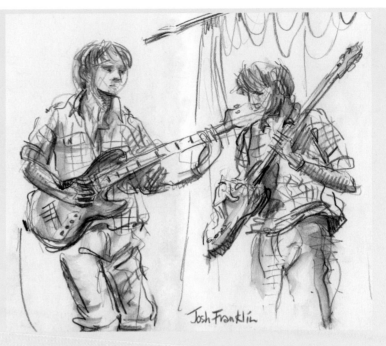

Josh Franklin

▲ Double Vision

Guitarists tend to walk the stage, which can be frustrating, so try working on more than one view. The hands are in constant motion, but regularly repeat the same basic positions, so you can get an impression down. Look out for the angle of the wrist and the lines between the fingers rather than details.

Watercolor pencils, waterbrush

◀ Keeping It Fluid

Sketching to music helps you to keep your arm moving, which is a good discipline when drawing people. A graphite stick is a great tool for sketching a musician because it glides over the paper so easily, allowing you to create lines that respond to the music. Look at how the marks up the back of his jacket and pants wriggle and dance.

6B graphite stick

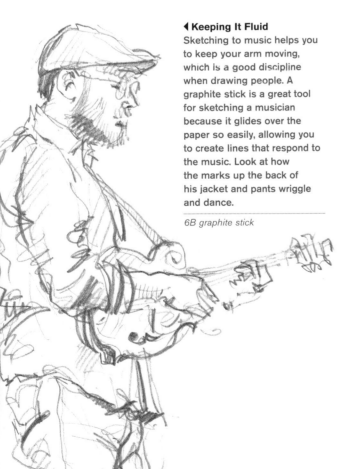

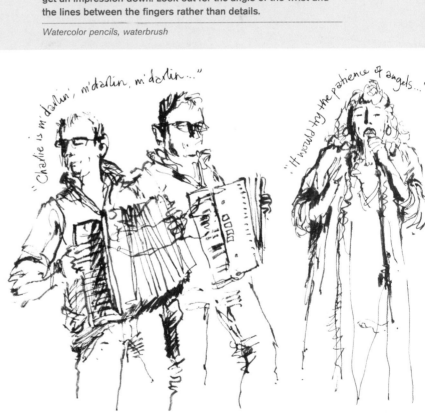

"Charlie is m'darlin', m'darlin, m'darlin..."

"It would try the patience of angels..."

▲ Capturing More

The ragged line of a Sailor fountain pen is great for catching the liveliness of a performance. By writing snatches of the lyrics on the sketch, I hear the music each time I open the book, just like one of those musical greeting cards!

Sailor fountain pen, black ink

▼ Considering the Format

Standing behind a musician can give you an interesting view and removes you from their line of sight. To capture the drama of the double bass, I turned a landscape sketchbook upright. The building details behind are important to communicate that he is outdoors, but by keeping this area monochrome, the buildings drop back and don't fight for our attention.

Watercolor pencils, waterbrush

▶ Sketching Live Music

Caroline Johnson had a second-row seat so got a great view at this gig. She used a fineliner for ease at the venue and added the color later, as she was trying to be discreet. Luckily, the band kept fairly still, but when she did make a mistake, she stuck another piece of paper over it. The music helped to inspire her and keep the flow going.

0.5 Uni Pin fineliner, watercolor

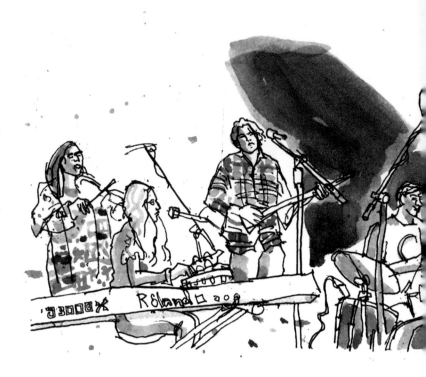

Toen hij zijn vestje nog aan had, zag Anton Eger eruit als een schooljongen.

▲ A Spark of Life

Pieter Fannes' sketches are often rather stylized. Here, he takes liberties with proportion and shape in the lower body, and yet it reads really well. His dynamic pen strokes capture only what is needed and their urgency gives real life to the character.

Pentel brush pen, watercolor

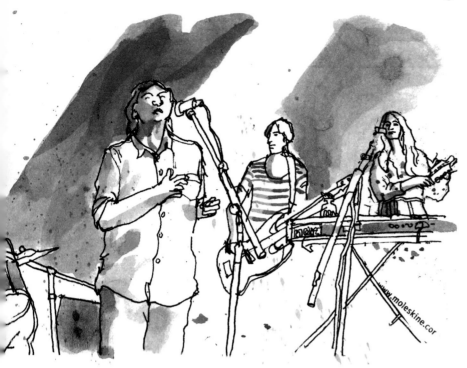

Things to Remember

- Smaller venues are better for getting closer, especially if you arrive early.
- Keep your sketching arm loose to better capture the vitality of the music.
- If a musician is pacing the stage, draw two positions simultaneously.
- Choose a medium that will glide easily, then let the music into your hand.

▼ **Capture the Energy**

To capture the atmosphere and diversity of this busy street in Marrakech, Morocco, with its musicians, jugglers, serpent charmers, and henna artists, Isabel Fiadeiro drew as quickly as possible, trying to capture all she could without attracting the attention of people who might hassle her for payment. She later digitally altered the background to enhance the sketch.

Pen and watercolor

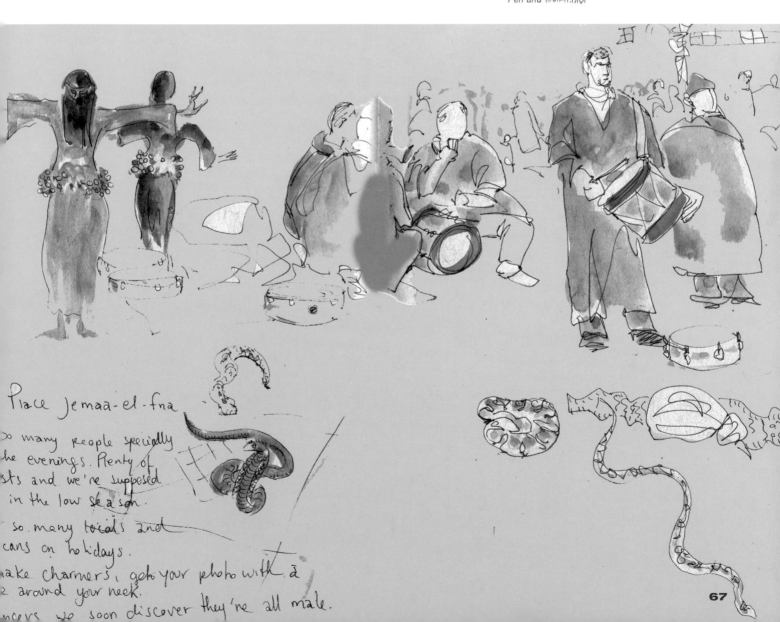

Place Jemaa-el-fna

So many people specially
the evenings. Plenty of
sts and we're supposed
in the low season.

so many locals and
cans on holidays.

ake charmers, get your photo with a
around your neck.

ncers we soon discover they're all male.

Sleeping

Airplanes and intercity trains are great places to catch people sleeping. Beaches are good, too, and, of course, your family around the house. Although people will occasionally wake and catch you in the act, for the most part, you will go unobserved, so it's a great way to begin building your confidence for drawing strangers.

Unfortunately, you can't count on sleeping subjects staying entirely still for you. When you're not sketching, sleeping people appear to stay in one position, but once you begin to draw, you notice how much they shift in their sleep. Heads sometimes roll back and forth, mouths can gradually open. Those who are asleep sitting up are the worst; their body may slide gently sideways, but most commonly, their head will slump forward, sometimes suddenly, often very, very slowly, which, over the course of a 15-minute sketch, makes a huge difference.

Don't be tempted to ignore changes—it's better to work on several little sketches that are accurate than one big one full of anomalies.

▲ **Diving in Head First!**
This woman was slipping slowly forward down the window. Subtle position changes are most obvious when drawing the facial features (and glasses reveal the slightest alteration). One technique I use to combat this is to finish drawing the head before moving on to the body. Be careful to accurately observe the angle of the chin and eyes.

Sailor fountain pen, black ink

▲ **Finding the Center**
Working quickly in case he woke, I plunged straight into this sketch without giving enough thought to the position on the page. If you are drawing a complete figure and don't want to chop the feet off, it is a good idea to take a moment to give yourself quick guide marks. You can centralize your subject on the page by first holding your pencil vertically in front of them to work out where their center point falls—it's often not where you expect.

6B graphite stick, watercolor

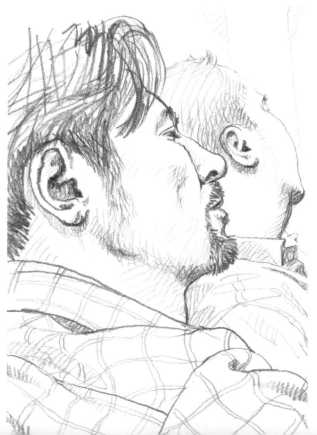

▶ **Sitting in the Best Position**
You don't have to wait long before people start to doze on a plane, but for the widest selection of sketching options, it's important to book an aisle seat. That way you get a close-up view of your row and the row across the way, plus the long views down the aisle in both directions.

3B pencil

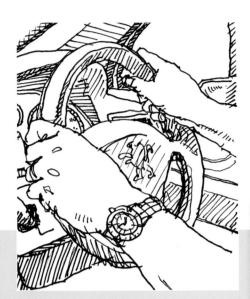

◀ Practicing Hands

There is some variation in a driver's hand positions, but not too much since they have to keep both hands on the wheel, so you have some time to capture the position. Be careful, though; I was focused so much on the hands in this sketch that I managed to shrink the steering wheel down to toy size!

Black fineliner

In the Car

The car is a great place to practice drawing people—as long as you are not driving! Everyone is belted in, so you are guaranteed they will not move too much and certainly won't wander off. The driver, in particular, is a great subject, as their pose is especially fixed.

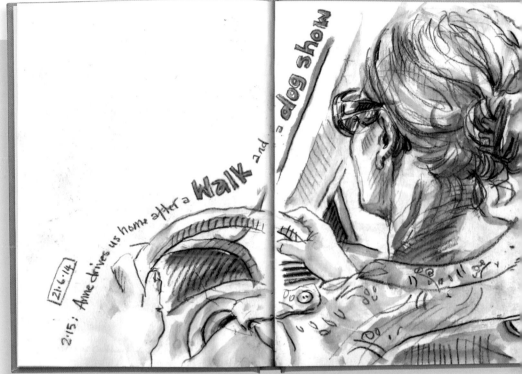

▲ Practicing Back Views

From the backseat, you get an unusual viewpoint for drawing the driver. It's a good time to practice drawing hair and ears from the back. It's important to get the face molding right. Notice how just the eyelashes are visible.

Watercolor pencils, waterbrush

Thinking Laterally

On long journeys, the benefit of nothing changing can work against you, as you can run out of things to sketch, so don't forget the mirrors.

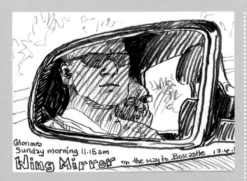

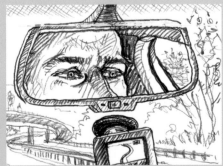

■ From the backseat, the door mirror provides a new view of the people up front and even fellow passengers. It's a good idea to draw in the actual mirror shape for context and because the top of your subject's head will otherwise be strangely missing.

■ When you are in the back of a taxi, the rearview mirror is interesting, as you get the driver's eyes juxtaposed against the view of where you are heading. He or she will be very still, since they will (hopefully) be keeping their eyes on the road!

▼ Two Positions

Book readers generally only move their heads. They alternate between two positions: one for each side of the book. You can either wait until they keep returning to your position, or work on two sketches side by side.

Watercolor pencils, waterbrush

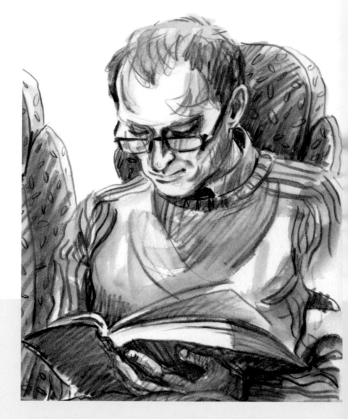

▼ Multiple Positions

You can read a newspaper in so many ways. People often start out with it open on their lap, but might fold it over, which will suddenly mean different arm and hand positions. Sometimes they fold it up even smaller, usually to focus on a puzzle or crossword. I was lucky to get time for this level of finish.

Watercolor pencils, waterbrush

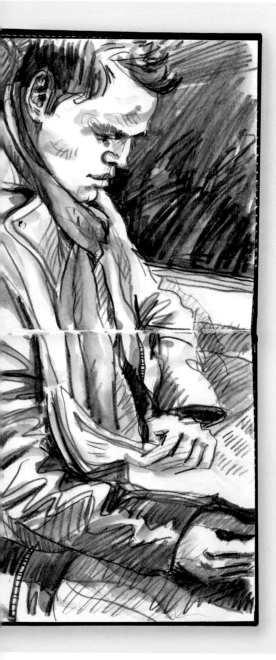

Reading

People who are reading are not looking in your direction. They are usually pretty absorbed and generally staying put, for a while at least, all of which is good news for a sketcher. They don't keep entirely still, however. To make your life easier, always choose someone reading a book over a newspaper; newspaper readers move a lot more. It's also unlikely that someone will finish a book while you are mid-sketch, but some readers skip through newspapers and are done before you are.

▶ Heads and Hands

Because of the larger format of a newspaper, the reader has a multitude of head positions. Their hand positions vary a lot, too, especially with an open paper, which is more awkward to hold. I used a graphite stick to grab a two-minute impression before he moved.

6B graphite stick

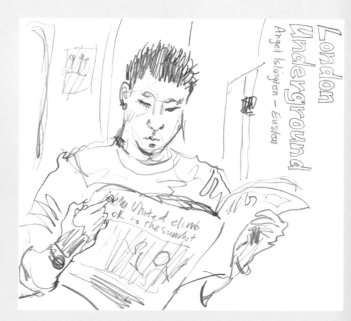

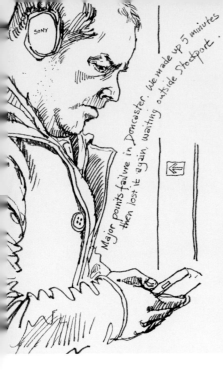

Texting

◄ **Oblivious**
This man was standing up on a train next to my seat. He was so focused that he never realized I was sketching him. Having headphones on was an added bonus, as he was truly in another place!

Black fineliner

Sketching people who are texting is a very good place to start because there are few other activities in which people keep quite so still. Only the fingers move, and then usually only the fingers on one hand. The other huge advantage is that, because a phone screen is small, people narrow down their field of vision and become unaware of what's happening around them. This means you can sit right opposite to draw them, and they will probably not even glance up at you.

◄ **Focusing Attention**
Carol Hsiung does not waste her line on things that do not interest her, but glides from one area of focus to another, tracing shapes as she goes and linking the elements of interest. Her sketch's focus on the texters conveys a sense of their own intense concentration.

Pen, black ink

▼ **New Positions to Try**
It might not be polished, but Marina Grechanik's fluid line has speedily caught the essential lines in this pose, conveying the way one arm supports the other and the different ways the fingers wrap around the phone.

Watercolor, watercolor pencils, Lamy fountain pen

◄ **Waiting**
People use any little bits of spare time to text or check their phones. In any waiting room, there is likely to be at least one person staring at a phone. When you enter a space, do a quick scan to spot them, then sit down as close as you can get.

Sailor fountain pen, black ink

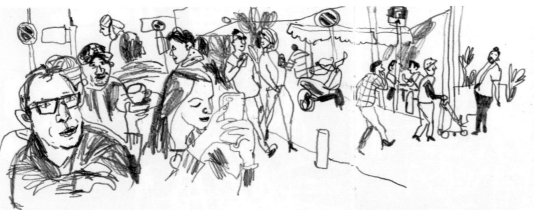

◄ **Hands that Keep Still**
There is a lot of movement in Marina Grechanik's drawing, but the texter at the front is static as ever. Her hands are also in an interesting position. Even if texters move their hands, they are likely to resume the original pose if you wait. Great for hand practice!

Graphite pencil

Eating and Drinking

Cafés and bars provide a relaxed atmosphere for sketching, and people will be in very natural positions. Be slightly wary of sketching strangers in restaurants, however—you are more likely to be challenged, as there is a greater expectation of privacy than in some other places. With this in mind, unless you are drawing friends or family, lunchtime is a better time for sketching than the evening meal. As a rule of thumb, the more formal the setting, the more discreet you need to be.

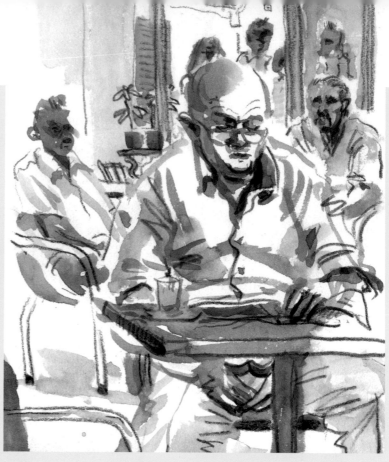

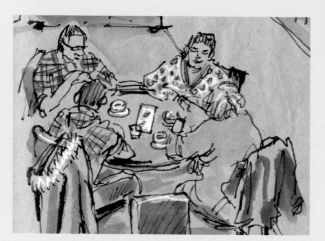

◀ Vantage Points

This café had a balcony. If you can find a vantage point above your subject, you not only get more interesting angles, but it also allows you to study people closely rather than having to steal glances.

Sailor fountain pen, black ink, watercolor, white Conté

▲ People on Their Own

With practice, you learn to spot people who are likely to keep still. This bar was full of old men, each at his own table. People on their own are far easier to sketch, as there is no animated conversation. It's still a good idea to build the sketch quickly, capturing simple impressions, as anyone could leave at any point. Notice the man at the front has three hands—he moved halfway through the sketch.

Watercolor, watercolor pencils

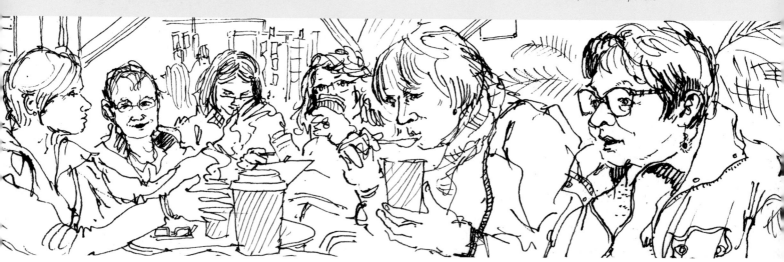

▲ Conversation

When eating or drinking, people move a lot, but luckily, they tend to repeat very similar positions. The main difficulty is that people in groups also chat. Watch people in conversation, and you will be amazed at the constant and varied movements of hands and heads. You have to build things up, snatching elements and positions as they appear.

Sailor fountain pen, black ink

▶ **Drawing Around the Table**

When out with friends, it can be fun to record everyone at the table. Lapin is the master of this, playing with scale and perspective, and using various techniques to fit everybody in. The inclusion of his own hands and the exaggerated scale changes create the impression that you are looking around the table through his eyes.

Watercolor pencils, waterbrush

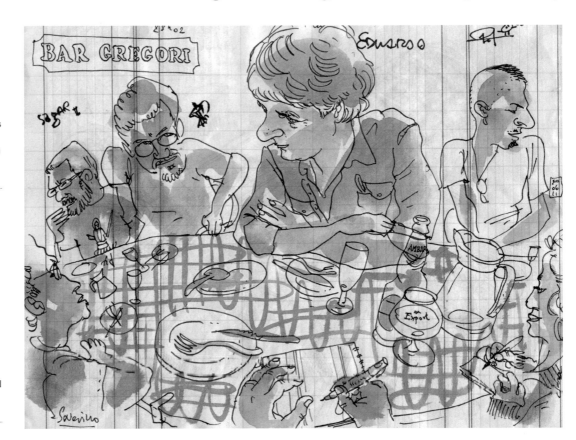

▼ **Creating the Setting**

It is useful to include interesting features of the setting, such as the tree and balcony in this café, but it is not necessary to draw all you see in order to create a sense of place. This sketch by Laura Murphy Frankstone only offers an impression of the tables and chairs; the figures are allowed to dominate the foreground.

Brush pen, watercolor wash

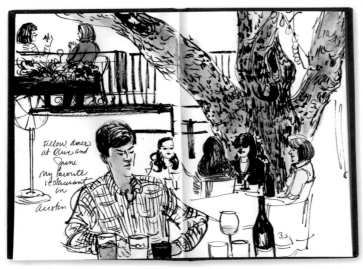

▶ **Loose Impressions**

If people are moving a lot, don't feel you have to capture all the detail. A quick impression—just part of a person's expression or gesture—can still tell a story. Anette Grimmel's use of deliberately loose, wet watercolor creates a great backdrop for adding linear elements as they come along.

Rollerball pen, watercolor

▲ Blending in

Street games provide a great opportunity to sketch. You can blend in with the other observers, and everyone is too interested in the game to pay you much attention. People have their own way of standing, so they tend to repeat the same positions. The man in the foreground was a montage of several people who held the balls that way before play.

Watercolor pencils, waterbrush

In the Street

At first glance, the street might seem to be a place people are just passing through, but if you keep your eyes open, you'll find all sorts of activities and characters to draw. There are plenty of nooks and crannies if you want to keep a low profile, but because the street is a public domain, you'll find people rarely have a problem with sketchers.

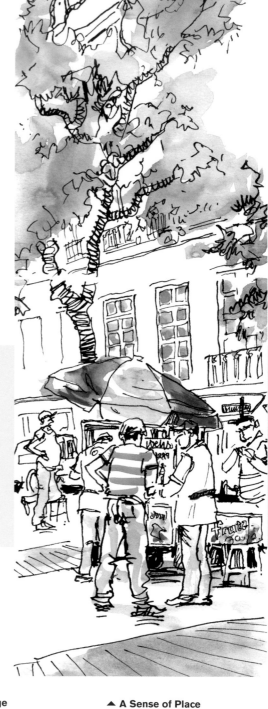

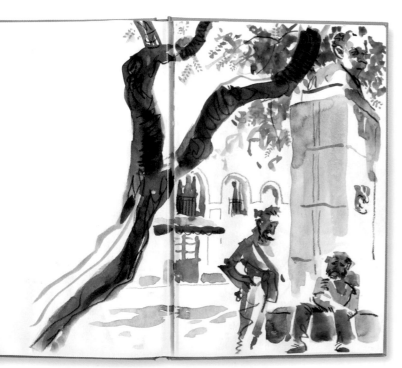

◀ Body Language

I came across these men drinking in the street in Barcelona, Spain. I used watercolor to sketch them very quickly, as I was unsure of their reaction if they spotted me. Luckily, I didn't need detail, as simple body language conveys character—you can tell from basic body angles that the standing figure was more aggressive, the seated man submissive.

Watercolor, watercolor pencils

▲ A Sense of Place

A street vendor like this one is the perfect subject. He was not too busy, so there was time for him to stand and chat, holding one position. Keeping the figures small allowed me to create a sense of place, with the tree and buildings behind. I was pleased to catch the man running, as this makes the street seem more alive.

Sailor fountain pen, black ink, watercolor

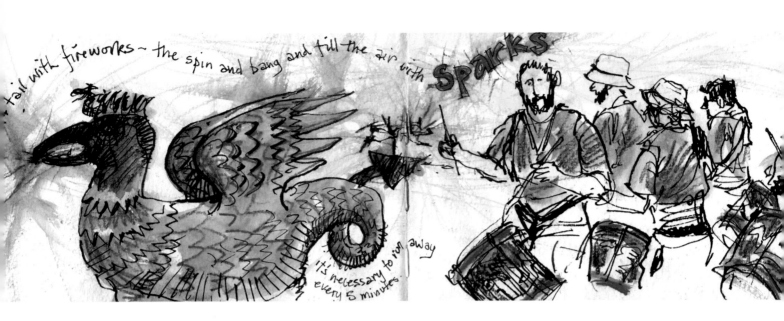

tail with fireworks ~ the spin and bang and fill the air with SPARKS

it's necessary to run away every 5 minutes.

▲ Moving with Your Subject

I love the challenge of trying to capture a moving target, such as a parade, but you need to be tenacious. To make it possible, I focus on a specific section of the action and move slowly along with them while I draw. The fireworks added an extra challenge to this sketch!

Sailor fountain pen, black ink, watercolor pencils, waterbrush

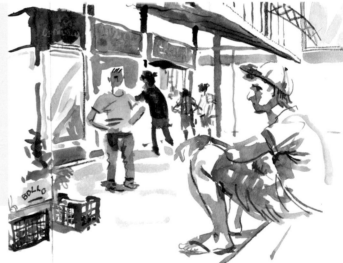

▲ Incidental Details

Keep your eyes open: Often, it is people you happen upon around the edges of the action who are the most visually interesting. This youth was resting outside of a busy market in Barcelona, Spain. Part of the joy of urban sketching is the celebration of the ordinary, bringing little moments of "nothingness" onto center stage.

Watercolor, watercolor pencils

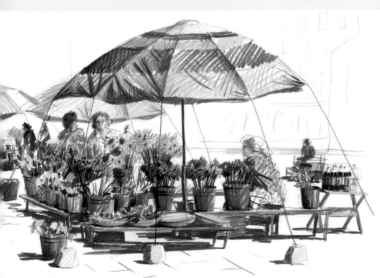

▲ Street Markets

Street markets are full of atmosphere, and flower markets, like this famous one in Krakow, Poland, are also absolutely full of color. One useful technique is to draw most of the background first, but watch where vendors and their customers tend to stand or sit, and leave space to insert them when you are ready, finishing the background around them.

Colored pencils

Things to Remember

- Parades are full of local color.
- Keep your eyes open for interesting characters hanging around.
- Think about the orientation of your sketchbook—a street scene can be very long or very tall.
- Keep a low profile: Tuck into doorways and alleys.

Hairdressers

It is impossible to be secretive while drawing at the hair salon; it is too small an environment. It is still a great venue, however. Apart from the fun of the mirrors, which give you all sorts of multiple views, the clients in the chairs keep fairly still. The hairdressers move a lot more, but you'll find they have a limited range of positions, which they alternate between.

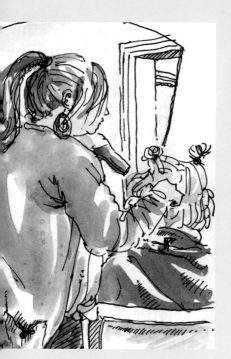

◀ Moments of Stillness
The nature of a hairdresser's tasks means that, though her hands might be in motion, she tends to hold each body position for several seconds at a time. I recorded things quickly with my pen and added the watercolor at home later to help bring out the shapes.

Black fineliner, watercolor

▶ Self-Portrait
Having highlights done involves a wait of around 30 minutes while the color sets. This provides the perfect sketching opportunity. If you are nervous about drawing the other people in the room, try an unusual self portrait with the salon reflected behind.

3B pencil, watercolor

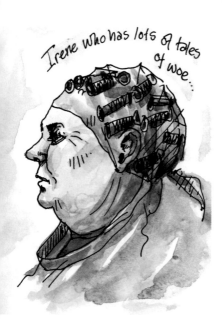

◀ Waiting
There is a lot of waiting around during a trip to the hair salon. I find that during "neutral" periods like this, when people are killing time, they are usually more relaxed about being sketched.

Black fineliner, watercolor

▶ Paraphernalia
It's often easier to judge body angles when people are interacting with objects. It also makes a sketch more interesting. Some years ago, in a small town in Hungary, I discovered a hair salon with this wonderful old-fashioned hair dryer.

3B pencil

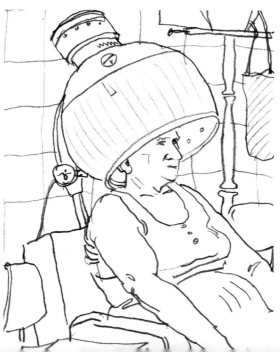

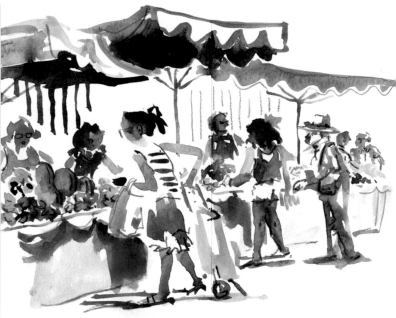

▲ End of Day
When a market begins clearing away, things are calmer and easier to draw. Shoppers drift home, so there are just the stallholders, who come out where you can see them better, to pack up their goods. A simple pencil is good for speedy sketches like this.

3B pencil

Markets

Markets are a visual feast, but quite a challenging place to sketch. There is so much going on and the people are constantly moving around and standing in front of you. It helps to focus in on a small area. It's also important to find a space to tuck yourself into, somewhere out of the way. This makes it less stressful for you, but will also prevent you from irritating the stallholders and shoppers.

▲ Different People in the Same Position
Sketching in elements of the background and stallholders first creates a framework for the figures at the front. Watercolor is useful for rapidly recording the shapes of arms and legs. Don't worry if people move away too soon. If you wait, someone new will stand in roughly the same place.

Watercolor, watercolor pencils

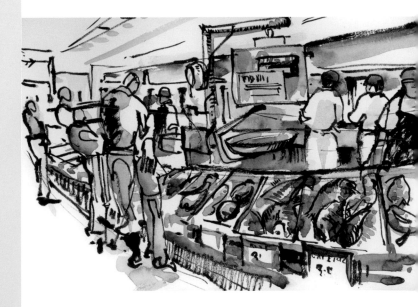

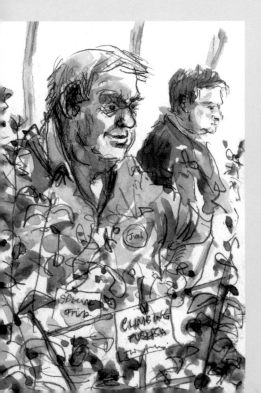

◀ Using the Goods as Markers
Stallholders are often partly obscured by their wares. This makes it easier, as you have only the top half to worry about. The goods stay still, so you can use them to help judge the sizes and shapes of your sellers, who will often return to the same place to serve each shopper.

3B pencil, watercolor

▲ Keeping Out of the Way
When sketching in markets, you don't want to get in the way of shoppers, or nobody will be pleased. Tuck yourself against a wall in an indoor market. Rough in the stall shapes to sketch shoppers against as they come and go, then fill in the stalls and goods properly when you have enough people, as with this fish market painting by Suhita Shirodkar.

Brush pen, watercolor

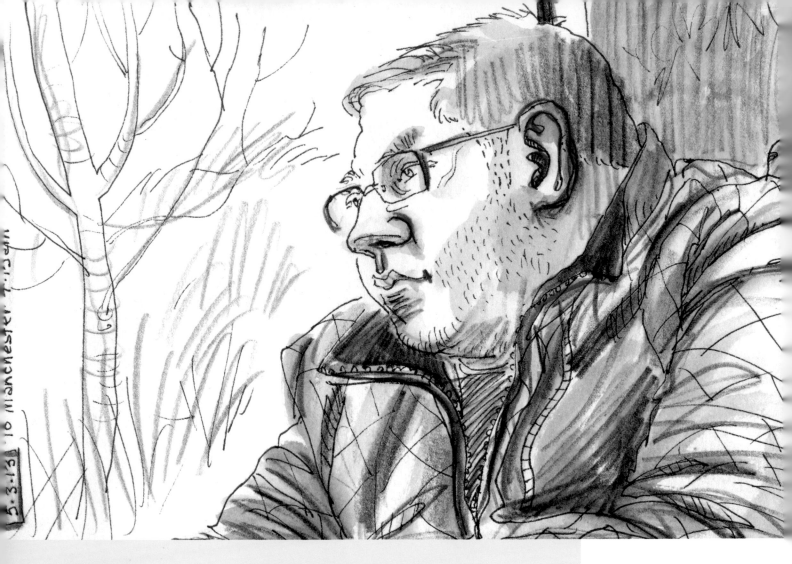

5·3·13 10 Manchester Piccad...

Strangers on a Train

I travel by train regularly, which is handy because of all the places I've tried sketching strangers, trains have proved to be the easiest and most varied. If you choose an aisle seat, you get a great view: a range of random people from all different angles in a variety of positions. If you travel between cities, most people will stay put for a fair while, too.

If you want to draw the detail in people's faces and clothes, you need to get reasonably close. You also need them to sit pretty still. A train gives you license to sit close to complete strangers, and as long as you avoid people chatting with friends, obvious fidgeters, and small children, you'll find passengers make very good life-models. Trains are usually a smooth ride, too, so it's more practical for drawing than a bumpy bus.

If you travel on commuter trains, there's a good chance some of your neighbors will be working. When someone's attention is focused on a task, they tend to notice very little else, so it's easier to sketch them without being noticed. Even if people are traveling for leisure, getting from point A to point B is usually considered "dead time" rather than personal time, which means that, if you are discovered, they are usually fairly relaxed about being drawn.

Another bonus is that your pool of models gradually changes over the course of your journey. It is annoying when your subject gets off halfway through your sketch, but someone fresh will take their place: something new to attempt.

▲ A Longer Format
A landscape-format sketchbook is great for capturing a train car. It's good to choose an angle with a little perspective if possible, as diagonal window lines create a more interesting composition than horizontal ones. I drew with a fineliner first, but it looked too spidery and flat, so I quickly picked out the shadowed areas with color. Using a waterproof fineliner allows you to blend your watercolor pencils with a waterbrush.

Fineliner, watercolor pencils, waterbrush

▶ Watercolor Pencils
Watercolor pencils are perfect for quick but expressive sketches. You can keep your marks bold, knowing they can be softened at the end with a touch of water. It's important not to overdo the water-blending; you don't want to dissolve the original marks, but allow the pigment to bleed out, creating areas of wash over the top, to complement them.

Watercolor pencils, waterbrush

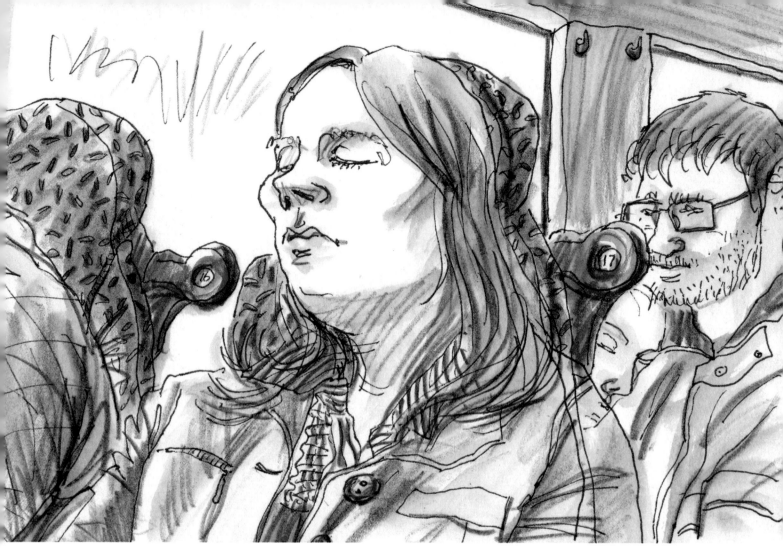

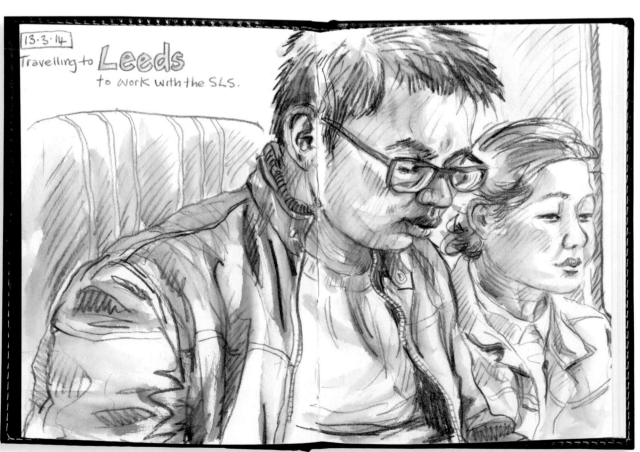

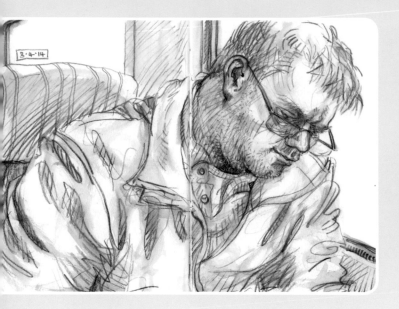

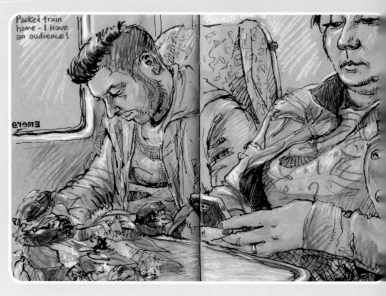

1	2	3	4	5
6	7	8	9	10

1 Leaving Out Some Detail
A sketch doesn't need the same level of detail all over. This can help to save time if you think a person might move. Or it can be a device you use to focus attention on particular areas. Notice here how the face is closely worked, but the clothing is sketched more freely, providing an impression rather than precise information.

Watercolor pencils, waterbrush

2 Mixing Media
It is fun to experiment with different media together, but if you're using a pen, it's often good to do that part first, as some media will clog your nib. The black ink here creates a good, strong contrast with the gray paper. When working on tinted paper, it is useful to carry a white pastel pencil to provide highlights. This is usually the last thing I add.

Sailor fountain pen, black ink, watercolor pencils, waterbrush, white pastel

3 Working Quickly
A graphite stick glides beautifully across paper, so it is great for speed-sketching. You need to be especially quick on the subway because people are on the move every couple of minutes. If it's full— as it often is—passengers will also come between you and your subject. You need a fast hand and a relaxed state of mind!

6B graphite stick

4 Keeping Color Clean
I particularly like drawing profiles, so I'm always hoping the person across the aisle will be sufficiently distracted. I used just three pencil colors to create this and was careful not to use all three together, except to create the deepest shadows, otherwise the sketch can get muddy and overworked once water is applied. Notice how the hatched shading lines follow the contours of the face, direction of hair, and weave of the knitting.

Watercolor pencils, waterbrush

5 Composition
How you frame your sketch on the page can make a big difference. Close cropping adds real impact. The negative space on the right is important as a balance to the composition; filling the entire page can make the sketch confusing. Note how the vertical text is also part of the composition (I often ask people's names if they ask to see my sketch).

Watercolor pencils, waterbrush

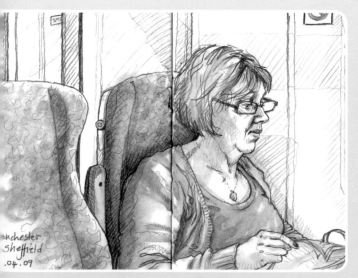

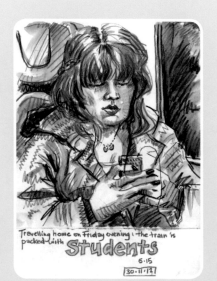

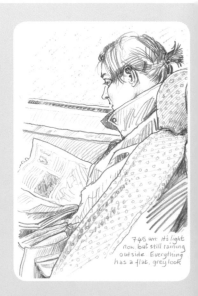

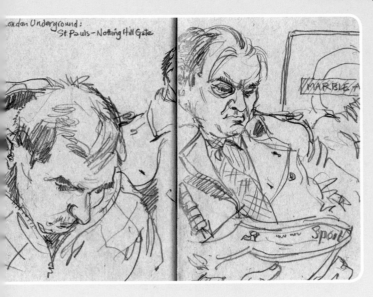

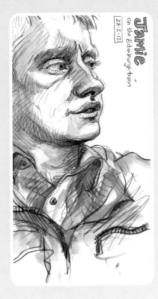

6 Using Negative Space

It is the passengers, not the train interior, that interest me, but drawing some background helps to tell the story and make your people more believable, too. Watch how the train structure can help you see more accurately: The vertical line in front of the woman makes it easier to judge the shape of her profile because the negative space acts as a double-check.

3B pencil, watercolor

7 Selecting Your Subject

Even though she was sitting opposite me, this woman didn't notice I was sketching her because her attention was so fixed on her phone. Before you begin drawing, scan the people around you and look at what they are doing. Is it something that will distract their attention? Is it an activity that is likely to last? I rarely draw somebody who has just gotten on the train—it's best to allow them a few minutes to settle in, as most people fuss and fidget at first.

Watercolor pencils, waterbrush

8 Choosing a Pencil

A soft pencil is very versatile. I use a 3B because it is soft enough to allow dramatic marks and rich black shadows, but with a sharp tip and a lighter touch, you can create delicate shading and fine detail, such as the rain on the window. Adding the weather helps to give the sketch atmosphere.

3B pencil

9 Adding Color Later

If you're traveling light, you can add color later. This frees you from the colors that are actually there. Choose colors you think will work, rather than worrying about remembering accurately. You can experiment without the risk of ruining the original sketch by scanning it and tinting digitally. You don't need to color the whole sketch—some areas of white prevent overworking.

3B pencil, digital tint

10 Capturing Posture

I worked from right to left, keeping the pen on the paper as much as possible, using the seat backs and window lines as guides for the size of heads and shoulders. Even when working quickly, it's crucial to look carefully at the shapes: Subtle differences in the head angles and lengths of neck capture different postures. The variable width of the ink line adds life and visual variety to the drawing.

Sailor fountain pen, black ink

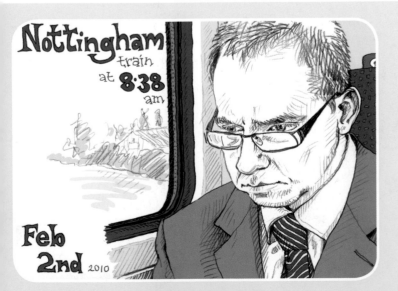

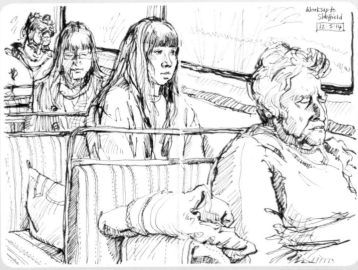

3

Different Styles and Approaches

There are no rules about how to sketch, and there are countless different materials to choose from, which can be both exhilarating and bewildering. Most people start off by trying to create as realistic a representation as possible, but, particularly when you are sketching people, this is not always practical. It also denies you the fun of self-expression. As well as the exploration of materials and the various techniques for using them, there are also different ways in which you can view the world and frame it on your page. Through continual experimentation and practice, a style of working that suits your personality will gradually evolve.

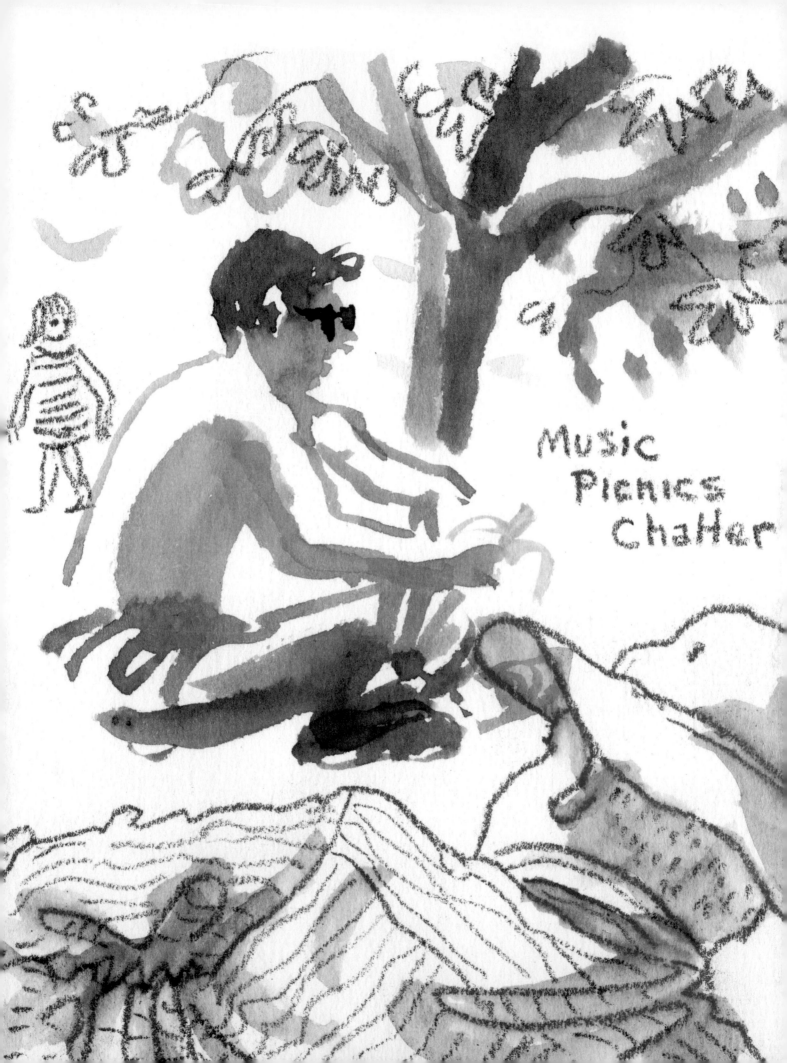

Music
Picnics
Chatter

Less Is More

Every sketcher knows the disappointment of an overworked drawing. It's often hard to know when to stop. One important thing to bear in mind is that you don't have to draw everything you see. Learning how to identify and capture only the essentials is particularly useful when sketching people because of the need to be quick.

Resisting the urge to overstate things is tricky. It can be surprising, though, how little information you need; our eyes are practiced at filling in any gaps. This applies when you are drawing figures and faces, but is something to bear in mind when sketching in backgrounds as well. There is, of course, nothing wrong with creating very detailed and complete drawings of both characters and settings, if that is where your interest lies and there is time. However, if you just want to give your characters

context, a great deal can be suggested with only a few carefully chosen lines.

It is also handy to remember that the white paper is an active part of your sketch, and it will provide your lightest tones. It can also serve as a useful contrast or as highlights in darker or more heavily worked drawings. I like to let glimpses of white paper dance throughout most of my sketches because this lends them a lightness of touch. Try not to drown out your paper through overworking. Experiment by allowing the white to show between your marks when you color.

In many places, the paper has deliberately been "missed." This creates an overall airiness, preventing the sketch from getting stodgy

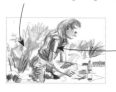

The white paper here provides highlights, communicating the strong sunlight

▼ Letting the Paper Breathe
Water has been used here to blend the colors, turning a line drawing into a painting, but the brush marks are understated so plenty of paper is left showing through the coloring of both the figure and the undergrowth.

Watercolor, watercolor pencils, waterbrush

Painting the negative space, rather than the room, creates a more interesting balance of shapes. Echoing the mustard in the shadows ties the outdoors to the interior

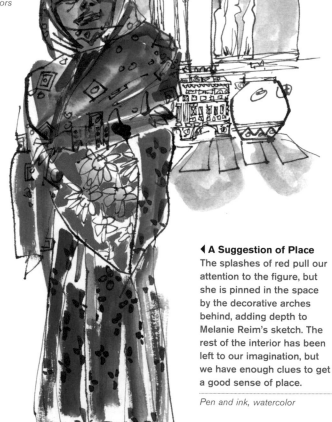

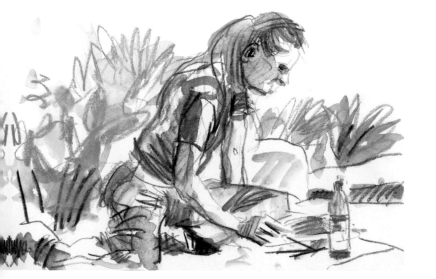

◀ A Suggestion of Place
The splashes of red pull our attention to the figure, but she is pinned in the space by the decorative arches behind, adding depth to Melanie Reim's sketch. The rest of the interior has been left to our imagination, but we have enough clues to get a good sense of place.

Pen and ink, watercolor

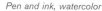

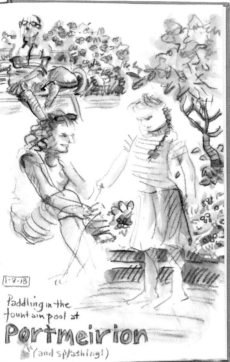

Despite the lack of detail and the woman's crudely drawn arms, the body lines convey all we need to know

▲ Capturing the Essentials
These quick sketches of paddling children are missing lots of information, but it doesn't matter. As long as the body angles are well-observed, our eye barely notices and is happy to fill in where needed. Keeping the drawings spare also helps them to feel animated.

Watercolor pencils, waterbrush

▼ Simplicity of Line
Here, so much is communicated by Shukri Sindi with so little. We feel the weight of the sleeping body, the push of her hands in her pockets, the quilting of her jacket. This is obviously a lightning sketch where time ran short, but it demonstrates how effective a simple, but well-chosen line can be.

India ink Pitt pen

Notice how pleasing it feels for our eye to join up the space across the top of her head rather than having it drawn in

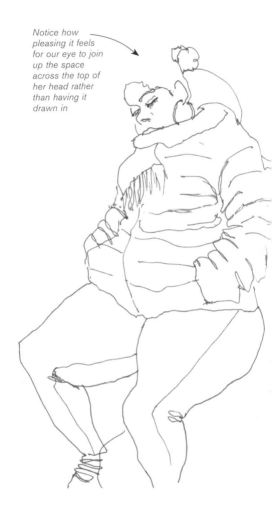

▼ Broad Statements
The beauty of Catherine Brunet's sketch is the way it is built with broad strokes, so that all the detail is inferred rather than shown. Catherine could have worked into the painting, but chose to leave it simple. Knowing when to stop is one of the most difficult things, and we all get it wrong sometimes.

Pencil, watercolor

You can make out facial details in the undersketch. Instead of pulling these out, one simple brush stroke creates a pool of shadow

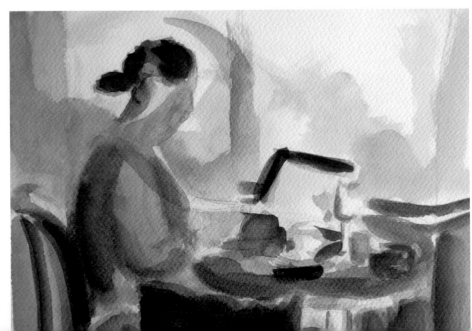

Things to Remember
- You don't have to draw everything you see, only what you need.
- Understated figures generally have more of a sense of movement.
- It's usually a good idea to leave white paper showing in places—let the paper breathe!
- A background can be suggested with just a few carefully chosen details.
- Some elements don't need to be drawn in. Our eye enjoys "joining the dots."

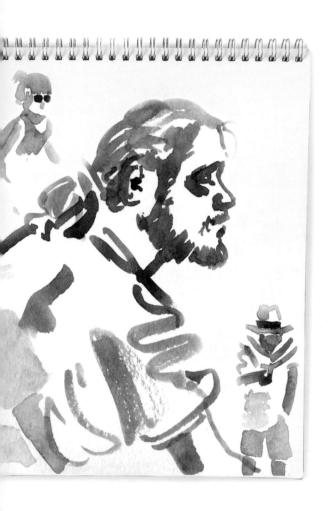

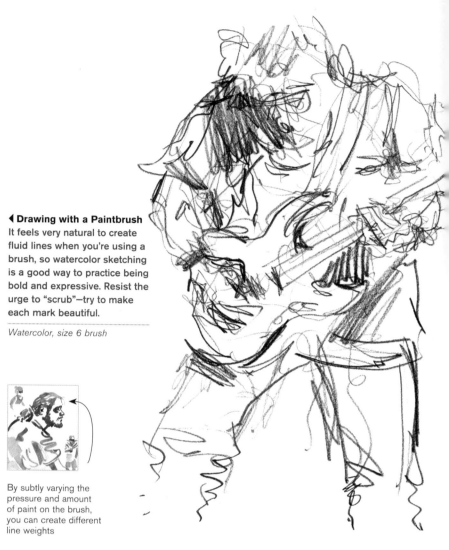

◀ **Drawing with a Paintbrush**
It feels very natural to create fluid lines when you're using a brush, so watercolor sketching is a good way to practice being bold and expressive. Resist the urge to "scrub"—try to make each mark beautiful.

Watercolor, size 6 brush

By subtly varying the pressure and amount of paint on the brush, you can create different line weights

Fluid Lines

One common mistake sketchers make when drawing people is to use straight lines. Look more carefully, and you will discover that most of the shapes you encounter, whether individual limbs, clothing, facial features, or overall body lines, are curved. Straight lines make your figures stiff. Instead, exaggerate the curves. If you create lines that undulate and flow through your sketch, you can add life and movement to your characters.

Take a moment to watch how you move your pencil when you draw. If you use principally the thumb and finger that are actually holding the pencil, your marks are limited to short lines and tight circles. Lift your arm from the paper and pivot at your wrist to get a much broader range of movements and a bolder, more intuitive line. If you have a slightly larger sketchbook, 8¼ × 11¾ inches (A4) for example, try using your whole arm up to the shoulder, bending your elbow as well as your wrist. If you find this way of drawing difficult or intimidating, play on a scrap of paper, drawing abstract swirls and undulations.

Another good technique for creating a confident and fluid line is to keep your pencil moving and in contact with the paper for longer periods. Hesitant sketchers often build up an image with lots of small, individual lines. This feels less scary because you don't have to commit to any one line being right. However, for stronger drawings, a single, more expressive line can get to the heart of the subject. It's something you have to practice. Your line won't always be accurate, especially at first, but this technique will eventually take your drawing to a new level.

Blocks of cast shadow are applied in the same animated way as the line and help to keep things three dimensional

◀ Shading from the Elbow
There is very little specific definition in this drawing, but the fluidity of the mark-making communicates the energy and movement of the subject. The vigorous shading is created by drawing with the whole arm and keeping the pencil on the paper.

6B graphite stick

▶ Non-Straight, Straight Lines
You might think the angles created by this man's position would require straight lines, but to avoid stiffness, a straight line can still be fluid. Note the subtle "wriggles" in the lines of the legs and torso, describing the clothing and retaining the sense of potential movement.

Watercolor pencil, waterbrush

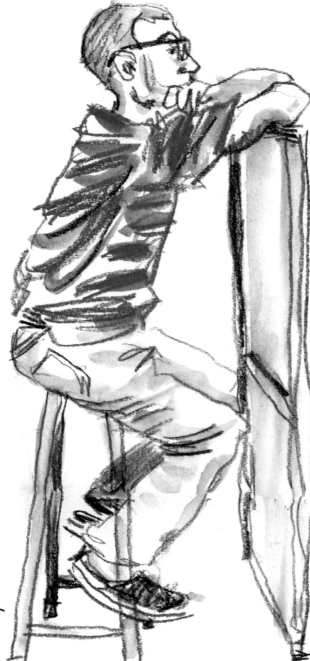

The sole of the shoe is curved, conveying the leverage against the stool's crossbar

▼ Continuous Line
Notice how few short lines there are in this drawing. The pen glides around the subject, describing only the essentials, in long, flowing lines, which loop back and forth. This was a two-minute sketch. Setting a time limit can really focus your hand–eye coordination.

0.5 fineliner

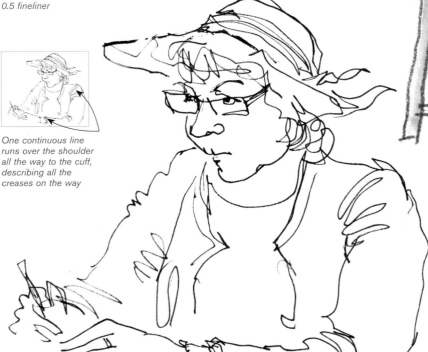

One continuous line runs over the shoulder all the way to the cuff, describing all the creases on the way

Things to Remember
- Drawing with your whole arm rather than just your wrist helps you to make bolder strokes.
- Keep your pencil moving. A continuous, fluid line has more energy than many short ones.
- Vary your line width for greater expressiveness.
- Try to look at your subject more than you look at your paper.
- A beautiful line is just as important as an accurate one.

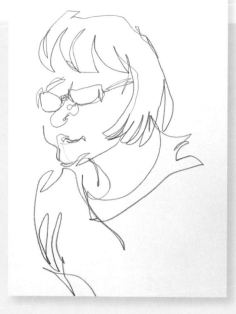

Blind Contour Drawing

A good way to begin your practice is through blind contour drawing because it forces you to keep your pencil on the paper. It's also fun. Get a friend to sit for you, or draw your family watching TV. Cut a piece of paper 2–3 inches (5–7.5 cm) square. Poke a hole in the center with your pen or pencil, so the paper sits about an inch (2.5 cm) above the point (Step 1). It should be impossible to see what you are drawing.

Start either at the top of your sketchbook, drawing from the top of your subject, or in the center of the page, drawing out from the center of the subject (Step 2). Looking at them rather than at your sketchbook, try to "feel" where the line needs to go. Work steadily in a continuous line, letting your eyes talk directly to your hand, and breaking contact with the paper as little as possible (Step 3).

Your results, when revealed, will sometimes be funny, sometimes crazy, but although they are rarely accurate, they often have a truthfulness. The other big advantage is the drawings are quick, so you can work through lots of them, allowing yourself to rapidly get a feel for this more fluid way of working.

Step 1

Step 2

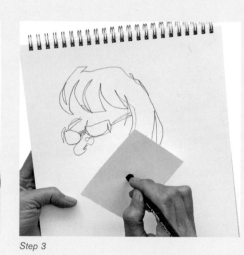

Step 3

▶ Eye-to-Hand Contour Drawing

Once you are used to the technique, contour drawing does not need to be "blind" at all, so you can reposition your pencil as many times as you like. You can still access the bold playfulness of the line, as Benedetta Dossi does in this sketch, if you practice the principle of constant movement, letting your eye direct your hand without hesitating to consider or measure.

Ballpoint pen

The fingers are not created from one continuous line, but still have the bold feel of a blind contour through maintaining an intuitive eye-to-hand connection while drawing

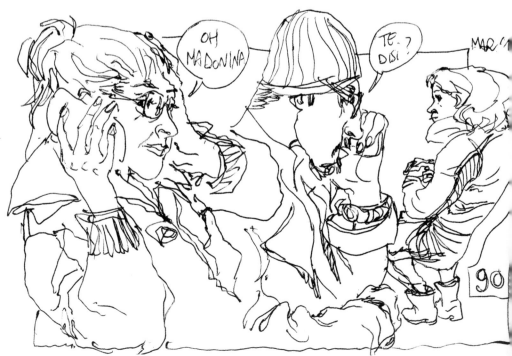

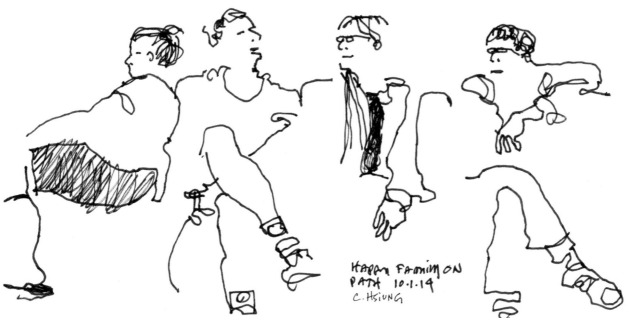

▲ Bare Essentials

This sketch by Carol Hsiung is a beautifully minimal version of a contour drawing. The line meanders from person to person, but only stops long enough to describe parts of each. There are massive areas missing, but your eye fills in the gaps. Note the fluidity with which shoes are described.

Pen, black ink

The shaping of the leg is slightly exaggerated—subtle overstatement of curves can be very effective

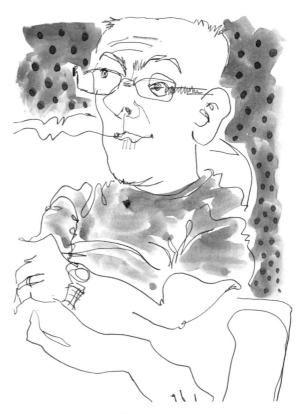

▲ Enhancing Contour Drawings

Because they use little or no tone, contour drawings can look rather "spidery." I sometimes enhance successful ones by picking out small areas with watercolor. It works best if you continue the loose theme, painting quickly and roughly.

3B pencil, watercolor

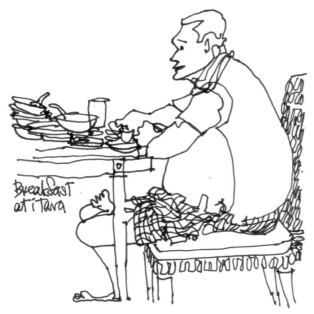

▲ Semi-Blind Contour Drawing

You can use contour drawing any time to help you to achieve loose and expressive drawings, as in this example by Asnee Tasna. A semi-blind system often works well; allow yourself to look at the paper when repositioning the pen, but otherwise concentrate on the subject alone. That way, you continue to draw instinctively, but have a greater control over the drawing as a whole.

1.0 gel pen

Note the continuous line along the profile and hair

The spotty pattern adds an additional texture, so the overall effect is more varied

The misjudged areas and odd proportions are a big part of the appeal of blind contour drawing, so don't worry about getting everything right

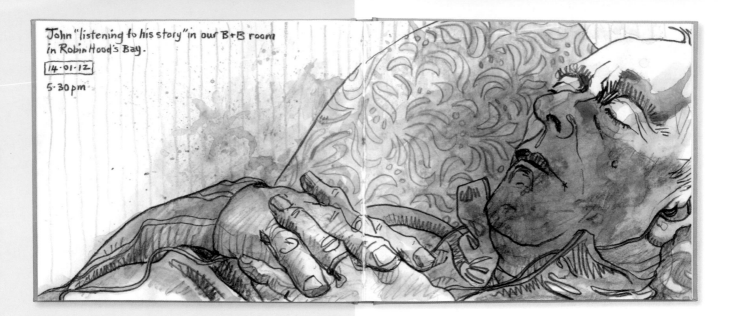

John "listening to his story" in our B+B room in Robin Hood's Bay.

14·01·12

5·30 pm

Creative Coloring

Many new sketchers are afraid of color. They often stick to black and white because they are not sure what to do with color. This is understandable, since our surroundings are a complex soup of thousands of subtle variations of colors, and if you are already nervous of your people-sketching skills, it might feel like a step too far. It is a shame because whatever your drawing skills, color is, in fact, a great place to have fun.

The trick is to release yourself from the obligation to be realistic. If we are happy to convert the world to black and white, which is, of course, totally artificial, why should the only alternative be naturalistic representation? There are so many possibilities. Try creating a black line drawing, then highlighting just a few areas using only a couple of colors. Try drawing with a colored line or using lots of different colored lines in the same sketch. Try matching your tonal values to real life, but inverting the colors. Or just go wild with deliberately crazy colors.

Another way to force yourself to think differently about color is to get a sketchbook with tinted, colored, or even black paper. This can be helpful because it removes the dominant white background, and a tinted background provides you with one new color already. White Conté is a great tool for bringing back the white on colored paper and giving you contrast.

Some of your experiments will look better than others, but it will be a voyage of discovery. The joy of a sketchbook is that it is a safe place for this kind of play. However, if you are concerned about the potential for ugly pages in an otherwise controlled book, why not start a new sketchbook purely for trying out new ideas and techniques? Make sure you carry it with you, though, or it won't get opened!

▲ **Splattered Background**

I was bored and wanted to play, so I splattered arbitrary colors onto my book, then drew over the top. The purple coinciding with the face was troubling, so I extended it to tint the shirt and introduced the two areas of pattern to help reduce the purple's domination, matching the blue and terracotta from the underpainting.

Watercolor, 6B graphite stick, watercolor pencil

Reintroducing the blue and brown for the patterned background areas makes the colors look like they belong, even if they are arbitrary

Finer weight

Heavier weight

The line weight is stronger on the figures, pulling them forward and allowing the window view to recede

▼ **Figures Against a Background**

If it is the characters you want to highlight, but you still want to draw in the background to give context, it can be very effective to color only the foreground. The monochrome line work then drops back. The color range here is quite limited, but the watercolor still provides a wide tonal range, from the delicacy of the highlighted areas to the deep shadows on the seat.

Sailor fountain pen, black ink, watercolor

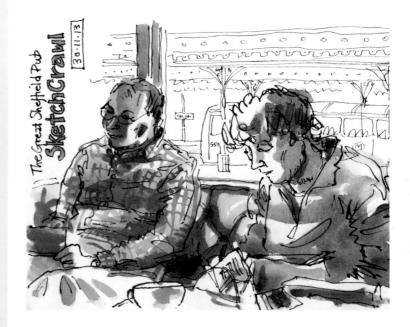

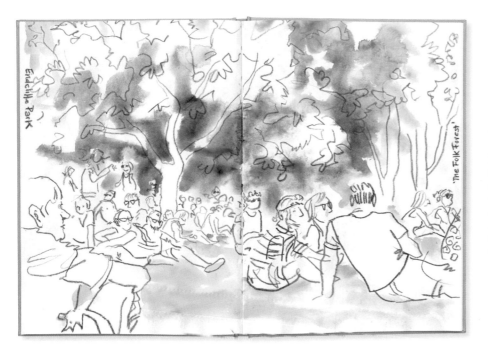

◀ Different Colored Lines

Here, I allowed myself three linear colors only loosely related to reality. The blue was the strongest tone, so I used that for darker areas and avoided it in background areas. The orange was the weakest, so I didn't use that for the nearest figure. Watercolor was washed in at the end to remove more of the white paper and increase the tonal range.

Watercolor pencils, watercolor

Watercolor has been used to shade only the background, pushing the figures forward: The exact opposite approach to "Figures Against a Background" (below, left)

The colors are very minimally blended together to keep things fresh and bright

▼ Crazy Color

In reality, her hair was dark brown. The purple works because it is a similar tone and because the same color has been used for other shadowed areas and for parts of the outline. The contrast with the lime green makes the page zing and arrests your attention so much more than the natural brown hair would have done.

Watercolor pencil, waterbrush

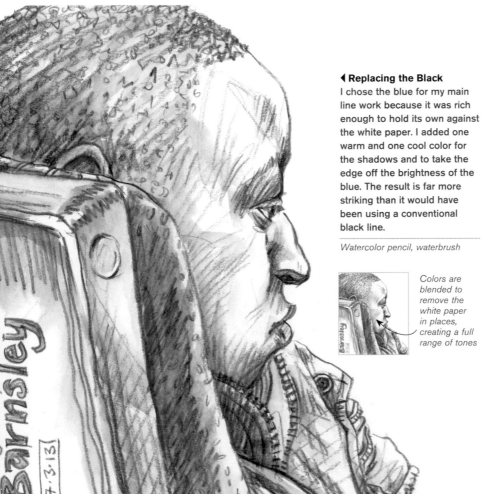

◀ Replacing the Black

I chose the blue for my main line work because it was rich enough to hold its own against the white paper. I added one warm and one cool color for the shadows and to take the edge off the brightness of the blue. The result is far more striking than it would have been using a conventional black line.

Watercolor pencil, waterbrush

Colors are blended to remove the white paper in places, creating a full range of tones

Tutoring session at a cafe

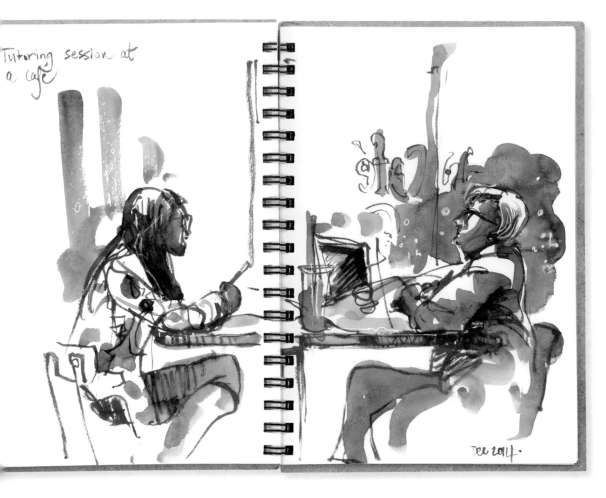

◀ **Limiting Your Colors**
One common mistake with watercolor is to try to use too many colors, which can easily make your sketch fussy or muddy. Suhita Shirodkar uses only three colors here, and they are only barely blended together, and yet the effect is of virtually naturalistic coloring.

Pen, ink, watercolor

White paper is used as a fourth color to describe highlights, and a white line subtly enhances the hair

▶ **Tinted Paper**
The neutral paper allows Takeuma to use really bright colors without them seeming garish. The sketch looks richer than it would on white, especially once the white is reintroduced, since there is a better balance of tones on the page.

Colored pencils

Note how most colors are used in two ways: as both line and block color

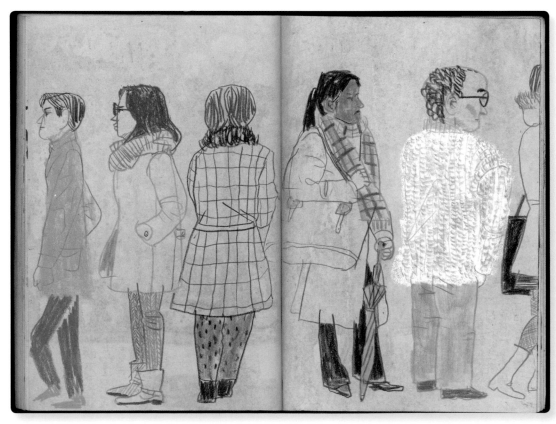

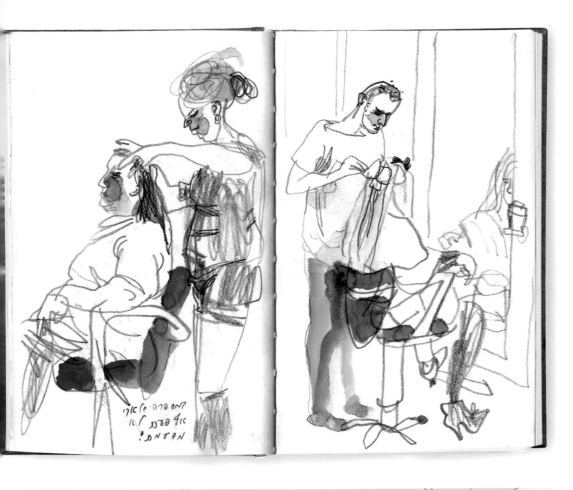

◀ Spot Color

The introduction of just a few spots of quickly applied color completely changes the impact of this pencil sketch by Marina Grechanik. Reusing the same colors in different places on the page ties everything together and prevents the sketch looking "bitty."

Graphite pencil, watercolor

The only color not reused is the blue, which draws your eye to a very pleasing spot in the composition

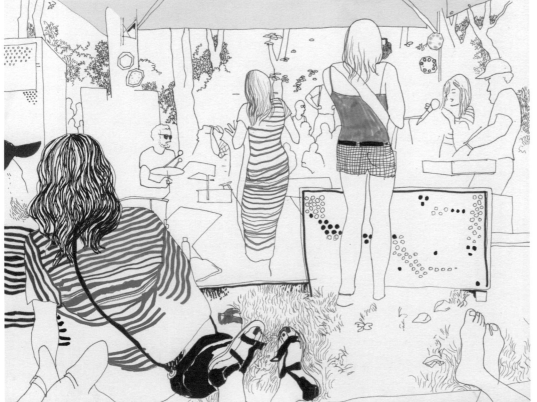

◀ Moments of Illumination

This sketch by Ekaterina Khozatskaya demonstrates how you can use color to pick out a few elements, either to focus the viewer's attention on a specific character or to bring another layer of interest to the composition. Note the different ways that color is used: to flat-fill the cap and purse; as a large area of pattern on the stripy shirt; and as tiny spots on the lights and toenails.

0.2 fineliner, fiber-tip pens

The quite minimal sketch is full of different textures created with a variety of decorative styles of mark-making

Stripes Checks

Painting Before You Draw

A few years ago, fellow sketcher Richard Camara introduced me to a new technique that I have been using ever since. I have found it works especially well for drawing people. It will feel a bit scary to begin with, but with a little practice, it is incredibly liberating and will help you draw more fluid figures that look as though they might walk off the page at any moment!

It feels natural to draw an object or sketch out a composition first and then paint in the color afterward, but if you reverse the process, all sorts of fun things happen. All the sketches in this section were created using this process, and they have a real liveliness, which is hard to create by conventional means.

Mix up three or four colors in advance, so you can work intuitively: a neutral skin color, a couple of brighter colors, and something fairly dark. Before you start, take a moment to look carefully at your subject, at the angles of the limbs and the shapes created by items of clothing or blocks of hard shadow. You are not going to paint it all, so choose the most telling or significant shapes. Don't worry at this stage about shading or detail. Remember: You don't have to use the real colors.

Hard, angular, straight lines

Soft, gestural, flowing lines

1 Where to begin: Start with the shape that most defines the body. I painted the purple first, which will act as a framework for the other colors. Use simple, fluid marks—try not to fuss. You're not trying to paint the exact shape.

Watercolor, 6B graphite stick

2 Building it up: Next, I added the shirt. If you are working quickly and the previous color is still wet, leave a gap between the shapes. It is, in any case, useful to leave a lot of white showing: less is more. The skin tones were next, just approximate shapes with no detail. Getting them in roughly the right position is more important.

Note the use of pinks and blues instead of browns for hair color. This allows me to use a limited palette without things becoming dowdy

▼ **Limiting Your Palette**
Instead of blocking the faces in skin color, I have painted just the shadows. This is more descriptive and makes the faces three dimensional. To do this, try squinting—it simplifies faces to tonal shapes.

3B pencil, watercolor

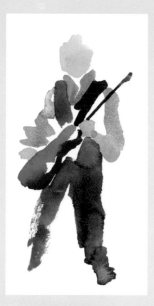

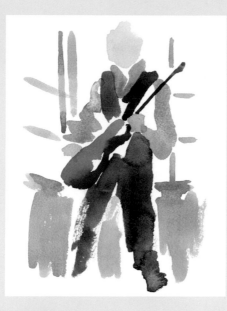

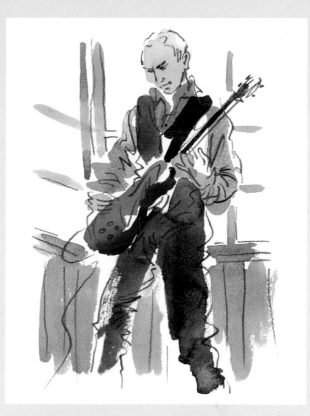

3 The guitar: To help suggest form, I used two colors for the guitar. The lighter orange first but, before that was completely dry, I added a darker tone along the underside, allowing them to run together slightly. I extended this color up for the guitar neck. I deliberately kept the body of the guitar very vague, but was careful to get the neck straight.

4 Background: You don't need a full background, but a suggestion will give your figure context. I used one color, so that the person would still stand out, leaving areas of white paper between the two elements once again.

5 Linework: Look hard at your subject while you draw, correcting any mistakes you made with the paint, rather than simply following the color. Try not to draw unnecessary outlines. Where the paint is in the correct place, let it tell the story on its own. Don't worry about places where line and color don't line up: Getting your line drawing right is what matters, and the vigor of the sketch comes from the mismatch.

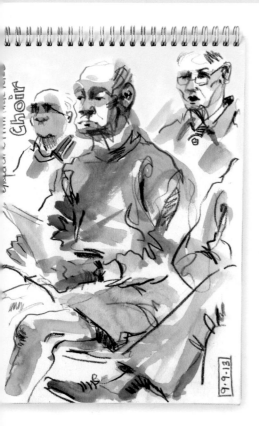

◀ Avoiding "Floaters"
As you become more proficient at this technique, you will find that you rely less on the linework to describe the content. There is no background, and only the receding figures suggest context, but by bleeding off the top and bottom, the sketch is "pinned" and doesn't float.

Watercolor pencil, watercolor

▶ Using Colored Lines
Notice the various different colored lines. This prevents the linework from getting too heavy and allows more sophisticated interaction with the paint colors.

Watercolor pencil, watercolor

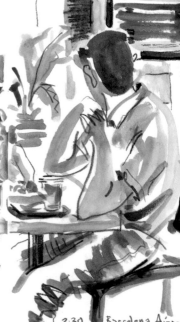

The watercolors more or less match the line colors, keeping things simple and unified

A red line can work well for skin and is particularly useful for defining ears

▶ Limiting Your Line Work

The line has been used very sparingly in this Marina Grechanik sketch, and only on the foreground objects and characters, allowing other elements to fall back. This gives depth and makes the characters stand out from the background. To keep things light, not everything is painted—some things are described in line alone. Notice the mismatch of line and color on the arms, a misjudgment that adds life to the figures.

Watercolor, watercolor pencils

The red and blue lines keep some areas from appearing overworked

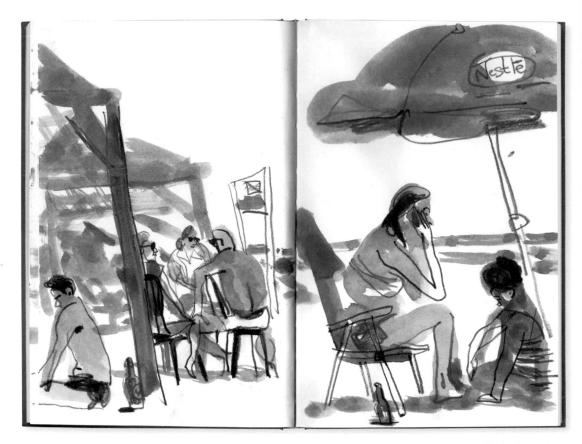

▼ Pastel Instead of Paint

You don't need to use watercolor: Here, Greg Betza has drawn the main shapes in colored Conté, onto colored paper. Drawing means the color can also incorporate linear pattern. The heavily textured paper grips the chalk, but also allows for added texture in the sketch. The ink line is very minimal, just helping to define the edges where necessary. The colored paper creates the atmosphere of a jazz club, and the abstract lines give a sense of the music.

Brush marker, water-soluble crayons, tinted paper

The head shape is described by the red, negative space, sketched in to denote the background

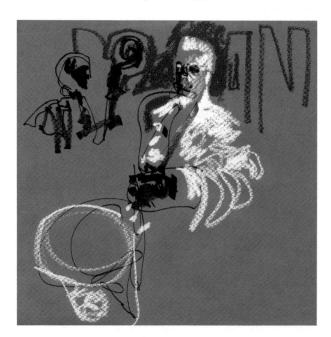

▼ Using Pattern to Define Edges

There is so much liveliness captured in this sketch by Emily Nudd-Mitchell. Notice that the two figures in front have very little line at all; their shape is mainly defined by the pattern on their clothes. By not "tethering" the figures with a hard line, a real feeling of movement comes across. See how little information is needed to describe the faces.

Fountain pen, black ink, watercolor

The background splatters create the impression of music

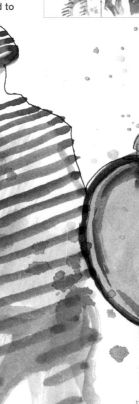

▶ **Filling the Paper**
The color in Rolf Schroeter's sketch has been applied very freely, covering almost all of the paper, which helps to add to an atmosphere of intensity and clutter. The line is almost a contour drawing, wriggling through the space and around the figures. Notice how nothing is square: Instead there is a playful rhythm, which describes the feeling of the space rather than the literal detail.

Fountain pen, waterproof ink, watercolor

The background detail is suggested rather than drawn accurately, with a wonderfully fluid line

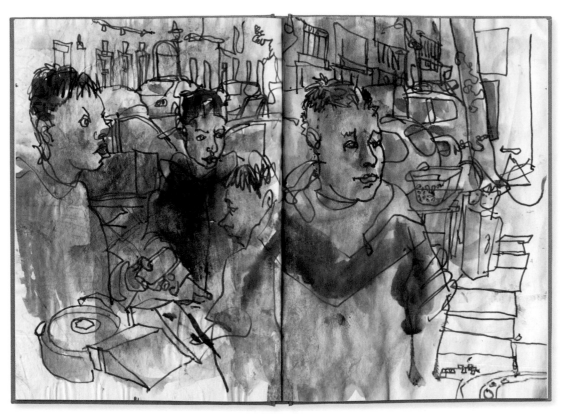

▼ **The Mismatch Creates Life**
Both color and line are very fluid in this sketch, applied quickly and instinctively by Tineke Lemmens, to capture the essence of figures in motion. The result is quite abstracted in places, but very expressive. Because nothing is solid, and the line and color are not conventionally pinned together, the people seem infinitely more alive than a more accurate painting. You can almost hear the music!

Watercolor, watercolor pencils

The red has captured an exaggerated version of the slight lean of the torso and the raised arms. This animates the corrected line work that sits on top

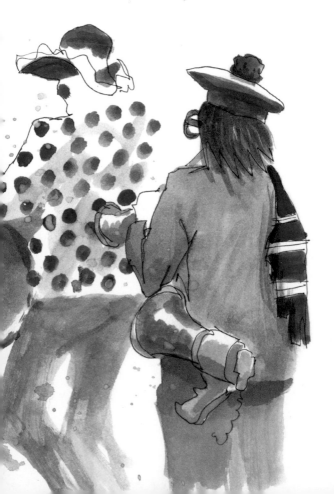

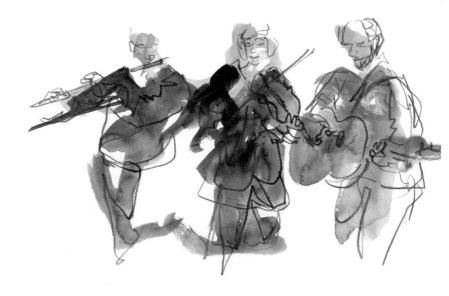

Quick Planning

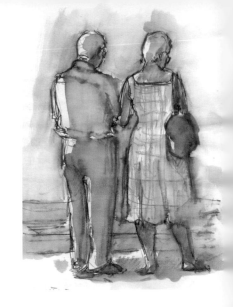

My favorite way of working is to jump straight in, but this does not always work well if your subject matter is complicated or if there is a lot of tricky background detail, like you get with some street scenes. There might be perspective to contend with, it could be hard to gauge how best to frame your subject, or to fit everything you want into the shape of your sketchbook page. There are many situations when it makes sense to do a little planning before you start, and there are various ways you can do this.

Whenever you are drawing on location, time is a consideration, but it is even more pressing when your subject includes people. You need to get things down fairly speedily before the situation changes, which means that it is generally a bad idea to spend ages planning your page out in detail. By the time you are ready to begin on the actual sketch, there is a good chance that any people in your composition will have either moved or, worse still, left completely.

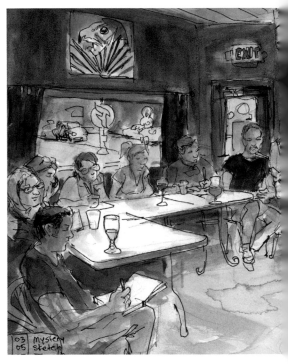

You need to find a way to plan quickly, and there are various techniques you can try. Some people fill a test spread with thumbnails, trying out alternative compositions. These are often subtle variations on the same view. They need to be small enough that you don't get bogged down in detail so they can be created very rapidly. Another technique is to use a light-colored pencil to sketch out the underlying shapes of your subject or your composition's basic structure. This allows you to establish important lines or proportions before working over the top in a darker pencil or in ink. If you are drawing in ink, you can use this pre-sketch technique with a graphite pencil, then erase the underdrawing once you are done.

A faster and more invisible approach is to plot the position of key elements on your page by drawing small dots. These disappear completely by the time you are done. This technique only works if you have quite a good eye, or if the subject matter is not too complex because you can't draw many dots before it stops making sense.

Not all of these techniques will suit your way of working, but it's good to experiment to find an approach you're happy with so when that slightly more complicated sketch opportunity arises, you are ready.

1 Thumbnail: Sketch a small thumbnail to work out the best composition for your page shape. You may need to do a few and then choose the best, so it's good to be speedy.

2 Basic shapes: Transfer just the basic shapes to your sketchbook using graphite or, as here, a pale colored pencil. Begin inking from the foreground characters. Use your undersketch purely as a position guide: It's important that you observe and draw afresh and don't "trace" from your guide.

3 Background: Once your characters are established, begin inking the background behind them. It can be useful to use a finer line for elements that you want to drop back.

◀ Double-Colored Line

An ocher line has been used by Manuel Hernández González to plan, then a stronger maroon has been used on top. Water has been introduced to blend these, creating mid-tones and softening the edges. Only limited additional colors are needed: a little blue cools the background and shadows; a tiny bit of red highlights her shoes. Existing colors are reused for her dress pattern. Note how white highlights are left, giving the sketch an important lift.

Fountain pen, sepia ink, watercolor pencils, water

◀ Undersketching on a Tablet

Rob Sketcherman works digitally on location using a tablet. This allows him to create a rough pre-drawing before he begins the real sketch. He then reduces the opacity of his pre-sketch to 20 percent so he can use it as a guide, while he draws the actual sketch on a separate layer over the top. This really helps with complex or detailed compositions like this one. Once Rob is finished, the pre-sketch layer can be deleted.

iPad sketch using Procreate and pressure-sensitive stylus

◀ Setting the Stage

Thomas Thorspecken usually begins his sketches by deciding what can fit on the page. He sketches the farthest left element and then the farthest right element lightly in pencil. He tends to set the stage by drawing the room, and then adds the actors as they catch his attention. Sometimes he pencils in people first and other times he puts them in with ink straight away.

Pencil, Micron pen, watercolor

▶ Framing with a Viewfinder

Katherine Tyrrell sometimes uses a camera's viewfinder to help her frame her sketch and plan her composition. This can be a useful way to decide which elements to include and can help you judge how best to crop the edges. Katherine draws directly in ink, so if the subject is complicated, she uses a few dots and quick pencil lines to locate key positions before she begins.

Pen, sepia ink, colored pencils

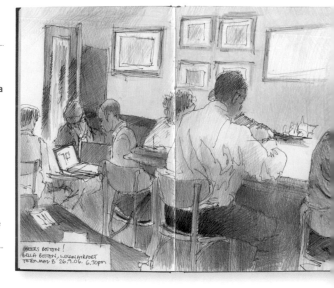

4 Adding color: Tint with watercolor but remember to keep plenty of white paper visible. Use more dense color for foreground elements. Note how the black in the scene is coded with a dusty purple to allow the line to read. By reusing many of the same colors throughout, you will give the image unity.

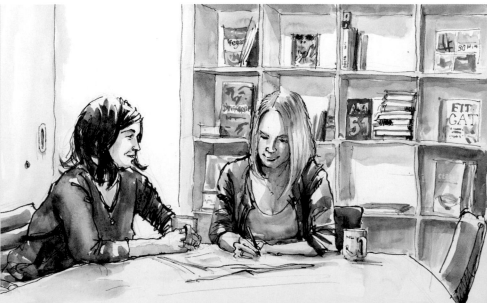

Focusing In

It can be quite liberating once you realize that you don't necessarily need to tackle the whole person or group of figures. There is nothing wrong with focusing in on a particular element if it draws your attention or has special resonance. This can also be a useful approach in a situation where your subject is moving or likely to head off at any moment.

When you focus in, try to draw your subject much larger than you would if you were sketching the whole person: Make a feature of it, so that it holds the page. In order for that to work, though, you need to make sure you are close enough to be able to see the detail sufficiently clearly, otherwise the result will be fuzzy and lack life.

Continued on page 102

▶ Draw What Excites You
I was interested in the way the arms fitted together, the folds and buttons of the shirt, the hand tucking under the sleeve, the watch. In my preoccupation with these details, I zoomed in rather too close and lost the other elbow, but the scale does add enormous impact.

3B pencil

The distortion of the stripes, created by the folds, really sculpts the cloth

▲ Zooming in on Necessary Detail
I did various quick sketches of the women at work in this bidi factory, but it was a short visit with no time to do a really detailed drawing. So, to get across what they were doing, it was necessary to sketch the hands alone. Rolling tobacco into a bidi is an extremely repetitive action, which enabled me to capture the position of the fingers.

3B pencil, watercolor pencil, waterbrush

Accurately capturing the shapes of the hands and angles of individual fingers compensates for the lack of detail

▶ When Time Is Short
If there is unlikely to be time to sketch the entire person you're focused on, you don't have to settle for the face. Look for anything that is a bit unusual about them, a feature that will sit well on your page, or just any detail that attracts your eye.

3B pencil

The hair marks curve over in the direction of growth. There is no confusion with the shadow marks because of the difference in weight and direction

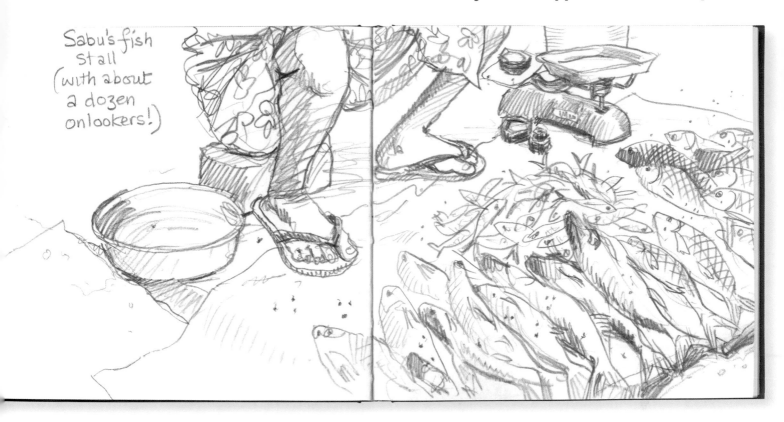

Sabu's fish
stall
(with about
a dozen
onlookers!)

▲ Focusing Attention

It was the improvised nature of this street scene in Kerala, India, that interested me. I wanted to capture the detail of the fish laid out on a sheet of plastic on the pavement, the handy water bowl and scales, and the seller's flip-flops. This was why I chose not to draw the whole man, just his feet, zooming in, so the elements telling the story filled the spread.

3B pencil

The acute angle of the foreshortened leg is accentuated by the light source, shadowing the shin and highlighting the knee

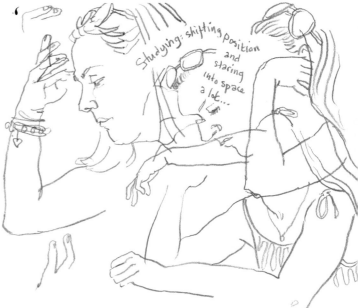

Studying: shifting position and staring into space a lot...

NO SEATS
AND MY FEET ARE
ACHING,
SO I SIT DOWN
RIGHT
IN THE
AISLE
WHERE
ALL I CAN
EASILY
DRAW ARE
A VERY
LARGE
LADY'S
FEET
IN PEEP-
TOED
LEOPARD
SKIN
SHOES.

And then suddenly lots of people get off and I have to move and let them out.

◀ Embracing Limitations

Sitting on the floor, my viewpoint was restricted, so I really focused in on what I *could* see, which was fun, because you don't normally get so close to someone's feet. The final sketch also has the added element of telling the story.

3B pencil

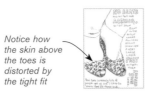

Notice how the skin above the toes is distorted by the tight fit

Keep things simple: A clean line drawing can allow you to quickly capture essential information and move on

▲ Tackling What Is Practical

If the person you are focused on is a fidgeter, it can be less frustrating to fix your attention on one element and draw it again and again in each new position. This turns an irritating situation into a fun game and is great practice for both speed-drawing and detailed observation.

3B pencil

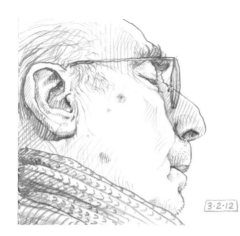

◄ An Intimate Portrait

If you are lucky enough to find yourself beside someone who is sleeping, it is possible to do a candid portrait in this tightly cropped fashion. You need to be close because it is the intimate details that help to make the sketch feel like a real person.

3B pencil

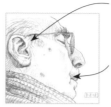

The slight wrinkling by the ear and the delicate stubble around the mouth are details you wouldn't notice unless you were very close

Although there can be reasons to focus in on any aspect of a person, the part of the body that most obviously draws the attention is, of course, the head. Many people are wary of faces, but if you continue to observe as truthfully as you can, a face is no different than anything else. You are still looking for shapes to guide you, still describing selected areas of tone. Take it one detail at a time and remember that a "likeness" is a happy by-product, not a badge of success or failure.

▶ Three-Quarter View

Drawing someone's head face-on is rarely as interesting as viewing them from one side. The three-quarter view allows you to see all the features, but without flattening them, so the nose is far more sculptural (and a lot easier to draw). It also gives you a better view of the ear.

Watercolor pencils, waterbrush

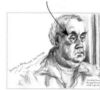

Note how the strong side light helps to define the shapes

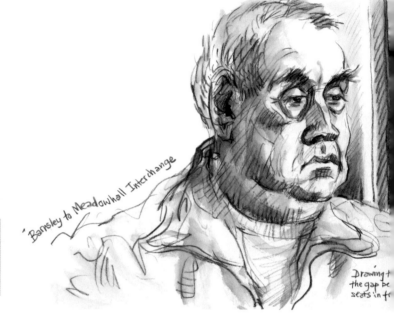

"Barnsley to Meadowhall Interchange"

Drawing the gap be seats in fr

▶ Beards

These two sketches, coincidentally focusing on very similar faces, demonstrate radically different approaches. Shukri Sindi's considered, minimalist line work (left) seems at first glance to have little in common with my more frenetic mark-making, but we are still finding similar answers to the same problems, conveying the various textures through different kinds of directional marks. We are both very aware of the white paper, balancing busyness and calm.

India ink Pitt pen (left), watercolor pencils, waterbrush (right)

The wriggly lines of the beard are overlaid for shadows, but allowed to disperse to nothing for highlights

The directional mark-making follows the growth of the beard.

Gentler hatching is variously angled on the skin to reflect its facets

Perfecting Profiles

Take the time to observe the subtleties of people's profiles. The line from forehead to chin is always beautiful, and every one is different. I find it fascinating and am drawn to it again and again.

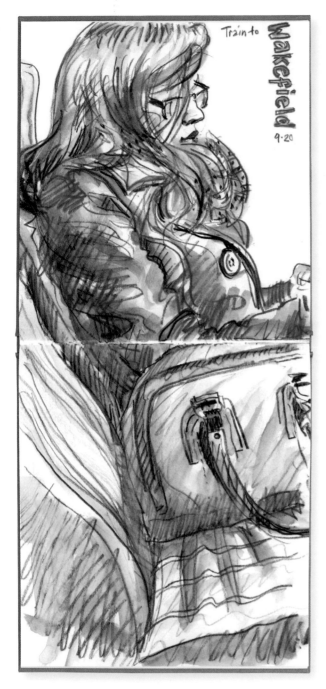

▲ **The Voyeur's Viewpoint**
This sketch is an interesting visual anomaly. The close cropping lends intimacy, but the bag, hair, and glasses that block our view, give her anonymity. She feels private, but we can't help our eye being drawn in—first by the perspective lines of the seat, then the curved handle. The red coat pulls us up over the bag, and the collar and hair swing our eye directly to her face.

Watercolor pencils, waterbrush

There are four colors in this sketch, but I have only combined two at a time so that when I use the waterbrush to blend them, I don't create "mud"

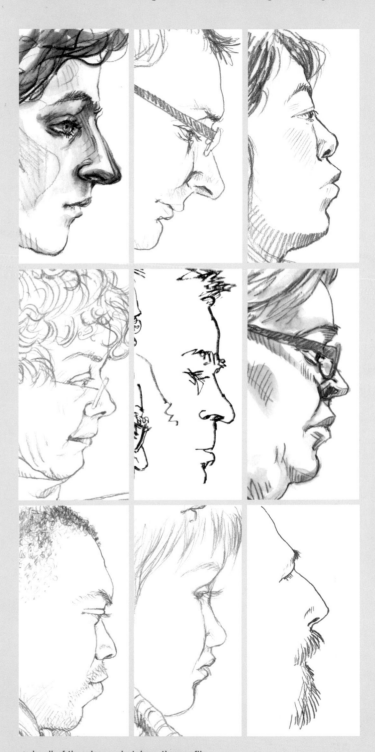

▲ In all of the above sketches, the profile line has been accentuated to draw your attention to it: Drawn as one continuous mark, or bolder than the adjacent shading, or a colored line. Practice contour drawings of profiles, looking at your subject more than your paper. You need to be close enough to see the subtleties.

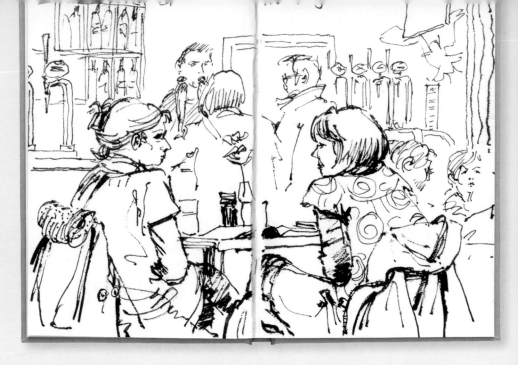

▶ **Characters First**
If the figures are the dominant aspect of a situation, I draw them first, then add background elements in between to give context. To avoid overlaps, you need to work from nearest to farthest: Here, the seated characters came first, then those standing at the bar, and finally, the bartender.

Sailor fountain pen, black ink

People in Their Environment

Capturing the essence of people going about their lives means drawing not just the individuals, but the environment around them. By showing how people interact with the world, you give context to your figures and tell us more about who they are.

This task is more straightforward if you are in a reasonably static environment, such as a train. It becomes more complex if people are coming and going, as they do in the street or in a store. On top of dealing with the moving figures, you cannot be sure how much of the background you need to draw since, at any moment, somebody may settle into the section you've just drawn.

There are two ways of tackling this. One way is to begin by sketching in your people, then draw what background you need in the spaces left around them. An alternative is to draw in the background first and draw the figures over the top. This is the more usual approach, as you can use the background shapes to help you judge the angles and proportions of your figures.

A common technique is to sketch in the basic features of the setting lightly in pencil first, adding people as they come into shot. The sketch can be inked and colored once the positions of the various elements are settled. Another approach is to draw the background and any fairly static figures in, then to add more figures as they pass through, drawing over the top, not worrying about the overlaps.

▼ **Placing Figures in a Setting**
In this sketch by Lis Watkins, you can just make out the pencil guidelines where background shapes have been established before drawing any characters. These benchmarks mean the figures can be "fitted" into the environment more accurately.

Pencil guidelines, watercolor

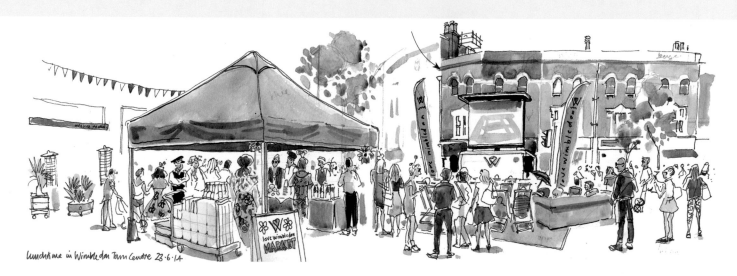

Lunchtime in Wimbledon Town Centre 23·6·14

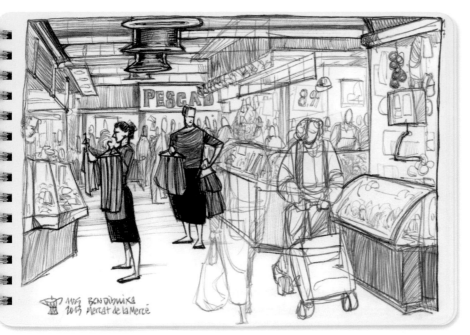

◀ **Capturing People Passing Through**
The structure of the market stalls creates a useful framework for Miguel Herranz to build the details of the sketch into. The two farther figures held poses to capture, but those in the foreground were passing through and have been quickly sketched on top. This loose treatment helps the market come "alive."

Ballpoint pen

The heavy line is only used in the foreground, to bring the two women forward and separate them slightly from the background

The moving figures have been drawn in colored line to prevent visual confusion and help them stand forward from the background

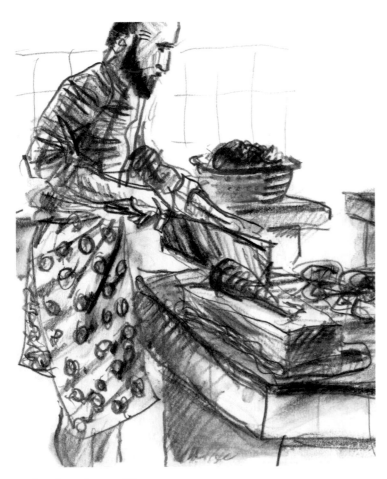

▲ **Creating a Sense of Place**
A person becomes more interesting if you can get across something of where they are to give context to what they are doing. The blue pastic basket; the simple surfaces; the suggestion of white tiles—these elements all help to paint the picture of the fish market in Kerala, India.

4B graphite stick, watercolor pencils, waterbrush

▲ **Capturing the Mood of the Moment**
This sketch by Caroline Johnson really conjures the slightly scary, clinical feel of a hospital ward. There is enough of the background detail to get across the environment, but we are close enough for the sketch to capture the vulnerability of the person in the bed.

0.8 Pilot drawing pen

People at a Distance

There will be occasions when the main focus of your sketch is the setting, but the environment has figures within it. This is a good thing: People can bring an otherwise sterile sketch to life. However, drawing people at a distance requires very different techniques from situations where they are closer and the primary subject on your page.

Gesture at Its Simplest

Sketching more distant people is more about creating the impression of figures, capturing the essence of their pose, and far less about detail. Look for the angles of torsos and limbs:

A curved back with elbow to knee is a very recognizable and natural pose.

The shape of a bent, pointing, or waving arm adds animation in just one or two lines.

A three-line triangle with a dot balanced above creates a squatting pose.

Legs apart and slightly raised arms suggest movement.

Crossed legs or ankles can be coded very simply, but say a great deal with very few lines. *(right from sketch by Manuel Hernández González)*

Arms raised and joined with bent elbows immediately tells us someone has a camera.

▶ **Incidental People**
This sketch by Lee Yong-Hwan would be a very different drawing without the lightly sketched figures passing through it. Notice how the more distant people are sketched without color, so they don't jump forward, but blend naturally into the background.

Fineliner, watercolor

Note how little information is needed at this distance

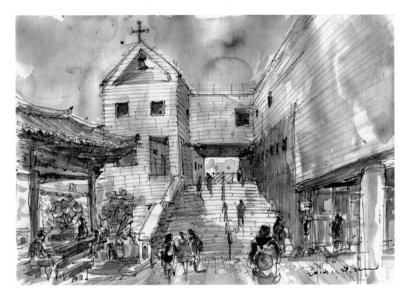

◀ **Coding Crowds**
This sea of people is a rather daunting subject, but spots of just a few colors overlaying a pinky wash create a very accurate impression (note that the nearer spots get larger). By adding pencil touches for occasional raised arms and a little linear detail in the front, Caroline Johnson completes the magic.

Drawing pen, colored crayons, wax crayons, watercolor, gouache

The waving flags bring everything to life, adding a real feeling of movement

Luckily, the people were well away from the cliffs or the tiny marks would have gotten lost. In that case, I would have moved them to where they are

▼ **The Tiniest Mark Can Have a Big Impact**
This sketch is obviously about the cliffs and sky, not the people. However, capturing the tiny figures walking along the beach pulls the rest of the drawing into focus. We suddenly get a sense of how large the cliffs are, and ironically, the added people communicate the emptiness of the beach.

Watercolor pencils, waterbrush

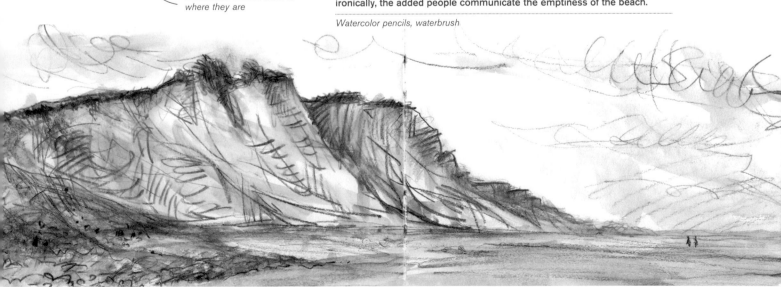

4

People Move!

Unfortunately for the sketcher, most people do not keep still for very long. Even when they are sitting down, they are inclined to fidget, look this way and that, wave their arms around when they talk, cross and uncross their legs ... Worse still, they can get up and leave at any point. All of this is extremely frustrating if you are trying to draw them. When you are still finding your footing, it can make the task of sketching an entire person, one with all limbs intact, feel close to impossible. Fear not: There are a variety of techniques that do make things easier.

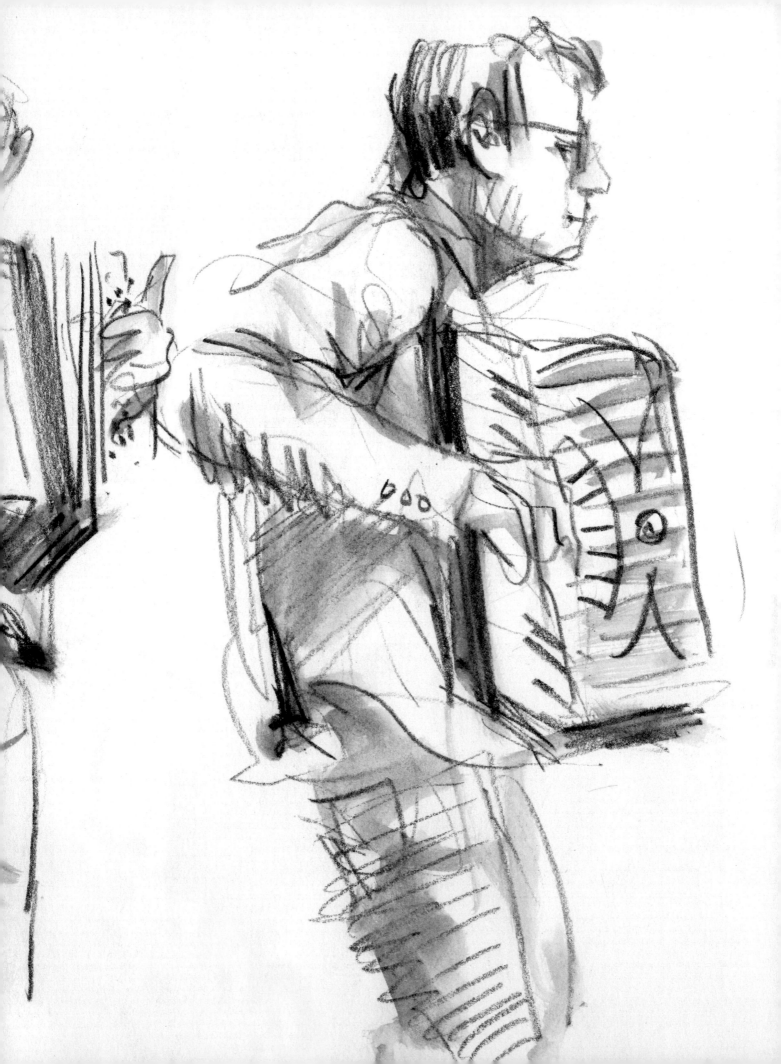

Working Quickly

The faster you can get information down onto the page, the more chance you have of drawing someone before they leave, and the more adventurous you can be about whom you tackle in the first place. Learning how to work quickly is, therefore, essential. I typically spend 15–20 minutes if I am drawing somebody on the train, but some of my best sketches of people were done in just five minutes. The ability to draw quickly comes with practice, of course, but there are also some tips I can share with you.

You can help yourself enormously by having your sketching kit organized in advance. When you don't have much time, you need to be able to concentrate on what you are doing and not have to worry about the wind flicking at the pages of your sketchbook (clip it before you begin) or your pencil becoming blunt (sharpen several before you set out or use a propeling pencil or fineliner).

Choose a kit that is easy to use and won't get in your way. If you are likely to be standing, a smaller book is much easier to hold while you work, and because it can be tucked into an accessible pocket, it can be grabbed and opened swiftly, so your moment isn't lost. It's also a good idea to slim things down: A set of 20 colored pencils might be lovely in other situations, but juggling too many tools when you are working at speed usually ends with things tumbling to the floor.

If you are trying to grab quick impressions, a single linear tool is great for getting things down in small amounts of time. A regular pencil might feel safe, but you don't have time for erasing, so you might just as well use ink to lend your line drawing more impact. This is another important thing to get used to—when you are working quickly, an eraser is a bad idea. Yes, you will inevitably misjudge things, and people will, of course, move when you are halfway through, but constantly erasing mistakes is frustrating and wastes precious time. If it goes wrong, it is better to either draw over the top or simply start again. In this way, you can train yourself to need an eraser less and less.

If you're struggling with confidence and don't want anyone to see your early efforts, try sketching people on TV. Chat shows can be pretty good, as people are seated, though you'll have to put up with cameras cutting back and forth. YouTube is a similar resource, but try to resist pausing the action!

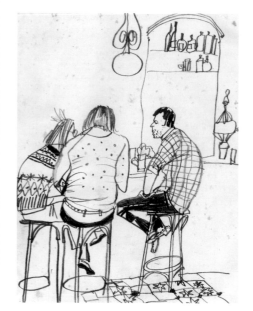

◄ Decide What's Important
This is a good rule, even if you are not in a hurry, because you don't need to draw everything. Capturing the hunched backs was key to this sketch by Victoria Antolini. The bar stools are also important to pin the group in the space and tell the story of their pose. The three different fabrics add huge interest and individuality, but are simply described. See how little background detail is needed to convey exactly where they are.

Graphite pencil

▶ A Simple Kit for Sketching on the Go
For sketching in an airport, a 4¼ × 5¾ in. (A6) book is ideal: discreet, easy to hold while waiting in line, and small enough not to be a nuisance while coping with luggage. I carried a handful of colors in my pocket, but worked with two at a time, for speed. I reused the purple of her blouse for the shadows and got the skin tone by bleeding the terracotta from her hair. I'm most pleased with the way her profile is implied rather than drawn—with more time, I might have overworked it.

Watercolor pencils, waterbrush

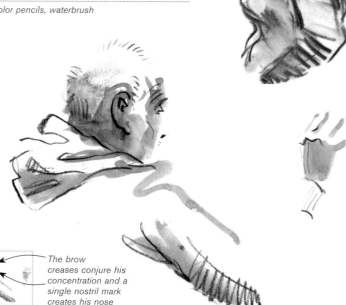

The brow creases conjure his concentration and a single nostril mark creates his nose

▲ You Can Say a Lot with a Little
This man was conducting a choir, which meant capturing a snapshot of his moving arm. For drama, I chose the highest point of the pose, and caught what I could, each time it came around. I didn't need to draw everything—just the upper arm and the echo of his hand are sufficient—because our eye fills in the gaps. In fact, the missing elements free up the arm and so add to the sense of movement.

Watercolor, watercolor pencil

The looping line behind the knees concisely describes the wrinkled denim

▲ Focus In

If time is short, it's useful to remember that you don't have to tackle a full person. Sketchers tend to focus on the face when they go for a detail, but the legs can be just as interesting, and in some situations, it's the head that will be moving most, looking around or talking. Shukri Sindi's uncluttered style shows she has a really strong eye, and ink helps to give her fine lines the power they need to hold the page.

India ink Pitt pen

▶ Setting the Stage

To capture people as they come and go through a detailed setting, it can make sense to draw in some background detail first so you can make compositional decisions and "set the stage," adding characters at your own pace. Matthew Midgley created the background as line work with distant, seated figures, then added the nearer, more transient figures over the top. The pool color came last, helping to pick out the foreground character.

Black ink pen, watercolor

Minimal color accentuates the composition: The palm trees carry your eye between the two areas of blue with balanced incidents of pale orange. The stronger orange ring sets everything off and is echoed in the tiny T-shirt opposite

▼ Don't Think: Just Draw!

OK, I know this is easier said than done, but it is at the heart of working quickly. Sometimes you have to jump in and see what happens. Practice with a pen so you won't be tempted to erase. Keep your hand moving, letting your line follow the shapes as best you can. When the person moves or things go astray, start again on the same page until there's no more room, then turn over and begin again. Use a small book, so you won't feel too reserved: I have a tiny one with really thin and nasty paper, which is perfect if I find myself feeling hesitant.

Sailor fountain pen, black ink

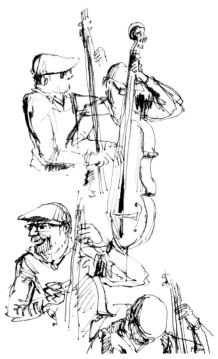

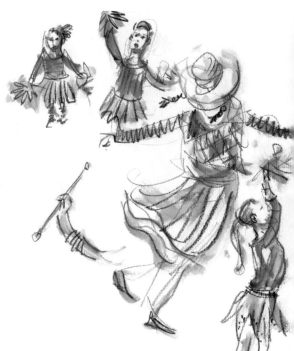

▲ Snatched Impressions and Remembered Shapes

Sketching dancers is never easy. Constant movement means you are almost always drawing shapes that are no longer there. You might begin the sweep of a raised arm during the action, but must follow through from memory, getting it onto the paper in a flash, while the image of it is still in your mind. It feels a bit like trying to remember a dream—the memory starts evaporating instantly—so you need speed and determination.

Watercolor pencils, waterbrush

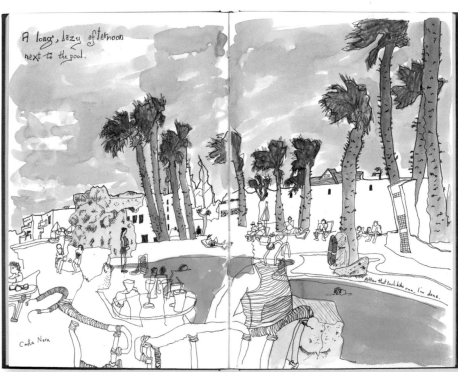

See how a single line feels its way from the shirt bottom to the tip of the bat

▲ Capturing the Essence

It is often impossible to get finished and complete drawings of moving people, but a snapshot that truly conveys the essence is often all that you need. These two sketches are of very different styles of dancing, each of which was captured by feeling the posture lines. Though neither sketch is "complete," there is a strong sense of where the characters were a moment earlier and where each dance is going next.

Watercolor pencils, waterbrush (left), Sailor fountain pen, black ink (right)

◀ Getting It Down as Fast as Possible

Even when people are standing still, you might have less than a minute before they are gone. The technique of "feeling the lines" uses every moment to the fullest, and allows your hand to travel really quickly, which ensures you get the maximum captured in whatever time you have. Note how the variety of colors in the pencil lead add interest to such a quick line drawing.

Rainbow pencil

▲ Solidity Through Strength of Line

Although Carol Hsiung's line is fine and her sketch is extremely understated, you can really feel the weight of the two standing figures; all that empty space and yet the bodies are totally solid, the poses absolutely believable. "Feeling the line" creates continuous, confident marks—much more powerful than lots of tenuous ones.

Pen, black ink

Feeling the Lines

Your hand can be trained to "feel" the edges of your subject as it draws, almost as if you are sculpting rather than sketching. It's an adaptation of the contour-drawing technique we looked at on pages 88–89. Many sketchers use it for drawing moving targets or subjects that must be captured immediately because they are likely to move at any moment.

The trick is to allow your hand to follow what you can see (or the visual echo of what you saw a split second ago) without too much interference from your brain. To make this work, you first need to train yourself to keep your eye on your subject, only glancing at your paper to keep scale and positioning under control. It's obviously easier to begin practicing this on static subjects. To start, try drawing your family watching TV, but to force yourself

into the right technique, be strict and allow yourself only three or four minutes per sketch. Don't cheat; set an alarm on your phone.

Start by describing the outside edges—the dipping and undulating profile of someone's face and hair or the scoop of a neck, which then cups itself over the shoulder, before sweeping down the arm, tucking briefly into the elbow on its way. Imagine you are literally running your hand over the surface. You need to practice "feeling" your way around your subject rather than thinking too much, so the line you draw is not ruled by the usual intellectual judgments of relative distances and sizes, but is a direct, almost tactile, experience.

Try to concentrate on the task in hand: Don't stop and assess the marks you are making. You are taking a journey

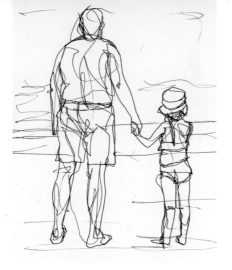

Paul has drawn the man's naked structure first, then introduced the shorts over the top

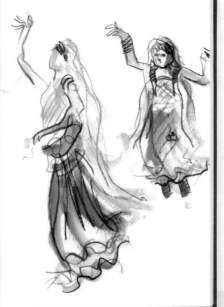

▲ Finding Shapes to Keep Your Line on the Paper

Paul Mennea's line does not just flow around the outside of his characters. He allows it to trace muscle shapes, the edges of shadows and highlights, the folds in clothing, any shapes he can find, however subtle, to allow his pen to keep traveling. The stance is totally believable because of the accuracy with which Paul's line has followed all the angles and gentle undulations. Notice how there are no straight edges at all.

Ballpoint pen

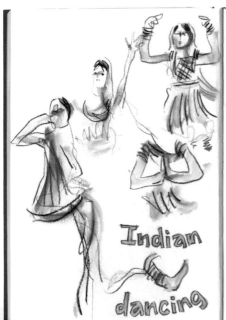

Indian dancing

▲ Keeping Your Line Moving

There are few things more difficult to draw than children running around at the beach. Suhita Shirodkar's technique is to keep a flowing line on the go, traveling rapidly around the shapes, capturing as much as possible of each person, before they move. Note how changes in line weight help to emphasize certain edges and make the image more easily readable.

Pen, ink, watercolor

Things to Remember

- Imagine you are actually running your hand over what you see.
- Stay in the moment and try not to think about mistakes.
- Find shadow-shapes to help you travel through, as well as around, the body.
- A sketch doesn't need to be "finished" to work.

▲ Letting Go of Mistakes

Not all the lines in this sketch are perfect: Some arms, for example, are very skinny, and some bend in slightly odd places. When "feeling" your way, it is necessary to free your hand to move where it wants to, doing its best to echo what's out there. If you worry about whether your hand is making mistakes, you will either never make a mark or create stiff ones with no fluidity.

Watercolor pencils, waterbrush

and need to keep traveling until the time is up, so keep your hand moving. Try not to overdraw the same areas too much, or your sketch may become overworked. Instead, let your line feel its way around your subject, describing each shape as it comes to it, then traveling on.

This isn't the same as contour drawing—you can take your pencil off the paper whenever you need to, though some sketchers do this less than others. If you want to

experiment with keeping a continuous line going, try traveling around the subtle shapes of shadows or the folds in clothing, as well as describing actual edges. This helps to mold the body, but also allows your line to glide across your sketch, joining one section of the drawing with another. If you have a tool that gives variable line weights, you can use stronger lines for important edges and spidery ones for soft shapes, such as shadows.

Drawings created by this method can be exciting to look at and can really get across the essence of a pose. You can work into them with color afterward, either from life—if your model is still there—or from imagination or memory, if not. The technique also allows you to capture shapes very quickly, which means that when you are faced with a moving subject, you have a practical technique to employ.

Composite Characters

There are many situations in which people are either in constant motion or are moving on too quickly to capture. Sketching them might seem impossible, but sometimes if there are enough different people doing similar things, you can create composites. Grafting one person's legs onto another person's torso with a third person's head is not cheating—there are times when it's a sketching necessity.

There are plenty of venues where this device is invaluable. Stand on any busy street corner, and people will walk back and forth across your path. They might be slightly different weights and heights, but their arms and legs will be repeating identical shapes. Sit in a bar or café and watch how different customers paying at the counter adopt the same position, or sketch paddlers in the sea, people looking around museums, or taking turns sitting on a park bench.

Not everyone is the same; sometimes you might have to wait a while before a second person stands or sits in the particular way you need. It's important to be aware of balance, too: If somebody is leaning forward, the center of gravity shifts and he or she unconsciously adjusts the position of their limbs to compensate. Using the legs of somebody who is not leaning will make your character look like they are falling over.

Since you don't need to capture the entire person before movement occurs, it is worth taking the time to really look at the angles and shapes as you draw. People sometimes stand with their knees slightly bent or their head at an angle. If they are sitting, check the height of their shoulders, the places where their clothes crumple. Subtle things make a real difference.

Just because they are composites, don't forget to capture accessories to make your characters believable. Be careful not to mismatch, though: The kind of bag and shoes people choose are linked to their persona, so need to make sense together. The same goes for body language—old men don't usually sit like teenagers. With care, you can make it pretty seamless. Later, nobody is going to be interested in whether you captured specific individuals, and after a while, even you tend to forget which of your characters are compilations.

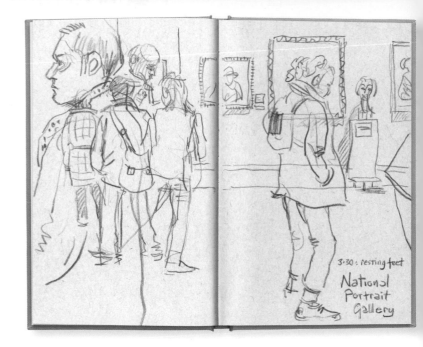

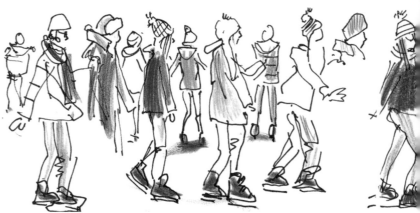

▲ **Easy Practice**
An ice rink is a great venue for trying out composite-character sketching. If you stand rink-side, as Lis Watkins did here, you can see a revolving parade of people, all so busy trying to keep upright, they won't be looking at you. You are also guaranteed the exact same footwear and similar clothing on everyone, and people will be holding themselves in a very limited variety of positions.

0.7 Rotring Tikky fineliner, colored pencils

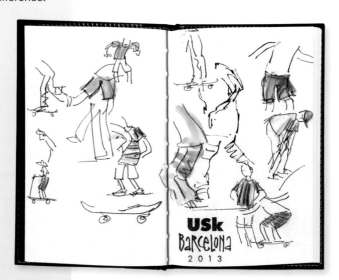

◀ **Capturing Fast Activities**
These skateboarders were moving so fast, I was really struggling to capture anything. I would get one arm or someone's lower legs, then he'd be gone. Luckily, there were about a dozen young men doing the same moves. By working a few sketches at once, I built up some of the main positions by grafting different people together one tiny bit at a time.

Sailor pen, black ink, watercolor pencils, waterbrush

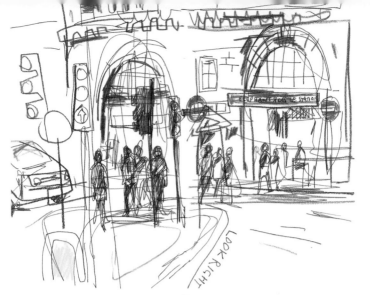

◀ Standing in the Same Spot

I wasn't out on a sketching mission—just resting aching feet—but discovered that a seat in a gallery provides the perfect vantage point. The exhibits are in fixed positions, so different people stand in the same place, looking in the same direction. They might not pause for long, but someone else will be along soon to help you finish your sketch.

Rainbow pencil

◀ Bringing a Sketch to Life

Sketches of places that should feature lots of people can look barren without them. The composite technique is great for peopling your environment in an understated way. These figures are featureless, but the leg positions Nick Kobyluch has captured make them walk convincingly through the space.

Fineliner, colored pencils

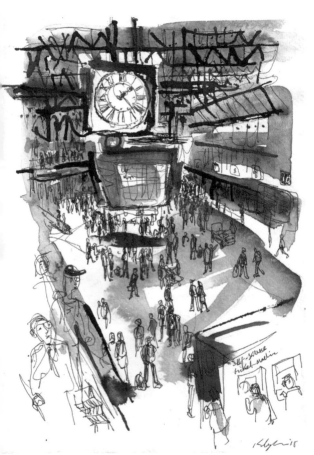

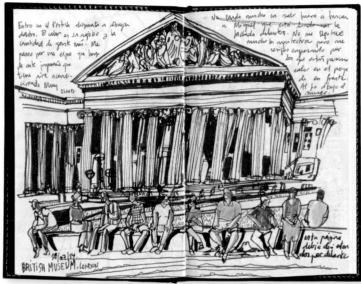

◀ Dealing with Crowds

An aerial view of a massive space full of people is a daunting subject. Having first created the space, Nick Kobyluch has filled it by observing the repeating positions that people adopt. The crowd is a mix-and-match of simple legs, bodies, and heads, combined with occasional individual details that bring it to life.

Pen and ink

▲ Interchangeable Body Parts

Every part of every one of these figures is different. However, if any one of these people had left while Inma Serrano was sketching, a composite could have been created, and you would never know. Imagine swapping the torsos, legs, and arms of the characters: With only minor adjustments for size, they could be very successfully interchanged.

Sailor calligraphy fountain pen, Pentel brush pen, black ink, watercolor pencils

▶ Standard Arms and Legs

Some of these people are walking across the page; others are crossing diagonally toward or away from the viewer. This makes an obvious difference to the legs, in particular, but notice how Takeuma repeats the same few basic leg and arm positions for various individuals. By adding personalized details to the clothes and hair, the group becomes real.

Colored pencils

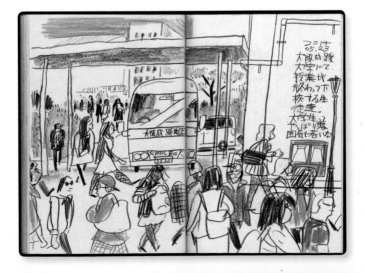

Things to Remember

- Take your time to get the body angles right.
- Be aware of your character's center of gravity.
- Record some of the details that bring characters to life.

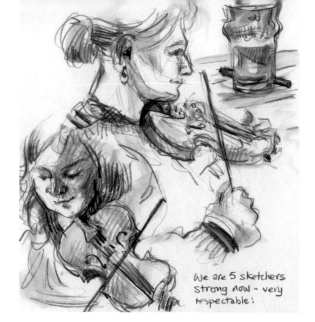

We are 5 sketchers strong now - very respectable!

◀ My Favorite Three Watercolor Pencils
My favorite tool for colored speed-sketches is the watercolor pencil. I find that three colors are usually enough to get a rich effect. I often use these particular three pencils when sketching people: A combination of the olive green and the tan gives me warm and cool skin tones, avoiding sickly pinks, and the navy gives me richer shadows than black. When I add water, the three colors blend well, allowing me a range of softer tones. Fewer colors means I never create "mud."

Watercolor pencils (Inktense range: Leaf Green, Baked Earth, Deep Indigo), waterbrush

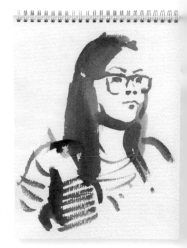

Limited Color

When you want to grab the moment, you need to find ways to slim things down and cut corners. Unless you are coloring in after the event, full color is too time-consuming, but this doesn't mean you have to stick with black and white when you're speed-sketching. You can give the impression of full color with a surprisingly limited palette, which is much quicker to use and also cuts down your thinking time by giving you fewer complex decisions to make.

Some people find the biggest challenge with using limited color is letting go of naturalism. Remember: A sketch is an artistic interpretation, not a photo. You don't need to capture all the colors you see. You don't even need to use the real colors. If you are struggling to decide which colors to choose because you find a small palette too limiting, make yourself use completely crazy colors. That will free you up and you'll be surprised—the effect can be really good!

If you are using drawing tools, you can hold two or three colors in your other hand while you sketch, allowing quick transitions back and forth. This is far more convenient than needing table space for a full box, and balancing materials on your knee generally ends in disaster. Also, don't underestimate the time it takes to stop and browse your selection, choose the next color, pick it up, then put it back in the box. You probably rely on a smaller selection of favorite colors anyway. Look back at past sketches, pull out the four or five colors you use most, and slim down from there.

If you are painting, you can save time by premixing a couple of colors. This might be a skin tint and one other for adding focus to a line drawing. Or you can choose two less specific colors, ones that give you some contrast, but that also blend well together. Add a little water, and you can get a fair range of colors and tones. For more speed and for more creative effects, try letting your colors mix and run together on the paper—there won't be time to wait for paint to dry anyway, so allow yourself to experiment with wet-on-wet.

Different spotty patterning creates two very different adjacent areas of green, and the small, repeated incidents of red add contrast

◀ Selective Tinting
To add vibrancy or focus to a line drawing, try selective coloring rather than evenly spread tinting. By choosing to add color to only some areas, the process is quick and you can draw attention to anything important in your sketch. This technique works best with a limited number of colors anyway because this unifies the page: There are only three colors here. The uncolored figures in the background are allowed to fall back, while tinting pulls the foreground characters farther forward, adding greater depth.

Sailor fountain pen, black ink, watercolor pencils, waterbrush

9.15am: Waiting for my connection at

◀ Sketching with Premixed Watercolor

This is a two-minute sketch and would have been totally impossible had my two colors not been mixed and ready to go. The colors are different enough to give some contrast, but not too starkly different, so they also blend well together. Note the added interest of the wet-on-wet marks, where the blue of her top bleeds into the yellower hair.

Watercolor (Prussian Blue, Raw Sienna)

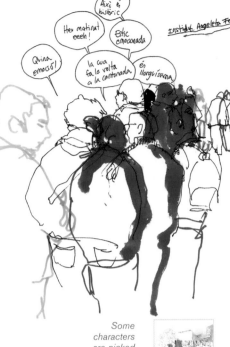

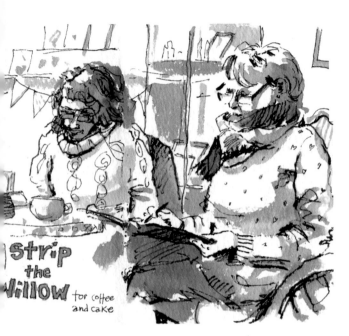

Some characters are picked out by their shadow

▲ Non-Naturalistic Color

Cristina Curto has used color to add depth and drama to her line drawing not by tinting, but by drawing additional, colored characters over the top. Her red and yellow color choices are completely non-naturalistic, and yet they work really well, complementing one another and making the sketch far more dynamic.

0.2 fineliner, watercolor, waterbrush, fiber-tip pens

▲ Warm and Cool Tints

Having two different grays allows you to differentiate shaded objects

If you want to quickly add contrast to a line drawing with watercolor, you can get a surprisingly rich effect by using just two terminal grays, one warm and one cool. Paint the shadows rather than coloring objects, leaving plenty of white paper. The combination of warm and cool lifts the sketch far more than a single, neutral gray and gives a subtle suggestion of color.

Sailor fountain pen, black ink, watercolor (Prussian Blue/Alizarin Crimson mix)

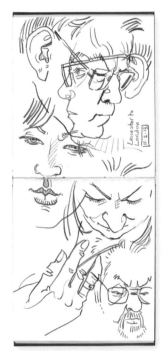

◀ Free Yourself Through Crazy Colors

If you find it hard to relinquish realistic colors, choose a random selection of colored pencils and use them instead of black to draw your line work. Swap between pencils for different elements, concentrating on the balance of color on your page rather than which thing ought to be which color. To keep the sketch from looking "bitty," it can help to keep the same color for individual elements.

Four watercolor pencils

◀ Minimalism Can Be Better

By premixing a skin color, Omar Jaramillo saved enough time to allow himself to concentrate purely on observation, so he was able to capture the shapes without the use of line. The dark brown is all that's needed to create sufficient contrast to bring things to life. The effect is of full color, and the minimalism is really pleasing.

Pen, sepia ink, watercolor

Things to Remember

- Fewer colors reused across the page can unify a sketch.
- You don't have to color everything.
- A darker color is always handy for your shadows.
- You don't have to stick to the real colors.

Drawing Without Drafting

If you want to be able to capture your subject as quickly as possible, you need to begin training yourself to do without underdrawing. People are not like architecture: If you spend more than a few moments planning out what you intend to do, you are likely to find that the subject has changed before you get started. Sketching "blind" might make you feel uncomfortable to begin with, but will get easier, because it is not just about honing your hand-eye skills through practice, but also about confidence.

A blank page can be intimidating, especially when you are still learning, and even more so when what you are learning is people-sketching! Start simple: Begin by tackling individual characters or parts of people, which need less planning than entire scenes. If "leaping in" still feels way too difficult, start by scaling down your drafting, limiting your underdrawing to the fewest possible simple shapes. Look carefully though at the way different people hold themselves. Make sure any drafting considers the body, limb, and head angles—these are often more important than form or size.

An alternative technique is to block a basic shape with watercolor, which does a similar job to sketched underdrawing, helping you to tame the page and giving you a rough framework to work with. You only need a simple shape in just one color, and your specific color choice is less important than the shape it describes. Even that will be

approximate, though; the idea is to help you to judge how a character might sit on the page or the basic shape of their pose, not to be perfect. Any errors in judgment are corrected with your actual drawing, which will sit over the top, the same as with a pencil underdrawing. Where the watercolor turns out to be accurate, it can sometimes remove the need for some of the line work and speed things up, but even if not, the colored underpainting makes the linear sketch bolder.

The key to strong sketching is to free yourself from the need to use underdrawing. When you have plenty of time, planning is probably a good idea. You might find that one of the methods above suits you well for much of the time. For maximum flexibility, try to work toward the goal of using no drafting at all, at least occasionally. This process will strengthen your sketching across the board, and your confidence will grow as you gradually get better at judging the basics more instinctively.

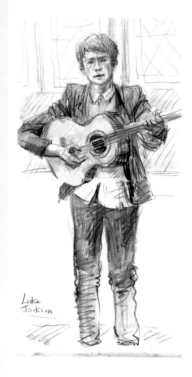

▲ **Mistakes Are Inevitable!**
Because I didn't waste time undersketching, but dived straight in, I was able to achieve a completed sketch before he finished his set. The downside of this approach is that I chopped his feet off. This happens to me fairly often, as I have a tendency to draw too big. It can be avoided if you take a few seconds before you start to just mark the highest, lowest, and central point of your character. Note to self!

Watercolor pencils, waterbrush

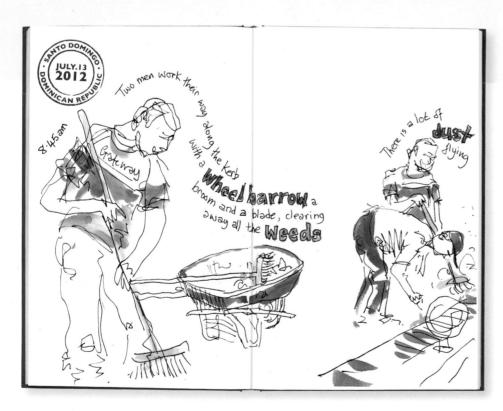

◀ **Recording Essential Body Lines**
This work team was moving along rather swiftly. I captured what I could by observing essential shapes. The broom handle helped me judge the angle of the front character's arm and torso. I recorded his neck angle and head, plotting facial features rather than drawing them. I needed to capture the strong curve of the middle man's back before I could position his angled arm. The peak of his cap helped me gauge the tilt of his head. Spot color was added after they had disappeared from view, with very loose marks, to match the feel of the line.

Waterproof fineliner, watercolor

▶ Keeping It Going

Small children are the perfect example of why you don't have time for drafting. This group was really engaged with drawing, so still for at least short periods, but even so I couldn't catch a complete one. It didn't matter: Each time a child moved, I started on another. The color was left until I got home and helps to make sense of the areas where characters run together.

Waterproof fineliner, watercolor

drawing Workshop with Korky Paul

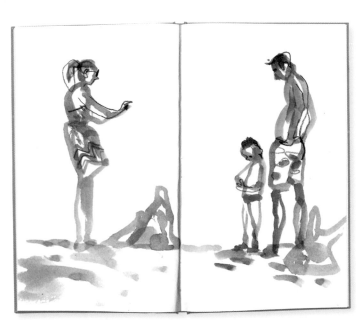

The torso leans slightly backward and is described in a single pass: Two curves, dinted together beneath the chest

The shin bone is straight, with the bulge of the calf muscle behind, pinched in at knee and ankle. Simple but evocative

◀ Simplifying with a Brush

The broad marks of a paintbrush help you to concentrate on the larger issues which will underpin your success, like well-judged body angles. To capture these transient poses so convincingly, Marina Grechanik simplified things down to fundamental shapes and angles, using bold marks, but accurate observation.

Watercolor, watercolor pencils

▼ Color as Framework

Some of the most interesting poses only last a minute. I used watercolor to draft in the lovely S shape of the man's torso and leg, the position of the back foot, and the angles of his head and arm. I fine-tuned this first impression with a watercolor pencil over wet paint.

Watercolor, watercolor pencil

◀ The Cumulative Effect

Where people are constantly moving, drafting is impossible. You have to capture what you can as you can. The success of the final sketch is often less about the accuracy of individual characters and more about the cumulative effect of various quick observations. When time is of the essence, forget about faces: Capture personality instead through hair, stance, or clothing, as Nick Kobyluch does here.

Fineliner, colored pencils

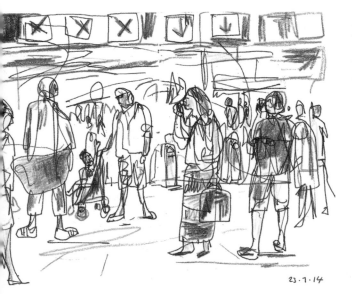

23·7·14

The underpainting does enough that only minimal additions for the ear and nose are needed

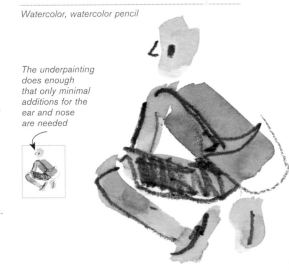

Repetitive Actions

There are some activities where your subject's motion is not random, but repeats on a loop. This is particularly true for sports and certain types of manual labor. This repetition gives you some options:

- You can draw two or more different stages from the movement cycle, showing the activity as a series of juxtaposed drawings.
- You can capture elements from the various positions as a page of unfinished impressions.
- You can wait and catch one part of the action each time it comes around, building up a single, detailed pose, a little at a time.

This loop of repetition makes life far easier, but often it is impossible to predict which of the above methods you will end up using. You might be hoping for one complete sketch, but discover you have picked a pose from the action that is too quick to capture, or find that your subject turns halfway through, so suddenly you have a different view. If you keep your options open, you are less likely to get upset if things don't quite go to plan. Sketching people is not like sketching buildings: Anything can happen. Drawing people in motion is difficult, even when you have a lot of experience, so don't be too hard on yourself—you will improve with practice.

Choose not only an activity that is repeating, but a subject who is staying in one place (or being constantly replaced by new subjects in the same position). That way, the angles won't change too much, and you won't need to move about. Start with a fairly big sketchbook, at least 8¼ × 11¾ inches (A4), and a simple tool such as a pen or pencil. You need to look at the subject as much as possible rather than your page—the fraction of a second you need to capture is easily missed.

Resist the urge to fiddle with your drawing after the event—unless you have an exceptional visual memory, you will only make it messy. My personal rule of thumb for sketching movement is, if you can't see it, don't draw it!

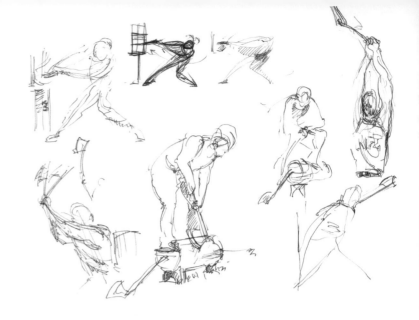

▲ Multiple Views Side-by-Side
This sheet of sketches by Meegan Parkee is an example of how well a series of juxtaposed studies can work, both for showing the viewer the story of an activity and for giving the artist an understanding of how the action is created. Note how Meegan is using fundamental body lines to underpin the poses.

Disposable ballpoint pen

▶ Visual Memory
By continually observing and sketching people in motion, it is possible to build up a reference library in your memory. Marc Taro Holmes has also done a great deal of life drawing, which means he is able to supplement his observations with details from this stock of memorized positions as the actual figures move on.

Pilot Hi-Tech 0.3 mm ballpoint pen

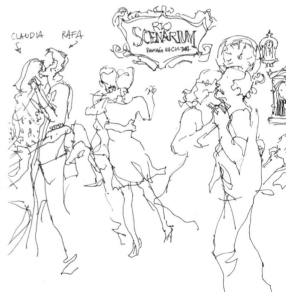

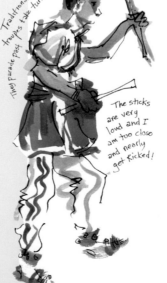

◀ Building a Person in Two Passes
To get close enough to see this street dancer, I had to push to the front of a crowd, then squat, so as not to block their view. This was very uncomfortable and impractical, so speed was essential. I grabbed a rough impression of her in paint first, then refined in pen as the movement was repeated. The resulting rough-and-ready treatment has more movement in it than a more refined sketch might.

Watercolor, Sailor fountain pen, black ink

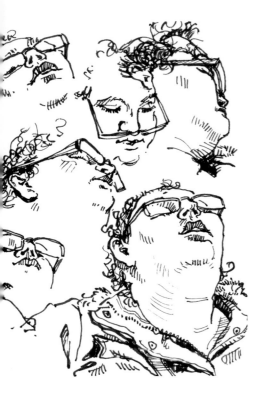

◀ Recording Movement as a Series of Bits

An individual's body language tends to run through a limited number of poses, almost on a loop. However, they may not come back to the pose you have started. To save the irritation of waiting around or being left with a half-finished sketch, you can keep beginning again on the same page. The result tells the story of the moment and also stops you from being tempted to "fudge" things—rarely a good idea.

Sailor fountain pen, black ink

▼ Creating an Overall Picture of an Activity

Last summer, table tennis tables were installed in public spaces in my hometown. The game involved too many different poses for me to be able to build up a single image, but there was enough repetition of similar actions by different players for me to create a page that recorded a picture of the game as a whole.

Rainbow pencil

When the Movement Is on a Loop

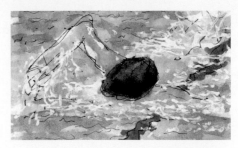

▲ Whichever stroke a swimmer is using, the action is totally repetitive. The loop of the motion is also so short that the timing is ideal for building up a sketch like this one by Tim Richardson, even if you only add a tiny mark each time around. Position yourself toward the end of the pool or build up your image from a number of swimmers passing by.

Pigment liner, watercolor, Pentel micro correct fluid

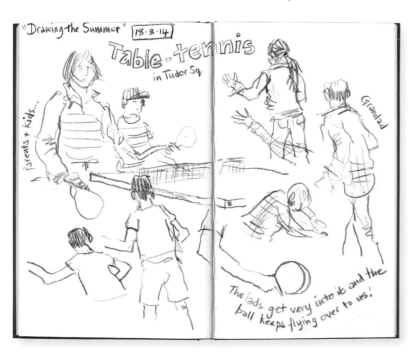

▲ Rowing is an action that swings between two poses: leaning forward and leaning back, as Paul Mennea has captured here. There is a very slight pause at either end, too, enough to grab an impression. The more you draw a movement, the more your visual memory will soak it up, so that you can keep drawing an echo of the action that little bit longer in between poses.

HB pencil

▼ Observation Practice

The act of walking is a very short, repetitive loop. If you sit somewhere such as a park or beach, you can use a combination of fast contour drawing and composites to create practice sheets, like this one by Suhita Shirodkar. Each time you do it, you will capture more and the walking will look more fluid.

Pen, ink, watercolor

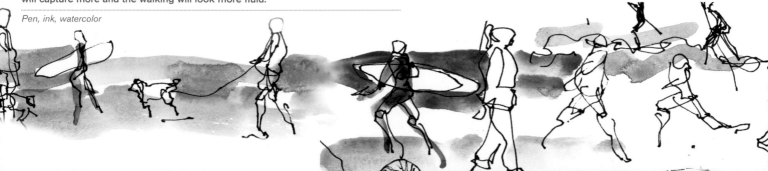

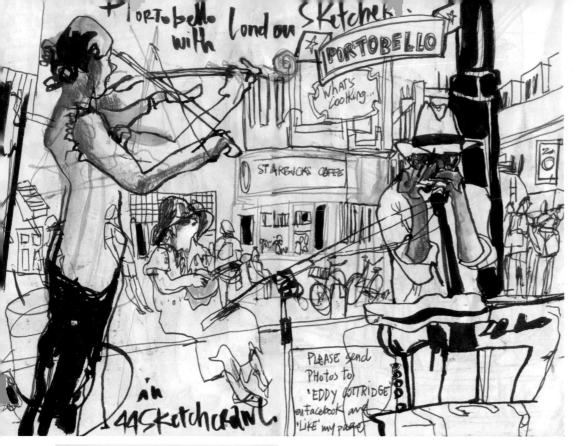

◀ **Truth and Immediacy**
A fiddle player's bow arm is in constant motion. The various versions of the bow, drawn at different angles, really get across the speed of the action and add a sense of immediacy, very much in keeping with the impromptu feel of a street musician. The arms of a banjo and harmonica player move less radically, so a single "snapshot" was the best approach for Inma Serrano.

Black Bic 1.6 mm Cristal pen, Pentel brush pen, watercolor pencils

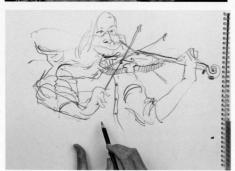

Superimposing Positions

Another interesting method for depicting constant motion is to draw the different stages on top of one another. Instead of separating out the various different elements of a moving pose, you incorporate them into a single sketch. You might be recording a cyclic motion, such as a sporting activity, or a more random movement. Either way, the results of this technique can be visually very interesting, and convey the sense of movement extremely effectively.

There are times when this is a planned technique. However, there are also occasions when it is the only way of finishing a sketch, because someone who started off motionless has suddenly begun waving their arms around or keeps changing the position of their feet. If you have already invested a fair bit of time in a sketch when this happens, it can be incredibly annoying. The key is to be adaptable: See it as a good opportunity to experiment. Forget about the potential for "ruining" a good drawing and focus on the fun of capturing as many pose variations as you can in the one sketch.

1 It's best to have more than one color at the ready: Different colored lines help separate the different poses and keep things under control. **2** Swap between colors where one position overlays another so you don't end up with a visual tangle. Don't worry if some colors are not realistic. **3** You can add a little hatched shadow at the end to help define some positions where necessary. A little waterbrush blending stops the sketch from looking spidery and can be used to define certain areas to help things "read."

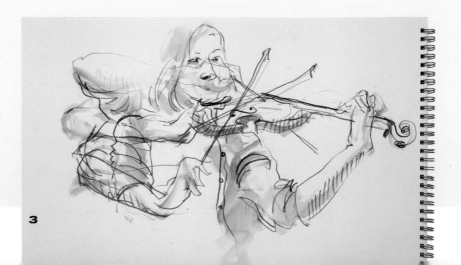

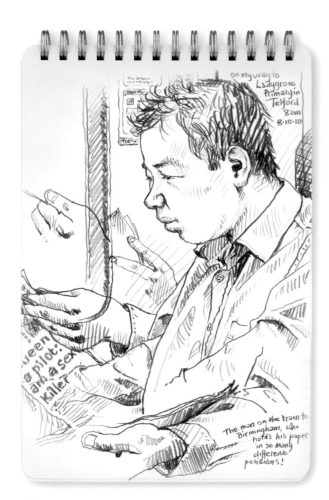

▲ **Capturing Moving Hands**
There is always a lot of movement when someone is reading a newspaper. Luckily, the head and torso generally remain fairly stationary, which allowed me to "anchor" my character to the background. This helps to make sense of the various floating hands. Because of space restrictions, the hands are not necessarily in a realistic relationship with the rest of the man, but the drawing still works as a record of the activity.

3B pencil

▲ **You Don't Need to Restart**
Even when we are sitting "still," we all have a tendency to shift between different positions, and sooner or later, a position change is going to happen when you are halfway through a sketch. If you embrace it, this can be a bonus: The superimposed second position in this sketch by Don Low adds more of a sense of the person and makes the sketch feel alive.

Pentel brush pen

◀ **Different Colored Lines**
A batsman is the perfect example of a cyclic movement and the ideal candidate for the "superimposed action" treatment. The relatively stationary heads and torsos pin the two moving characters in place, so that all their different arm and leg positions work without confusion. By picking out the bats and some limb positions in terracotta, Takeuma helps us make sense of it all.

Colored pencils

Things to Remember

- Your sketch will be easier to "read" if one element remains constant, e.g., the torso.
- Use two or three different colored lines to help separate out the different elements.
- A moving character will take up more room than a stationary one, so allow space on the page for them to "expand."

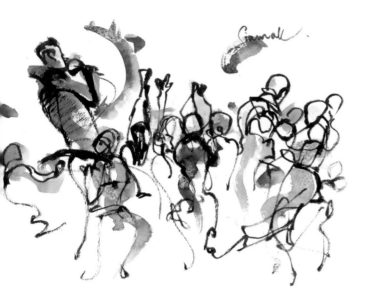

◀ **An Impression Works Better**

The excitement of the crowd leaps from this sketch by Suhita Shirodkar; we can feel them jumping with the music. There are discernable heads and arms, but when you look closely, there is nothing representational apart from the singer. The rest is a twisting line, which follows the energy of the audience.

Pen, ink, watercolor

▼ **Portraying the Spirit Not the Detail**

I was attempting to sketch a lantern festival parading through the street. It was getting dark, and the participants were moving past me faster than I could draw. I decided to let my pen glide continuously over the paper, recording snatches of shapes as they went by. I picked out the deepening sky in watercolor later to make more sense of the tumble of marks and splashed color over the linework to express the carnival atmosphere.

Super5 fountain pen, black ink, watercolor

The splashes of color add to the dynamism, because they too are abstract and expressive, rather than sitting within any lines

▼ **Kinetic Energy**

The sense of movement in this sketch by Meegan Parkee is so powerful that you can feel the energy about to bear down on the drums, almost as if you were the drummer. This success comes partly from the instinctive mark-making, but also from accurately expressed angles. The arms are what you see first, but the angle of the drummers' backs and the bracing of their legs are also very important.

Disposable black brush pen

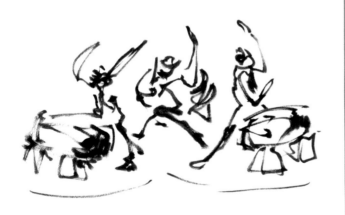

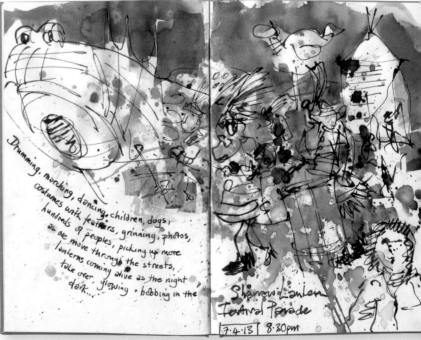

Abandoning Realism

When faced with a figure in constant motion, especially when that movement is either too quick or too random to capture by the usual means, the best answer is to try to convey the spirit of the action and forget about the detail. Instead of drawing faces, hands, etc., you need to concentrate on body lines using expressive marks or splashes of color. The results, although not conventionally representational, can be really eye-catching and can still convey a good sense of motion.

Sketches done in this way require intense concentration: You have to be totally in the moment. There is no time for thinking or planning—the marks that you make need to be an instinctive reaction to what you see. If you have ever tried two-minute life-drawing poses, you will understand the principle of instinctive drawing. Bold marks are more useful than tiny ones. It's a leap of faith, for which you have to relax any need to control the outcome.

The easiest way to practice this is in a big sketchbook so that you have plenty of space because it's difficult to predict what is going to happen and you may need to keep starting afresh. Observe for a minute before you

Continuous Lines

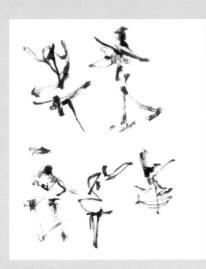

◀ Each of these little studies by Tom Pellett is obviously in motion. Individually, they are very abstracted, but if you view them as a set, you can easily read the passage of the dance. Note how each figurine is created as a continuous line, almost like a piece of calligraphy.

Pentel brush pen

Note how the marks do not leave the paper between studies but flow like ribbons between them

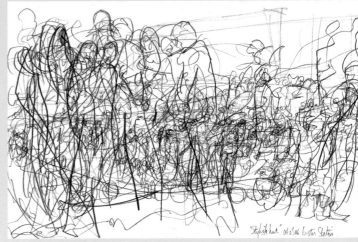

▲ In a busy station during rush hour there is a constant flow of people—impossible to draw realistically. By keeping his pencil moving, superimposing quick sketches of body shapes passing by, Chris Fraser conveys perfectly the energy of the commuters.

Pencil

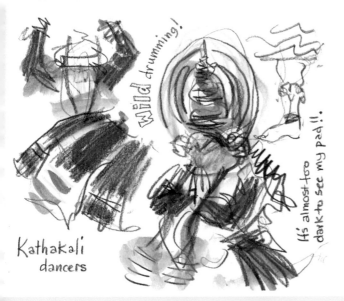

Wild drumming!

It's almost too dark to see my pad!!

Kathakali dancers

◀ **Following the Colors**
The costumes of Kathakali dancers are intensely colored, so it didn't seem appropriate to draw in line. I first tried to describe the shapes, following predominant areas of color. I then used a graphite stick in places where the marks fell too static to better express the fluidity of the bodies beneath the costumes.

Watercolor pencils, waterbrush, 6B graphite stick

Things to Remember

- Take a minute to soak in the movement before you begin.
- Look at the subject, not your paper.
- Choose a tool that's easy to work with so you can keep your hand moving.
- Give yourself plenty of space to experiment.

begin to draw. What kind of shapes are the limbs describing? Is the head in line with the body or held at an angle? Look for the changing angles of the torso—your subject won't necessarily be upright, and catching them off-balance will add dynamism to your sketch.

Once you put pencil or brush to paper, you need to draw quickly. Try to keep your eyes glued to your subject. This is easier if your tool stays in contact with the paper. Try not to worry too much about the results on the page but focus on moving your hand in synchrony with the movements of your subject. Keep your marks fluid: Curves and loops describe motion better than straight lines.

Depending on what you are drawing and the way you like to work, you might fill the page with a series of smaller impressions or create larger "explosions" of mark-making, superimposing the various elements of the movement. Whichever technique you go for, think of it as experimentation and don't expect too much to begin with—if you achieve anything more than a page of scribbles, you are doing very well indeed! Like everything, it gets better if you practice.

Index

Credits

Quarto would like to thank the following artists for kindly supplying images for inclusion in the book. All artists are credited in the caption to their sketch. Unless otherwise stated, all other artwork was produced by the author. While every effort has been made to credit contributors, Quarto would like to apologize should there have been any omissions or errors—and would be pleased to make the appropriate correction for future editions of the book.

Ana Rafful, www.annarafful.blogspot.com
Andres Silva Vignoli
Anette Grimmel, www.flickr.com/photos/anette-grimmel
Asnee Tasna, www.flickr.com/photos/asnee
Behzad Bagheri, www.flickr.com/photos/behzadbagheri
Carol Hsiung, www.flickr.com/photos/48097026@N02
Caroline Johnson, www.carolinejohnson.org
Catherine Brunet, www.flickr.com/photos/94941493@N02
Catherine Gout, http://catgout.blogspot.co.uk/
Chris Fraser, chrisfraseronline.wordpress.com
Don Low, www.donlow-illustration.com
Edurne Iriarte, www.flickr.com/photos/eiriartea
Ekaterina Khozatskaya, www.flickr.com/photos/bogema
Emily Nudd-Mitchell, www.flickr.com/photos/emily_nudd-mitchell
Enrique Flores, www.4ojos.com/blog
Greg Betza, www.gregbetza.com
Inma Serrano, dibujosypegoletes.blogspot.com.es
Isabel Fiadeiro www.flickr.com/photos/mauritanie
Jane Horton, www.janehorton.co.uk
Jeroen Janssen, www.bakame.be
Jerry Waese, www.flickr.com/photos/waese/16733387050
Juan Linares Vargas, www.juan-linares.es
Julie Bolus, www.flickr.com/photos/jamboju
Karole Amooty, scribure.tumblr.com
Katherine Tyrrell, www.makingamark.co.uk
Lapin, www.lesillustrationsdelapin.com

Laura Murphy Frankstone, www.laurelines.com
Lee Yong-Hwan, archiartistlee.blogspot.co.uk
Lis Watkins, lineandwash.blogspot.co.uk
Manuel Hernández González, www.flickr.com/photos/mhglez
Marc Taro Holmes, citizensketcher.com
Marina Grechanik, marinagrechanik.blogspot.co.il
Matthew Midgley, matthewmidgley.com
Meegan Parkee, scratchyas.com
Melanie Reim, www.melaniereim.com
Miguel Herranz, www.miguel-herranz.com
Mikael Eklu-Natey, www.behance.net/Mekaeli/following
Nick Kobyluch, www.facebook.com/nickkobyluchsdailydrawings
Omar Jaramillo, omar-paint.blogspot.co.uk
Paul Mennea, yep.it/mennea_p
Peter Wenman, www.peterwenman.co.uk
Pieter Fannes, www.pieterfannes.com
Richard Johnson, http://newsillustrator.com/
Rita Sabler, www.portlandsketcher.com
Rob Sketcherman, www.sketcherman.com
Rolf Schroeter, skizzenblog.rolfschroeter.com
Shukri Sindi, www.flickr.com/photos/92698806@N05
Suhita Shirodkar, sketchaway.wordpress.com
Takeuma, www.k5.dion.ne.jp/~s-tkm231
Thomas Thorspecken, www.analogartistdigitalworld.com
Tim Richardson, www.flickr.com/people/timillustrator
Tineke Lemmens, www.tinekelemmens.nl
Tom Pellett, www.flickr.com/photos/126948036@N02
Victoria Antolini, www.behance.net/viksa
Virginia Hein, worksinprogress-location.blogspot.co.uk
Xavier Boutin, https://www.facebook.com/xavier.boutin.16?_rdr=p

Twitter, Tweet, and Twitter Bird Logo are trademarks of Twitter, Inc. or its affiliates, p.12b
Yahoo! Inc., p.12b

All from Shutterstock.com:
Alan Poulson Photography, p.52cr; Champion studio, p.50tl; Everett Collection, p.54tl; Ewais, p.52cl; Irina Bg, p.42l; Kiselev Andrey Valerevich, p.38t; Lichtmeister, p.54tr; Maradon 333, p.40cl; Photka, p.50cr; Pindyurin Vasily, p.40r; Pkpix, p.50cl; Pressmaster, p.38 2nd from top; Sanneberg, p.40cr; Se media, p.54cl; Seanika, p.40t; Serg Zastavkin, p.40c; Straight 8 Photography, p.38 4th from top; Tatiana Popova, p.50tr; Viacheslav Nikolaenko, p.54cr; Vita Khorzhevska, p.38 3rd from top